THE COWBOY BOOT BOOK

To all those cowboys

who rode the cattle trails,

and their bootmakers,

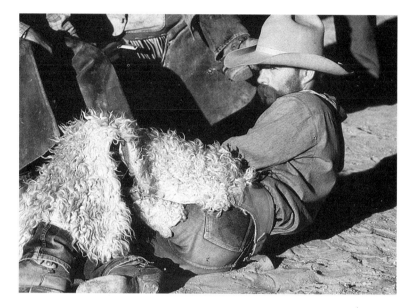

and all cowboys

and bootmakers

that have followed.

THE COWBOY BOOT BOOK

Text by
TYLER BEARD
Photographs by
JIM ARNDT

GIBBS·SMITH PUBLISHER

PEREGRINE SMITH BOOKS
SALT LAKE CITY

ACKNOWLEDGEMENTS

Sincere appreciation goes to the following people, who helped me gather materials for this book and furthered my education in boot making: Mary Olsen; Angela Featheree of Nocona Boots; Eddie Kelly and Ken Schaeffer of Justin Boot Company; Robert Castleberry, Dahl Tate and Arch Baird of Leddy Boots; Wilson Franklin and Joyce Franklin; Marty Snortum of Rocketbuster Boots for his "Cowboy Boot Book" boot; Eddie and Kathy Kimmel; Ray and Elizabeth Jones; and Butch Brown.

A special thanks to Patti, typist deluxe, for her assistance. Thanks to Gibbs Smith, publisher of Peregrine Smith Books, for offering me this project and to Madge Baird for helping turn it into a book; to Gary van der Meer for his enthusiasm for boots and to Jim Arndt for his extraordinary photography.

I am grateful to my parents for stickin' me into cowboy boots at age three, and to my wife, Teresa, for holdin' a gun to my back until this book was finished.

TYLER BEARD

Thanks to Connie Evingson, Steve Goodwin, Craig Gjerness, Joe Michl, Chip Schilling, Gary van der Meer, Billy Martin's, Corner Store, Amado and J. B. Peña, and Mark Palas.

JIM ARNDT

First edition 1992
Text © 1992 by Tyler Beard
Unless otherwise credited, all photographs © 1992 by Jim Arndt

This is a Peregrine Smith Book, published by
Gibbs Smith, Publisher
P.O. Box 667
Layton, Utah 84041

Design by J. Scott Knudsen
Manufactured in Malaysia by Times Publishing Group
Front cover photograph © 1992 by Jim Arndt
Back cover color photograph © 1992 by Jim Arndt, boot designed and manufactured by Rocketbuster.
Photograph of author and photographer © 1992 by Jim Arndt

Library of Congress Cataloging-in-Publication Data

Beard, Tyler, 1954-
 The cowboy boot book / Tyler Beard ; Jim Arndt, photographer.
 p. cm.
 ISBN 0-87905-529-4
 ISBN 0-87905-471-9 (pbk)
 1. Cowboy boots. I. Title.
 TS1020.B35 1992
 685'.31' 00973—dc20 92-15968
 CIP

The cowboy ain't no dandy,
When it comes to wearin' clo'es,
But when he trails to the city,
He'll go as other folks goes.
But there's jest two things he's wearin',
From where he never scoots—
He'll stick to his ol' Stetson hat,
He'll stick to his high-heeled boots!

E. A. Brininastool
Trail Dust of a Maverick

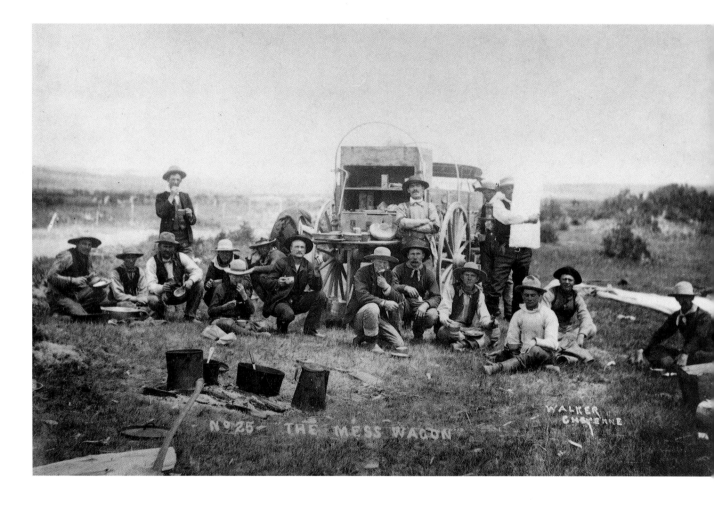

Cowboy boots are, without question, America's most recognized fashion contribution to the world, outdistancing even blue jeans. While maneuvering into a pair of boots early in the morning, most of us are struck with a vision of our horses patiently waiting, tied to a rail, shaking off the trail dust from the day before. We breezily walk out the door to the jingle-jangle of spurs as we enter our own make-believe mirage of the West.

Out in the real West, most people over the age of sixty—even city dwellers out for a Sunday drive or picnic—can still remember sun-bronzed, working cowboys on horseback or on foot, mending fences or a windmill. They were always roofed by a wide-brimmed hat, decorated with a well-worn pair of spurs, and inevitably finished off with boots. Back at home, on the radio and on Saturdays at the picture show, everyone's memories of cowboys and the wild-and-wooly West that grandparents and great-grandparents often spoke about nostalgically were kept alive through radio and movie serials and films featuring the likes of William S. Hart, "Bronco Billy," Jack Hoxie, Buck Jones, Ken Maynard, Hoot Gibson, Tim McCoy, and Tom Mix, and then along came "Singin'

Sandy," better known as John Wayne, in the late 1920s. None of these tough hombres would have been caught dead without his boots on. These screen idols were also proud of their boots, which resulted in the fashion of rolling Levi's up about six inches in order to better show them off. Sometimes trouser legs were also jammed into the boots to add a hurried, rough-and-tumble look to the western hero.

Tom Mix was the earliest entertainer to endorse children's boots. William Boyd, better known as "Hoppy," Roy Rogers, and Gene Autry later got into the endorsement business.

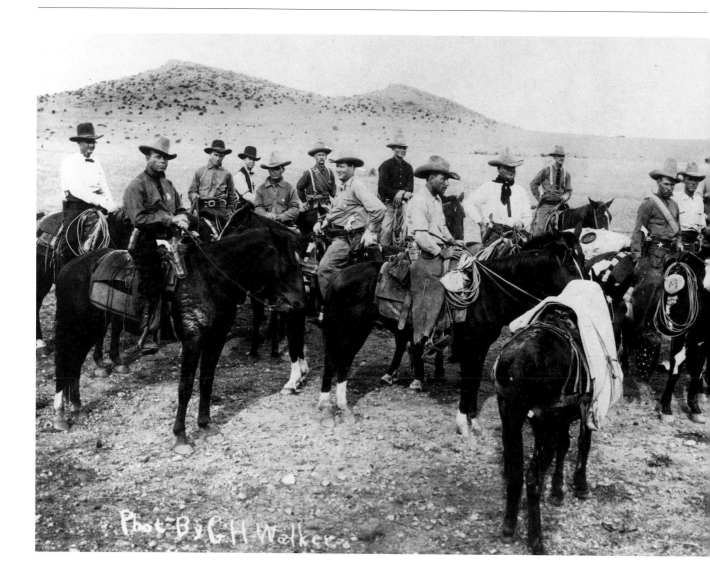

Phot-By G.H.Walker

Actual cowboys were for the most part a migratory breed who traveled from ranch to ranch or cattle drive, according to the season and the pay. They valued only a few possessions and were never without them: a hand-made saddle, custom spurs, a good rope, a store-bought Stetson hat, a bandanna and a "poke" with small mementos of home or a girl they had met, and last and most important, a pair of shop-made boots. The rest of their clothing was usually standard dry-goods attire.

Fewer than forty thousand men with an average age of seventeen to twenty-four ever got to drive cattle from Texas to the rail-heads and cow towns of the Kansas plains. These were the original, mythic cowboys from whom all lore and legend have sprung.

Yet for over 120 years the cowboy and his style have endured throughout the world. These cowboys originally wore every type of shoe and boot known to man. It was these cattle drives after the Civil War that made them realize what sort of boot they needed. When they reached Kansas, with its small boot and shoe shops, the cowboy and the bootmaker slowly created the various styles of boots suitable for cowboy work and attractive to cowboy vanity.

Because of the stories of our ancestors about those who ventured west from New England to the "frontier" in covered wagons, all of us have been touched by images of the uncharted West and many yearn to go back to those times. We want to discover and understand what life was like then. We want

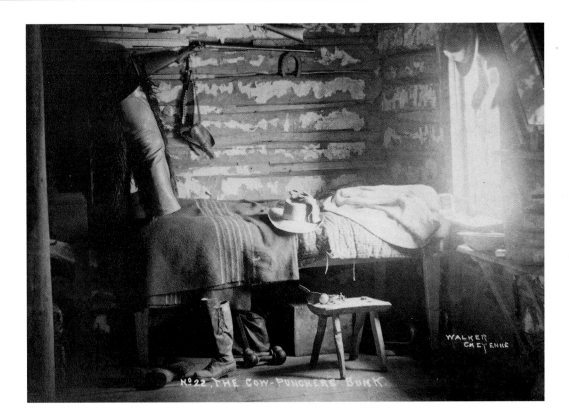

to own actual objects or replicas from that period that we feel can keep us somehow in touch with our roots. We need something tangible sometimes in order to know the stories were true. What was it really like to be a cowboy or a cowgirl . . . to wear boots and roam the plains?

Even before the cattle drives ended, there have always been wanna-be dudes and dudettes. Only one generation actually had the cattle drive experience. Before it was over—in less than twenty years—cowboys with their gear, their manner, and their lore were being romanticized all over the world through dime novels, newspapers, and the Buffalo Bill Wild West Show, which started to travel in 1883. Soon the entire world wanted to go west.

For thousands of years horsemen have relied on protective footwear. In the fifth century Attila's Huns were wearing tall-top boots, and Genghis Khan's horsemen wore boots in the twelfth century, along with the riders of the Mongolian steppes. Spanish settlers and Mexican vaqueros all wore tall-top boots with spurs, many with beautiful silk-embroidered tops. When one old cowboy was asked why cowboys did so little walking, he replied, "If the good Lord hadn't intended for man to straddle a horse, he wouldn't have split him up the middle and turned up the ends of his legs so they'd fit into stirrups."

T. C. McInerney was the only known bootmaker in Abilene, Kansas, in 1868. Up until this time cowboys had been wearing "stogy" boots—heavy-soled, fully pegged, tall-top boots made from a black hard leather called kip. In the late 1860s "saddle dandies" created cowboy fashion and the high-heeled boot swept through the plains, replacing the low-heeled boot with its duck-billed toes which the average cowboy was wearing at the time. In the 1880s the high heel was seen a little bit less, but by the early nineties, all the illustrations in boot catalogs showed high-heeled boots. The prices of boots varied greatly between 1860 and 1890, from three to twenty-five dollars a pair, depending on the skin, the height, and the maker.

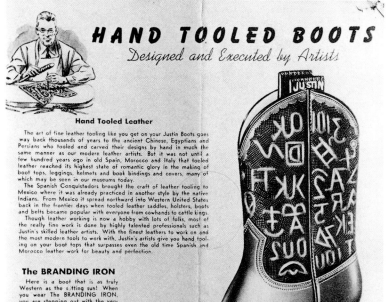

HAND TOOLED BOOTS
Designed and Executed by Artists

Hand Tooled Leather

The art of fine leather tooling like you get on your Justin Boots goes way back thousands of years to the ancient Chinese, Egyptians and Persians who tooled and carved their designs by hand in much the same manner as our modern leather artists. But it was not until a few hundred years ago in old Spain, Morocco and Italy that tooled leather reached its highest state of romantic glory in the making of boot tops, leggings, helmets and book bindings and covers, many of which may be seen in our museums today.

The Spanish Conquistadors brought the craft of leather tooling to Mexico where it was already practiced in another style by the native Indians. From Mexico it spread northward into Western United States back in the frontier days when tooled leather saddles, holsters, boots and belts became popular with everyone from cowhands to cattle kings.

Though leather working is now a hobby with lots of folks, most of the really fine work is done by highly talented professionals such as Justin's skilled leather artists. With the finest leathers to work on and the most modern tools to work with, Justin's artists give you hand tooling on your boot tops that surpasses even the old time Spanish and Morocco leather work for beauty and perfection.

The BRANDING IRON

Here is a boot that is as truly Western as the setting sun! When you wear The BRANDING IRON, you are stepping out with the very newest and most exclusive of Western styles, because never before has any bootmaker (that we know of) decorated his boot tops with the famous brands of the West. The BRANDING IRON is trim and beautiful to look at — with its brand-studded tops of special tooling Calf leather, with Saddle Tan brands standing out boldly on a Black background, and vamps of any color you choose.

You can have your own selection of about forty brands (depending on type) on the tops at slight extra cost (see price list) and be completely individual.

MADE ON ORDER ONLY

SPECIAL JUSTIN DESIGN
PATENT NUMBER 92932
Cannot Be Imitated

JUSTIN MADE-TO-ORDER BOOTS ARE "TOPS" IN QUALITY AND STYLE

When you buy genuine Justin Boots you get as fine a boot as can be made. The price you pay will, of course, determine the quality of materials and the design of the tops, but every pair of Justin Boots has all the style and quality that comes from over sixty years of leadership. This long experience has developed certain manufacturing operations that other bootmakers have never been able to attain—giving Justin Boots many refinements of construction and style that others never have. So be sure you get the "tops" in style and quality by buying genuine Justin Boots, made only by the Justin Boys in Fort Worth.

Copyright 1941 by H. J. Justin & Sons, Inc.

Hand tooled boot with cattle brands © 1941, by Justin Boot Company.

Boots have changed greatly since these early years. In the 1860s the "Coffeyville Boot" from bootmakers in Coffeyville, Kansas, was popular. It combined elements of the British Wellington boot and various U.S. Cavalry styles. By the 1870s the "drover," "stovepipe," and "cattleman" models had become popular. These all had tall tops, at least fourteen inches, and many came up to the thigh. These boots were the precursors of the cowboy boot we know today. The stovepipe name stuck because before 1900, most boots were black, tall, and had level tops.

Bootmakers and cobblers traveled from the East to the West to take advantage of the booming cattle towns where cowboys ended a drive and always ordered new boots. Dodge City, Wichita, Ellsworth, Abilene, and

Caldwell were among the best-known railheads. It was not uncommon for a cowboy or rancher to travel over two hundred miles on horseback to order a pair of shop-made boots. He could soak up the atmosphere, maybe find a job on a ranch nearby, or buy some cattle in town. Later on, usually six to twelve weeks afterward, his new boots would arrive through the mail. This was all before the advent of mail-order boots about 1880.

Boot heels reached their upper limit at three to four inches in height, gently sloping to a bottom no bigger around than a quarter. The two- to three-inch-wide duck-billed box toes gave way to gently curved U toes and narrower one-and-one-half-inch box toes. About 1900 the first "toe wrinkles" appeared to keep the vamps flat and smooth. C. H. Hyer, in his 1903 catalog, became the first bootmaker to advertise wrinkles on toes. Around 1915 the style of adding a flower design in front of the wrinkles was introduced.

Today most people regard their boots as a fashion accessory. But just as with many everyday things in life, boots were a product of form following function. "Big Daddy Joe" Justin (yep! the same family) is credited with making the first cowboy boot in his shop in Spanish Fort, Texas, a frontier settlement on the Great Eastern Cattle Trail (later, Chisolm Trail). A bootmaker, today as then, can turn out on his own an average of twelve pairs of boots a month. Justin Boot Industries now kicks out more than three-and-a-half-million pairs a year.

Cowboys were the rock stars of their time and contrary to popular belief, they were more than a little vain about their appearance, which prompted Will James to write: "The high heel was made to slope so far under the foot in order to leave a size-six boot print instead of size ten!" Cowboys took great pride in what they wore, especially on their feet. More frequent trips to town and

Justin's Rangeland, king of boots, with seventy-two solid silver conches, 1930s.

CONVENTION RODEO
HOUSTON, TEXAS. 1928
RICE FIELD
PRICE 25¢
JUNE 26-30
THIS PROGRAM AND SOUVENIR NOT COMPLETE WITHOUT DAILY PROGRAM INSERT

Saturday night dances, combined with images from silent pictures, made them more aware than ever of how they looked. Fancier boots in a variety of toes, heels, and styles, with multicolored rows of stitching and small amounts of brightly colored inlaid designs, began to appear about 1920. Then when Hollywood really got a stranglehold on cowboys and their boots, it was "Katy, bar the door." Boots were no longer designed only to protect cowboys against rattlesnakes, cacti, mesquite thorns, saddle chafing on the leg, and inclement weather, or to hold up a pair of spurs. Nope.

Rodeo started as a pastime for cowboys. Then ranch rodeos evolved, and ranches competed against each other in events. By the 1920s rodeo was an organized sport and entertainment all across the country, from Pendleton, Oregon, in the west to New York's Madison Square Garden. Rodeo had a profound impact on boot popularity.

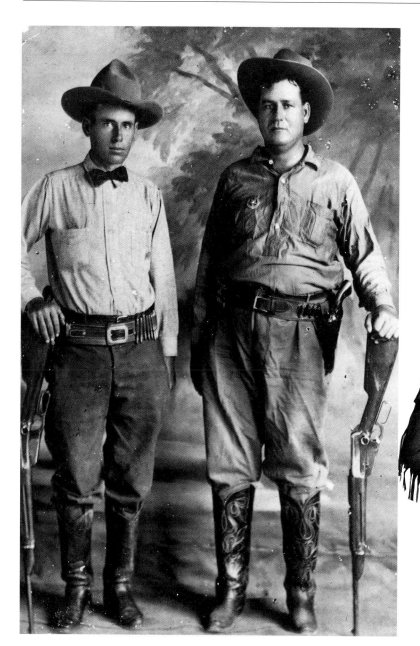

Roy Rogers—king of the cowboys—wore out hundreds of inlaid eagle boots over the years. Some are on view at the Roy Rogers Museum in Victorville, California. Roy Rogers and Dale Evans still visit their museum, and Roy is frequently seen on television and has done recording duets with stars such as Randy Travis. Roy never gave up his 1950s cowboy image and today looks and yodels better than ever.

Texas Ranger Glenn Beard (right) with a fellow Ranger. Glenn is wearing boots with the Rodermund stitch pattern. "Old Man Rodermund," as he is called by all the bootmakers, designed the stitch while working in San Angelo, Texas, from about 1870 to 1915.

Until about 1920 boots were a mark of distinction for cowboys, sheriffs, Texas Rangers, and cattle kings all across the West. With the advent of rodeo as a sport, combined with the impact of cowboy crooners such as Tex Ritter, Gene Autry, Roy Rogers and Dale Evans, and later Rex Allen, boot designs suddenly and dramatically changed. Now limited only by the imaginations of the bootmaker and the wearer, styles featuring simple stars, moons, hearts, diamonds, ranch brands and initials were soon looked down upon as rather dull and old-fashioned. A

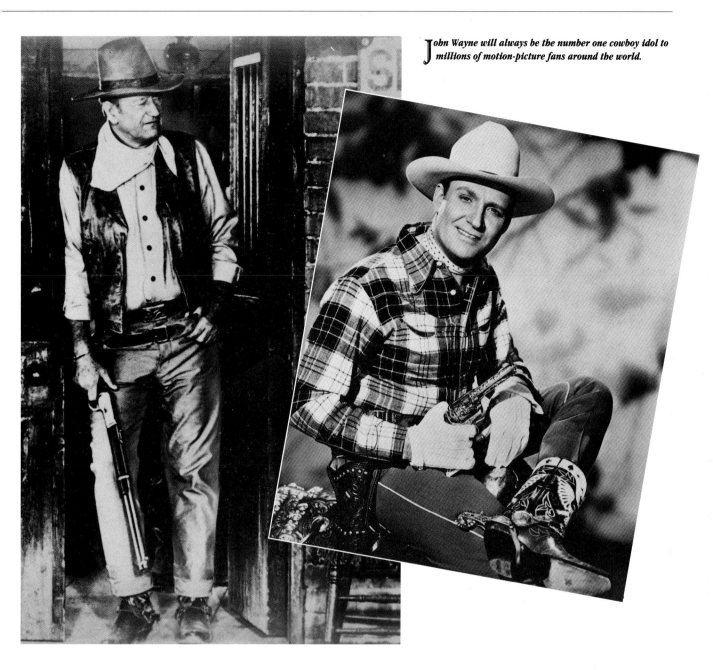

myriad of stitched spiderwebs, decks of playing cards, flowers and vines, prickly pear cacti, longhorns, eagles in flight, a favorite horse or bull, bucking broncs, oil derricks, and even hand-tooled boots resembling saddles became commonplace. Boots in dozens of new leather colors and exotic skins, with overlaid and inlaid designs using up to twenty rows of stitching, all pieced together artfully and finished to the bootmaker's perfection, appeared on men's, women's and even children's feet all over the country.

A number of custom bootmakers from the first half of this century have vanished. David Posada Boot Company started in 1915 in Hollywood, California. Some of its famous customers included early cowboy stars Jack Hoxie, Ken Maynard, Rex Bell and Tom Mix. In the 1920s, E. T. Amonett from Roswell, New Mexico (who later moved to El Paso, Texas), the Beck brothers in Amarillo, Texas, Rudolph Matzner, Fort Worth, Texas, Joseph Zihlman in El Paso, Texas, and L. White in Fort Worth were only a few of the prominent small bootmakers of their time.

Gene Autry, singing cowboy movie star and highly successful businessman, still lives in California. Gene never left home without his eagle or butterfly inlaid snub-nose peewees.

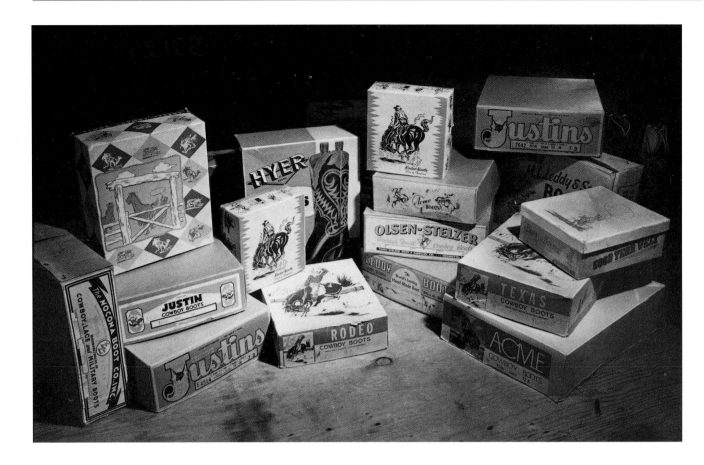

G. C. Blucher, pioneer bootmaker, worked for H. J. Justin for twenty-seven years. After his stint with Justin, Blucher opened a shop in Cheyenne, Wyoming, and later partnered with Western Boot Company in Tucson, Arizona, for eleven years before moving to Olathe, Kansas, in 1943, where he continued making boots until his death.

From the 1930s through the fifties, other boot companies sprung up in towns all across the West: Goding Boot Company, Ranger Boot Company, Westex Boot Company, Bern Whit Boots, Dixon Boot Company, Kirkendall Boot Company, Tex-Tan, Lone Star, Texan, Bronco, and Cow Town Boot Company.

Mail-order catalogs were also popular in the 1930s and forties, mailed out by Justin, Hyer, Nocona, and many other small boot-makers. Even the dry-goods stores, such as Denver Dry Goods and Miller Stockman, joined in the craze. During the 1950s you could dream about going to Texas or the Cheyenne Frontier Days in Wyoming while sitting in your living room in Buffalo, New York, wearing all the western duds you had ordered from a catalog, and listening to your radio serial or later watching your choice from dozens of western programs on television.

In the 1940s and fifties, Acme Boot Company of Tennessee was known for its moderately priced inlaid boots for men, women and children. It still claims to be the largest boot manufacturer in the world. Along the way Acme quietly acquired other boot companies—Dingo, Dan Post and Lucchese.

Boot art reached a pinnacle about 1955. A story from The *Cattleman* magazine that year says it all:

Last summer a customer wearing handmade boots walked into the John Furback jewelry store in Amarillo, Texas and asked to see their silver belt buckles. The jeweler could not

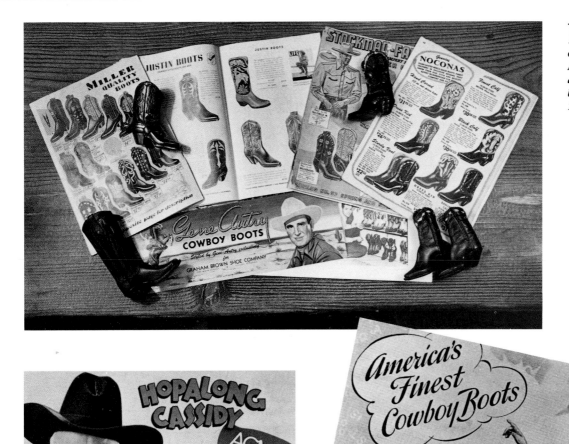

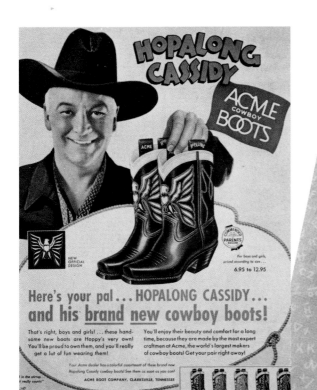

William Boyd, better known as "Hoppy," endorsing his brand of children's cowboy boots.

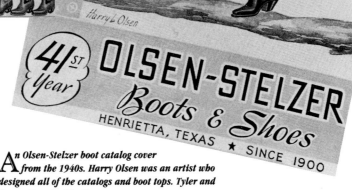

An Olsen-Stelzer boot catalog cover from the 1940s. Harry Olsen was an artist who designed all of the catalogs and boot tops. Tyler and Teresa Beard collection.

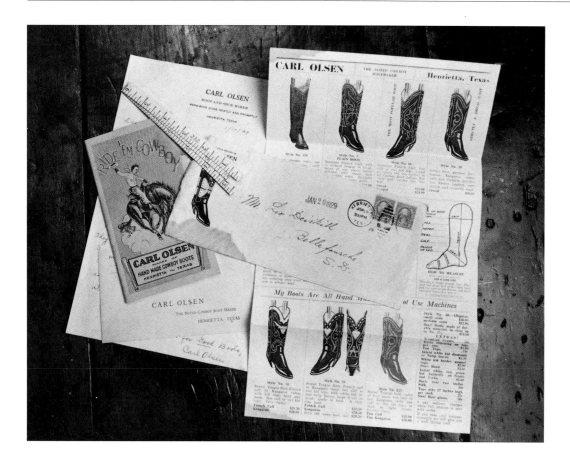

A 1929 mail-order-boot measurement chart and catalog from Olsen-Stelzer, Henrietta, Texas. Tyler and Teresa Beard collection.

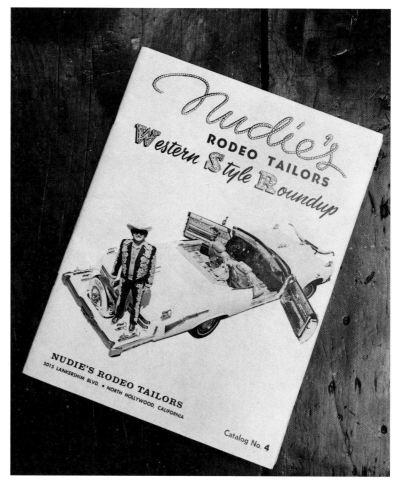

Nudie's of Hollywood made embroidered and rhinestone-studded western clothing with boots and hats to match from the 1950s to the early seventies.

concentrate on the sale for staring at the customer's boots. His practiced eye skipped over the richly engraved, sterling silver plates covering his boot heels and toes. Right in the middle of the toe caps were mounted two-carat diamonds. "Sir," John Furback, Jr., asked the stranger, "would you mind showing me your boot tops?" The man obligingly peeled up his trouser leg. In the middle of his cordovan boot top was the emblem of the state of Texas embroidered in pure gold thread, complete with the blazing lone star.

On both sides of the border, boot making has always been a time-honored tradition, steeped in pride and governed by a deep sense of the past. Bootmakers pass down their skills to a son, daughter, or an outside apprentice. In the same way, a child's first pair of custom-made boots by the family bootmaker is also an initiation into this tradition between bootmaker and customer.

In 1964 after Elvis settled in and The Beatles came to America, western heroes and the western look took a backseat for a while. Some cowboys tried to go a little "mod," but that was a disaster. Boots basically did not change much during the sixties. The low point, however, occurred when one boot company started making boots out of paisley nylon, a sad day for western wear. By the seventies many rock bands were wearing cowboy boots and even hats with long hair hanging out the back. Again there was no getting away from our American history and the influence of the cowboy.

When *Urban Cowboy* was released in 1980, I was living on the East Coast. My friends could not understand why I burst into tears when John Travolta's aunt in the movie gave him her husband's rodeo buckle after he died. In the West cattle brands, belt buckles, hat creases, and daddy's first pair of boots are passed down from father to son, generation after generation. This is a quiet

ritual. Publicly the evidence of this custom is still visible at rodeos, horse and cattle auctions, family reunions, and funerals. I know of one family in Rising Star, Texas, that has over 120 pairs of boots. They have never thrown any away. These boots span four generations of Texans and were all made by one Texas bootmaker and his sons.

In 1981 *The Texas Boot Book* was released. The boot bible for almost ten years, it only added to the boot mania sweeping the world that year. By 1982 the urban cowboy trend was in full swing, and that year boot factories in this country alone manufactured over seventeen million pairs of boots. Andy Warhol bought five pairs of Olsen-Stelzer boots from legendary Judie Buie, a native Texan. Judie was the first person to open a store in New York, The Judie Buie

Dave Little's father and grandfather (left and center) in their San Antonio boot shop, about 1940.

17

Boot Shop & Texas at Serendipity, which sold only old dead-stock boots and leftover styles from the factories and attics of old boot shops. In addition she began to design her own line of boots. After selling boots to everyone who was anyone in New York, she sold the store and moved to Aspen, Colorado, to pursue a career in photography. Others soon followed her lead in Los Angeles and Paris, France. But by 1985 boots had leveled out and factories were only making eight million pairs a year. But here we are again: in 1990 they produced over twelve million pairs. The popularity of cowboy boots has baffled journalists and financial analysts for years.

Flipping through the *Texas Boot Book*, one becomes painfully aware that most of the independent custom bootmakers are either retired or deceased. There is only one boot-making school left in the United States—in Okmulgee, Oklahoma. Fledgling bootmakers abound, however, in small towns throughout the western United States, and with the ever-increasing interest in American folk crafts, more and more young men are coming to see boot making as a viable profession grounded in American history and graced with aesthetic and utilitarian values. There are over one hundred fifty independent small boot shops throughout the West.

Ralph Wildman and Sharon Goldberg minding the store, Rancho Loco in Dallas, Texas.

No, it's not Manny, Mo, and Jack, but owners of Rocketbuster Boots in El Paso, Texas— Marty Snortum, Ivan Holguin, and Lencho Guevva. Photo by Snortum Studio.

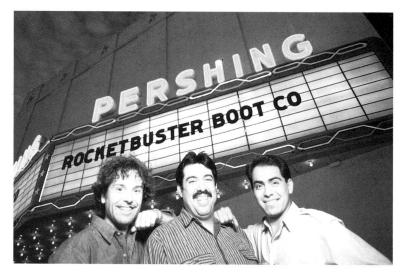

*A*lfonso Díaz hammers a leather sole at Little's Boot Shop.

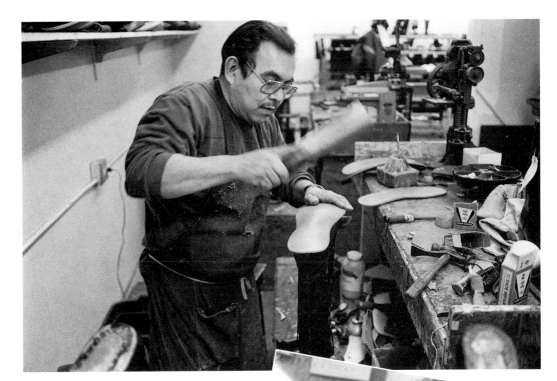

*J*uan Ortiz, top man at Little's Boot Shop, carefully stitches an alligator vamp to the shaft.

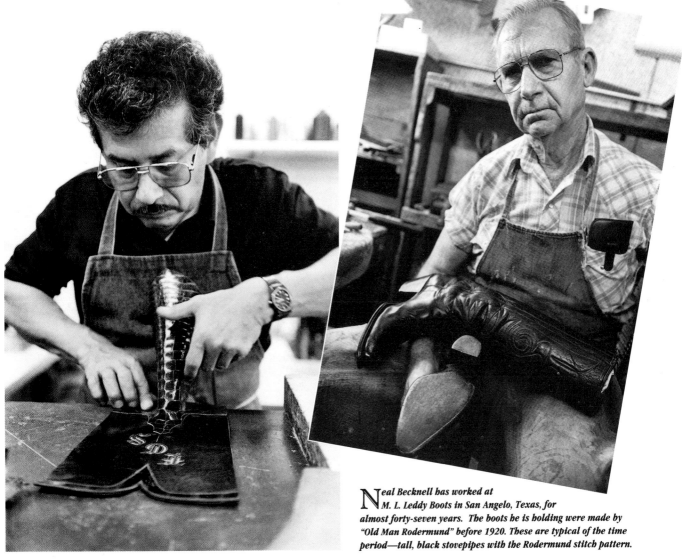

*N*eal Becknell has worked at M. L. Leddy Boots in San Angelo, Texas, for almost forty-seven years. The boots he is holding were made by "Old Man Rodermund" before 1920. These are typical of the time period—tall, black stovepipes with the Rodermund stitch pattern.

People all over the world love cowboy boots. The movie, television, rodeo, country music, and even the high-fashion industries have embraced, interpreted, and popularized this distinctive American look. This has been going on since the 1930s. We are told every few years that western wear and cowboy boots are "out," but we just keep on wearing them. Then every so often the whole world of fashion explodes with the American West influence and BOOM!, the cycle starts all over again. In Texas alone there are over twenty million head of cattle on over 150,000 ranches. Just these families and the people who work there could keep a small boot industry going—think about that for a while.

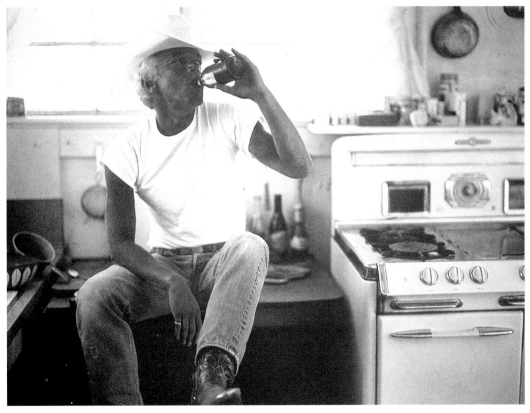

The romance of the American West still reaches out to millions of people worldwide.

Ralph Lauren kicks back with a sarsaparilla in a bunkhouse kitchen in Colorado, wearing a pair of beat-up-just-enough boots. Courtesy Polo/Ralph Lauren.

Why cowboy boots? They are the enduring icon of the American cowboy, a true free spirit. An independent, self-reliant individual, he symbolizes strength, determination, and the American way. After all, we were the ones who got away, and the cowboy is every American's personal hero. Cowboy boots seem to instill confidence in the wearer; they give you an attitude. Boots can be euphoric.

In a time when tradition is looked down upon and people are trying to rewrite our

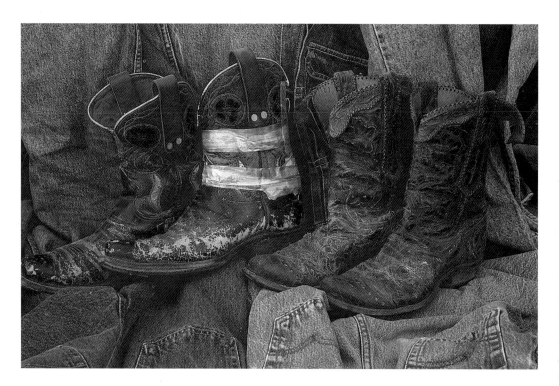

Two pairs of old Nocona boots vintage 1940s. Everybody needs at least one pair of broke-in peewees to go with their favorite Levi's. Courtesy Nocona Boot Company, photo ©1992 Jim Arndt.

history, we all want to cling to some vestige of our past. Boots have an ageless appeal: cowboy charisma, cowgirl couture. These are anything but new ideas. Yet baby boomers, raised in the shadow of their television sets with western idols flickering by on horseback, are now desperately searching for what they lost along the way. The past was a saner time full of hope, prosperity, and heroes. Roy Rogers, Dale Evans, and John Wayne made anything seem possible. It was a time when things were not discarded without regret. You wore your Roy Rogers or Annie

Oakley suit, complete with boots, holsters, cap guns, and spurs, and had a stick horse to ride. Your mom or dad removed your little felt hat and hung it on the bedpost while tucking you in with promises about tomorrow. All of your friends liked the same things. It was a simpler time and everyone wanted to be a cowboy or cowgirl.

For the last twenty years men and women have been wearing boots in honkytonks, boardrooms and offices, banks, locker rooms, the White House, and now they even appear in rock videos. Regardless of job, state, or even country, everyone wears cowboy boots. Again in the nineties, *Vogue* and *Harper's Bazaar* have featured old, rough, vintage boots along with new ones copied from old styles. Designers such as Jean Paul Gaultier, Georges Marciano (GUESS), Alexander Julian, and of course Ralph Lauren, who has always reminded us that we should be proud to wear and remember styles from our American past, affirm that boots are in once again. Billboards and full-page magazine ads are featuring boots. Cactus Juice Tequila, Marlboro, and Absolut Vodka are among the many products to use cowboy boots this year to reach their markets.

A boot can be as personal as a tattoo, but you can take your boots off at night. With an ever-increasing selection of leathers, colors, exotic materials, and a resurgence of the old boot styles, we are experiencing a renais-

sance of artful boot making. You can buy your boots right off the shelf and that may satisfy you. But if you really need to let the world know exactly who you are, or if you need to express yourself or take a stand with what you stand in, go to a custom bootmaker. It costs about the same as a few visits to a good therapist, but it's a lot more fun, thing. You've found out after a little guilt that alligators are farmed now and off the endangered list . . . whew. But the boots cost four thousand dollars. Yes, a full gator boot in 1930 cost thirty-five dollars. So what? A Camaro in 1967 cost two thousand dollars. Now it costs almost twenty-five thousand dollars. Maybe you should start by digging up

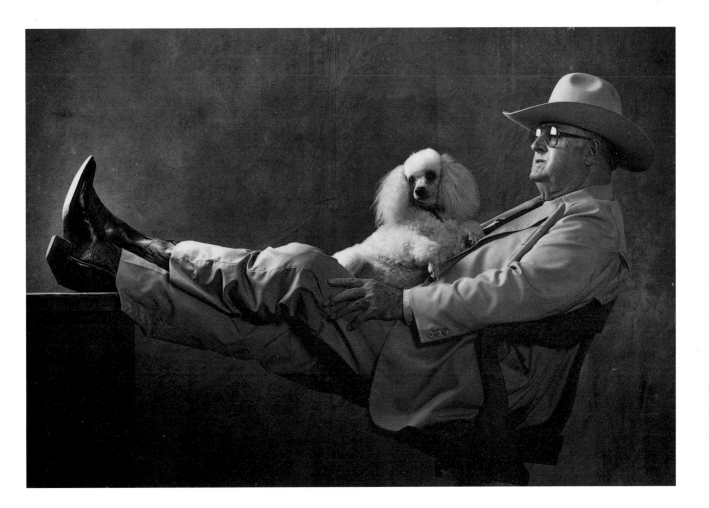

and you end up purged, with your heart, mind, and soul proudly displayed on your feet. Everybody needs a pair or twenty or even a hundred pairs of genuine bronc bustin', snake stompin', or just plain old concrete-sidewalk walkin' boots. Let's face it, we all see a lot more concrete than cactus these days.

All right, so you've decided you have to have a pair of alligator boots, but you're not sure if alligator and crocodile are the same

your first pair of boots. If they are tiny and scuffed and cute, put them out on display proudly on your mantel. It's cool now to have worn boots as a kid. Or dust off your needle-nose cockroach killers that have been sitting in the back of the closet molding since 1965. Pull them on . . . that feels great . . . they might be just a little tight.

Now you have to go to your local western-wear store or bootmaker to get some new boots. If you don't have a local western

Rufus Jordan, sheriff of Gray County, Texas, in 1984. Photograph by Kent Barker, Santa Fe, NM.

23

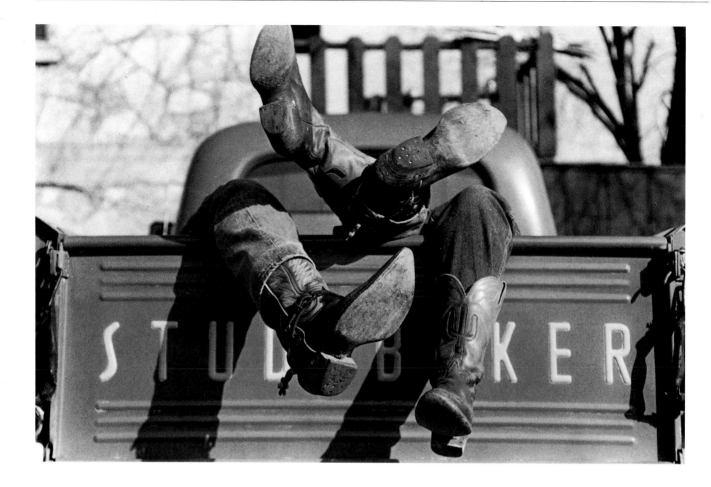

store or bootmaker, you probably live east of the Mississippi. Then it's time to go west, take a trip, plan a vacation and get that pair of boots that you can't quit thinking about. You probably won't get out of the store for less than $200, and you can't get a custom boot made nowadays for less than about $350. But if you go for the alligators, you might have to let your wife or girlfriend follow in Elizabeth Taylor's matrimonial boot steps this year and order a custom pair of cowboy boots with 8.09 carats of white diamonds for just a little more than forty thousand dollars. My advice is: if the boot fits, wear it; if it doesn't, collect it as folk art. Long live the cowboy boot.

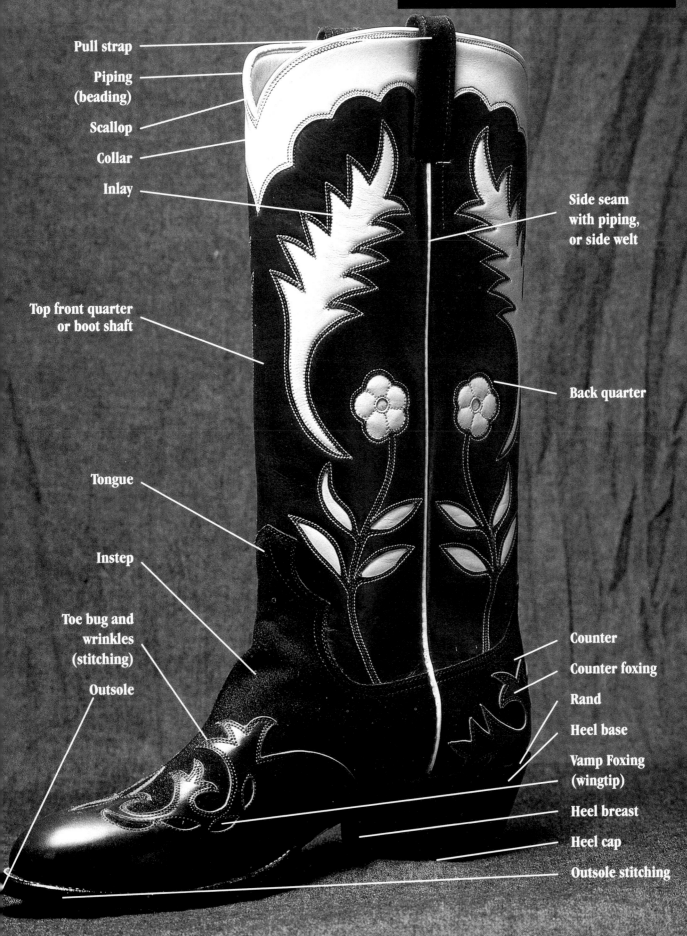

Pull strap

Piping (beading)

Scallop

Collar

Inlay

Side seam with piping, or side welt

Top front quarter or boot shaft

Back quarter

Tongue

Instep

Toe bug and wrinkles (stitching)

Outsole

Counter

Counter foxing

Rand

Heel base

Vamp Foxing (wingtip)

Heel breast

Heel cap

Outsole stitching

THE PERFECT FIT

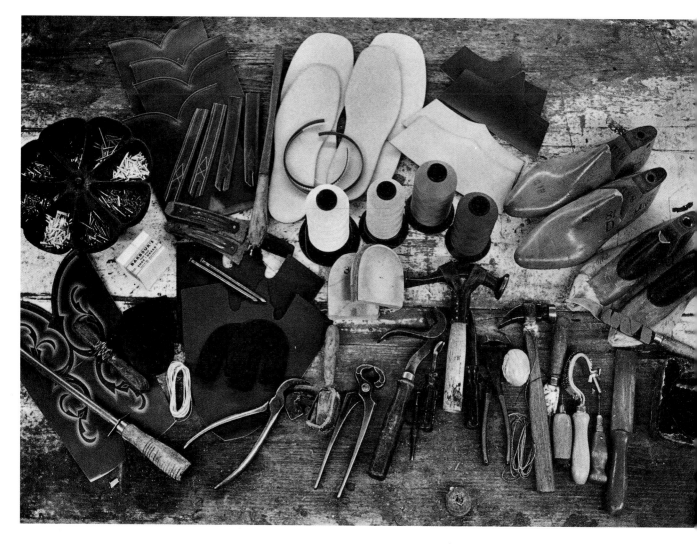

Bootmaker's bench
showing everything
it takes to construct a
pair of cowboy boots.

The human foot is comprised of twenty-eight bones. They are encased by numerous muscles, nerve endings and blood vessels, yet they have an acute, and also peculiar, ability to absorb pain and stress. Yet for all their forgiveness and strength, how many times have we heard people talk about how much their feet hurt? Those feet do a lot of work and deserve some consideration. Fewer than 5 percent of individuals over the age of twenty have two feet that match. Their weight, the way people walk and move, what they walk on, and how much they walk all have a profound impact on how a boot should really fit.

The perfect fit. Does such a creature exist? Yes. It's a boot that can be worn for eighteen hours without hurting your feet. Most people are content to stroll into a local western store or boot outlet and purchase boots off the rack. But if you want to express yourself a little more bootwise, feel the need to pamper yourself and relieve those barking dogs, or are just plain curious, I would suggest buying a pair of handmade, individually fitted boots. Speaking from experience, I can guarantee that once your bootmaker has your last down to perfection, you will be able to wear boots all day and night and never know they are on unless you look down.

Just as various boot companies use different lasts because they feel a boot should fit their way, the same is true of bootmakers. Some think a boot should be snug and take two weeks to break in. They would rather stretch the boot for you than have it be too loose. All bootmakers will gaze down at your feet, swimming or bulging in your boots. Then they will feel your feet inside the boots and tell you what is good or bad about the way you are wearing them. But you are the one who has to wear these boots all day, and you know better than anyone how you want a boot to fit, provided you have worn boots before.

If you have had custom boots made in the past, you have an even better understanding of what your foot requires for proper support and comfort. If it's your first time, or if you are unhappy with your current bootmaker, this is what you need to do: visit a bootmaker personally, if at all possible. If you can't arrange a vacation out West, write to several bootmakers and see what kind of response you get. Tell them what you are looking for and describe your experience with boots in the past. Be specific in your letter. Or call a bootmaker or several of them and set up a time when you can talk to them on the telephone to determine exactly what you need to do to order custom boots. Most bootmakers will take custom orders through the mail or over the telephone; however there are some who insist that you come to the shop.

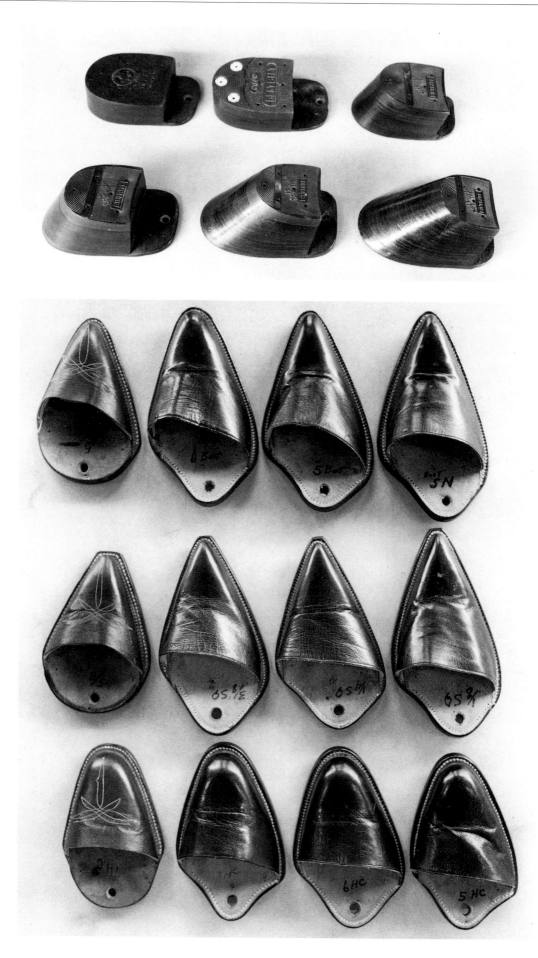

The six most popular beel styles. Back row (left to right): two walking beels and one slightly raised and angled beel; front row: higher and more undershot heels.

Twelve various toe styles at M. L. Leddy Boots in San Angelo, Texas.

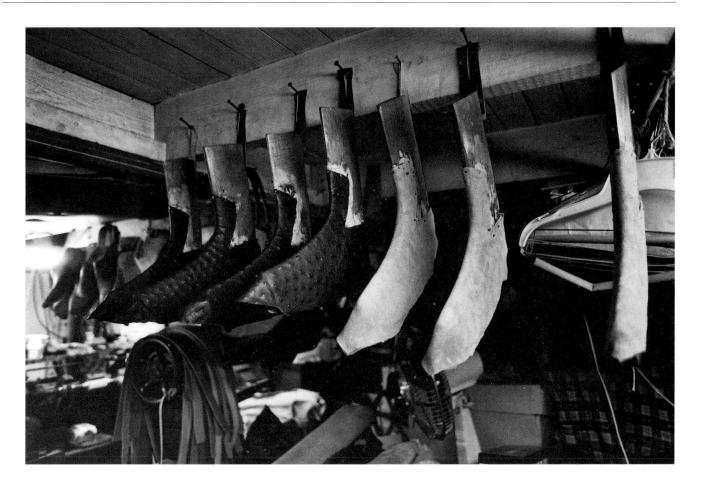

Many bootmakers would be happy to send you several pairs of boots made on their lasts that you can try on in a size close to what you wear in a factory boot. Then you can give them feedback about the fit of the boots to enable them to better fit your feet. It's also a good idea to wear your boots to the shop or send a bootmaker your favorite pair of boots. He can detect how you walk and much more from inspecting them. It's not quite as easy the first go-round, but the second pair will be a breeze.

Many people find, after wearing their first pair of custom boots, that they want to change a few details. These things could include minor loosening or tightening of certain areas of the boot, or they might just be cosmetic changes. For instance, you might want to change the height of the boot by lowering or raising the heel, or alter the toe or the overall style. The boot's outward appearance can be a never-ending can-vas for your imagination, but unless you gain or lose a dramatic amount of weight, your boots should always fit exactly the same if they have been made from the same last.

Any slight difference in the tightness or looseness of the boot material can be compensated for by a thicker or thinner lining. It should never take more than two pairs of custom boots from one bootmaker to achieve a perfect fit. The bootmaker, however, may do everything right, but he can't wear your boots or read your mind, so there is always a 10 percent guess factor in determining the customer's comfort zone. Most custom bootmakers will tell you that in any given year, 10 to 15 percent of their boots are returned because the customers feel that they do not fit. These are almost always first-time boot buyers, who have usually been wearing loafers and do not understand how a boot should fit.

Ostrich-skin vamps nailed to crimp boards at Capitol Saddlery and Boot Company in Austin, Texas.

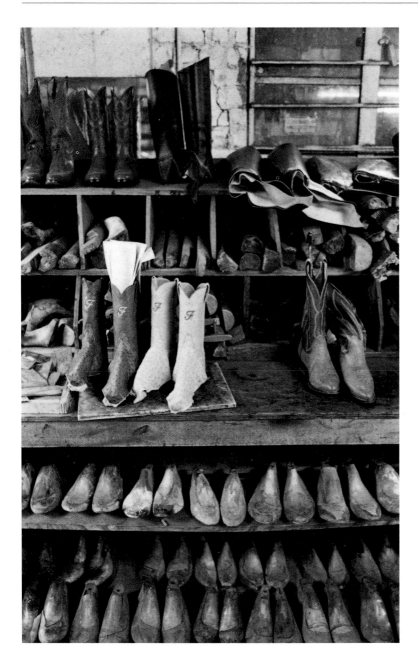

dated by using either a thicker sock or a sole cushion inside the boot.

Some bootmakers now have soft, impressionable foam boxes that can be mailed out. You step in to leave a foot impression. This, however, still doesn't consider the top part of the boot, and how you move. A good bootmaker will spend fifteen or twenty minutes with your feet. He will surprise you with the amount of support he will place under your arch, the way he will position the balls of your feet, and many other things you cannot imagine could feel so right. But one-sixteenth-of-an-inch difference in a custom boot can make it feel too loose or too tight. Once things are right in nine places, that tenth just cries out. Some folks like their boots a little loose, others like them snug, and I know one guy who had a bootmaker relast a pair of boots three times because they were not tight enough for him. That is very unusual because the most common complaint is that boots are too tight—not too loose.

It is true that skins used to make boots will soften over time. Your feet will make an impression, just as your lower body does in a pair of jeans. Leathers have different amounts of give. For instance most exotic skins will not stretch much. Calf, kangaroo, water buffalo, and ostrich will all adjust slightly to your foot shape. However any skin that has been properly crimped and lasted, which means removing all the stretch and memory from the leather, should not give much.

In short, a boot should fit and feel comfortable the first time you put it on—you shouldn't experience pain of any kind. A factory boot is not crimped and is lasted and dried in a day or two. These boots are run through a machine to speed up the drying process. For the most part this works fine, but a factory boot will definitely stretch out and lose shape more rapidly than one that has been crimped, left on a last for a week or

Considering the 10 percent guess factor and the fact that every once in a while a bootmaker can make a mistake, it is easy to see that custom boots are not a science, but an art. Measurement charts do not lie, but bootmakers will tell you that in your later years, most people's feet actually grow slightly longer and narrower. We tend to think that our feet always flatten, widen and shrink as we get older, but bootmakers who have made boots for fifty years for one customer say that this is simply not true. This slight size variation can easily be accommo-

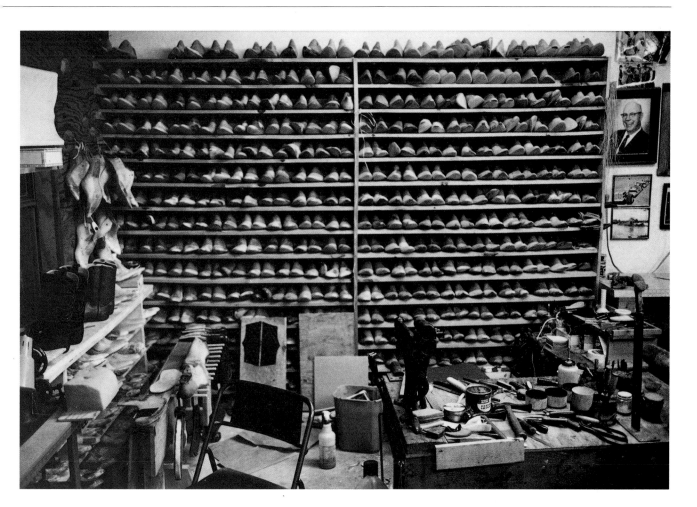

*J*ack Reed's Boot Shop,
Burnet, Texas.

*S*teel "dies" with sharp
bottoms are placed
over the skin and used
for consistency in cutting
out the various parts of a
boot. A hydraulic press
machine lowers with a
loud "click" to make the
cut. Photograph taken at
Dave Wheeler Boots in
Houston.

Early iron boot jacks from the collections of Tom Bailey and Tyler and Teresa Beard.

more, and left to dry out naturally. This boot, properly cared for, will maintain its shape and size for a lifetime.

When custom fitting, a bootmaker will also take at least eight measurements. He will pencil outlines of both of your feet onto paper while you are standing. The feet will be measured with each leg crossed over the other and the measurements will be rechecked with your feet flexed in a simulated movement position. Some bootmakers use giant ink pads to show where different parts of the foot touch the ground. Many also will double-check the top foot measurements with a contour gauge. All this information aids the bootmaker in preparing your last.

Bootmakers will tell you that most people wear their boots too short and too wide.

They want them to fit like a house shoe. Then when they want to walk, they put on a tennis shoe with no arch support and lace it up snug and tight. Very few athletic shoes have good arch support. I know it's hard to comprehend until you've experienced it, but a properly fitted boot with a heel no higher than two inches and proper arch support would be far better for your feet and more comfortable to walk five miles in than your average athletic shoe. The abnormal amount of pounding and stress from running make it crucial to choose a running shoe with proper support and fit. But if things were perfect, all shoes and boots in the store would be sized so that a 9B would come three ways: with a high, medium, or low instep.

You always hear people saying that pointed-toe boots hurt their feet or crunch their toes. The toe shape should have no impact on whether a boot fits or not. The fit starts behind the toe of the boot. Every man, woman and child wore narrow square- or pointed-toe boots from 1940–1970. But styles changed, and people forgot that when you wear a sharper toe, you must wear a slightly longer boot. Your toes do not go into the narrowest end of the boot. So don't worry; if you're thirty now and in the year 2048, when you're eighty-five, you want to kick up your heels, you can still wear those red, white and blue needle-nose, inlaid boots with the American flags, a portrait of your dog overlaid on the back, and your name and state emblazoned in multicolored leather running up and down the mule ears that touch the ground that you had made in Texas in 1993. Let 'er buck—boots are here to stay.

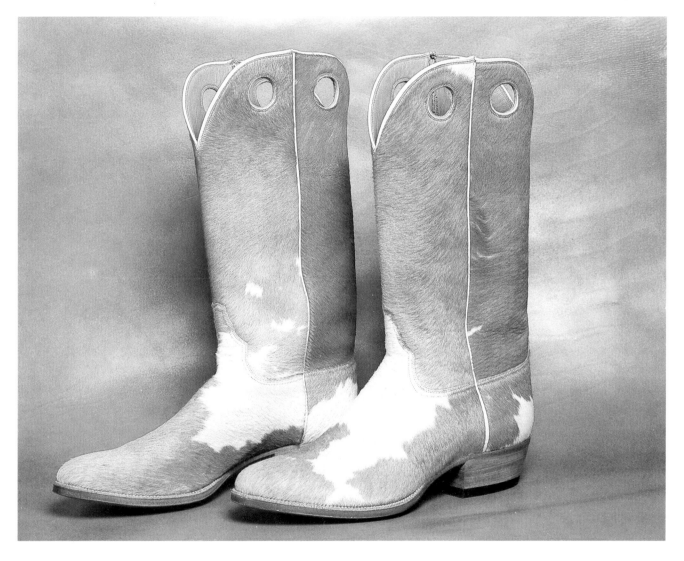

A *wild and wooly full hair-on calfskin boot by Dave Little.*

FROM THE HIDE

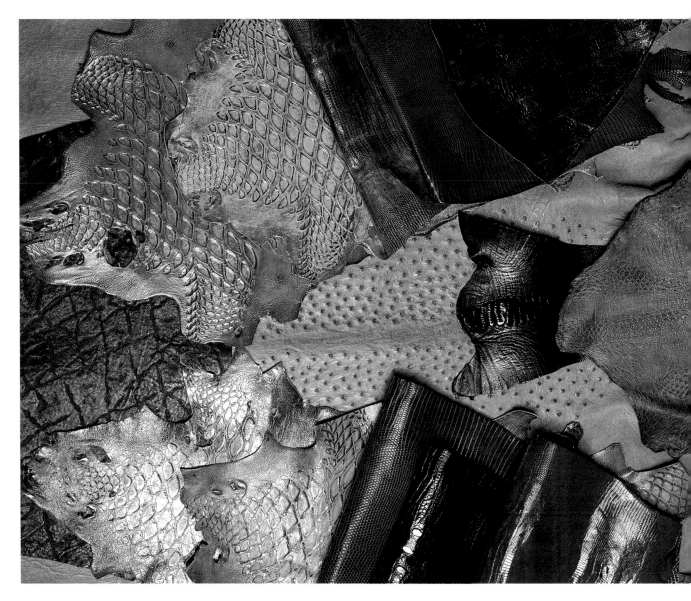

E xotic skins from all over the world.

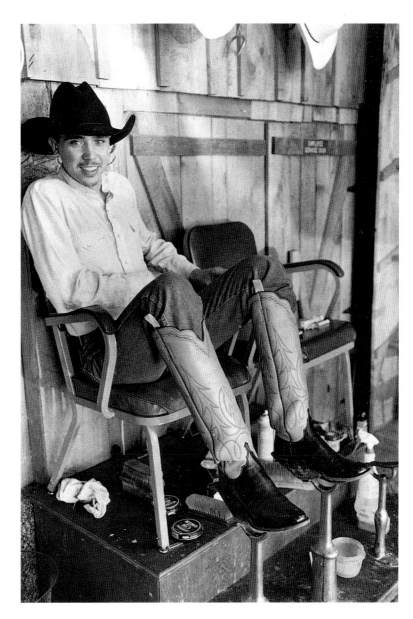

Most cowboy boots were, and still are, made from calfskin. It is durable, yet soft and comfortable. Most calfskin comes from France and Italy. Because most Americans eat beef, not veal, the best calf hides are found in Europe. In addition European cattle do not wear brands because they are not able to roam the range, so their skins are unmarred and smooth. Catalogs from as far back as the 1920s boasted alligator, kangaroo, and French calf boots.

Full-grained leather has a textured side where the hair has been removed, and the inside, or flesh side, which is smoother. Split skins have been literally split in half so that one of them will not have a textured or grain side. Full-grained leather, especially calf hide, has always been considered the best. Cowhide, or side leather, is less durable than calf. The leather is called "side leather" because it is literally taken from each side of the cow, left and right.

Boots have been fashioned from just about any animal hide or man-made material you can think of: armadillo, rattlesnake, turkey, toad or mink—somebody has tried everything. Various hides go in and out of popularity with fashion trends, and just as with sea turtle before it, currently there is a nationwide ban on the importation of elephant hide. There have been many other endangered animal skins that have gone off the availability list for bootmakers. Some of these hides, such as alligator, are now being farmed so that, hopefully, there will always be an abundance of hides for those folks who have just got to have alligator boots, and yet leave us plenty of alligators so our grandkids and their grandkids will know what a live alligator looks like.

Elephant hide, which has always been considered the toughest skin by bootmakers—waterproof and basically indestructible—will probably never be available again. It simply takes too many years for a young elephant calf to reach maturity, so those people who have been wearing elephant will have to choose the next best thing: shark, bull, or Norwegian ox.

The hide, the wear, and the use of the

C. L. Wallace waits for a shine at M. L. Leddy's in San Angelo, Texas.

boot will often determine the life of the skin. However sometimes the hide is naturally flawed or has been tanned poorly and will split for no apparent reason. In the 1970s, exotic hides from South America, Mexico, Asia, and Africa became very popular with factories and custom bootmakers. When you ask them today about changes in the quality of hides over the last sixty years, you will get as many opinions as there are bootmakers. One thinks Italian calf is better than French, another will tell you ostrich "just ain't what it used to be," and a third will swear that Swedish calf, which is no longer available, is the best skin that he ever cut. Many times I've heard this said of "box calf." Box calf came from a tannery in Ohio, and according to many old and retired bootmakers, was the best calfskin ever available.

The list of skins that follows is an A to Z of most of what has been available over the last thirty years. Many of these are no longer allowable, but if you hop in your car, drive to Texas, and spend a couple of weeks visiting all the bootmakers, you just might be able to find a scrap or two tucked away in somebody's shop under a recent arrival of French calf, ostrich or kangaroo, which are currently the three most popular skins used for cowboy boots in the United States.

Alligator: A pair of custom-made full alligator boots costs between three thousand and four thousand dollars. Contrary to public belief, alligator is basically a fragile skin, and most people wear it for dress occasions only. Even with great care, the hides are unpredictable, and can crack when you least expect it. Alligator has a hard and shiny finish. The skin's small scales are more flexible and should be used on the foot of your boot; the large scales should go on the heel. Most skins are imported from Central and South America; however many farms in the southern part of the United States are tanning hides now. Alligator comes in all colors from

black to red. Polishes, color creams, and silicone products should not be used on alligator. Simply wipe off the dust or dirt with a soft, damp cloth. Dry it with another soft cloth, and with the tip of your rag, lightly wipe a tiny amount of common Vaseline into the cracks between the scales to keep them flexible and moist. Good alligator never loses its sheen. If taken care of and worn sparingly, a good pair of alligator boots could last a lifetime.

Anteater: Most anteater originates in Asia and Africa. It is very durable and comes in all colors. The scales are diamond shaped and it is sometimes mistaken for alligator. However the skin is more flexible to work with and more comfortable to wear. Taking care of anteater is the same as alligator. If you don't want the scales to start turning up, keep them moist; otherwise a drop of good old Elmer's Glue-All will work fine on those scales.

Armadillo: This skin looks sort of like lizard and sort of like nothing else you have ever seen. There is precious little of it around. However any Texan can tell you armadillos are easy to find, but evidently they are hard to skin, so if you've got your heart set on armadillo and can't find a bootmaker who has any, drive through the center of Texas; you can pick them up all over the highway, and if you don't feel inclined yourself, maybe you can stop at your local taxidermist and he can skin it for you. The demand for armadillo boots does not seem too great. I heard about one pair from a bootmaker that had the head mounted on the toe and the tail sewn up the back of the boot. I guess armadillo is for the man who already has alligator.

Boar: This soft leather has a pronounced grain to it which has a triangular appearance and is easy to spot. This skin is tough and can be used for a work boot. Most boar has been treated for water repellency but will not get a high-gloss sheen because of

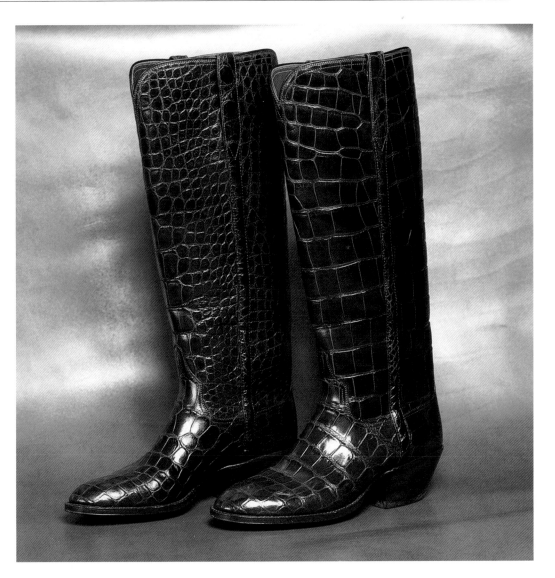

its heavy grain. Boar is uncommon and few bootmakers carry the skin.

Buffalo: Most water-buffalo skins come from Africa. Buffalo is currently one of the most popular boot leathers. It is a very tough skin available in dozens of colors, and is soft and supple, yet has good tensile strength and provides long wear. It resembles waxed, French calf and is resistant to scuffing, peeling and scratching.

Bullfrog: Bullfrog was a popular novelty for boot wearers a few years ago. It is hard to find now and, take my word for it, is not worth looking for.

Camel: Most camel skin comes from Asia and Africa. The hides are scarce because camels are only skinned when the animal dies, and camels alive are worth much more in their own country than the skin. It has a very hard finish that resists scuffing completely, and reminds me of linoleum. Camel skin has a faint vein effect running through its surface. It comes in many colors, and again is fairly hard to find.

Crocodile: Because crocodiles mainly live in remote freshwater rivers, they are hard to find. Crocodiles currently are not being farmed on a large scale like alligators. However their skins are virtually identical. Unless you are a bootmaker or hide expert, you will likely miss the tiny pinhole in the center of each scale, which is the only way to tell crocodile from alligator skin.

Deer: Deerskin, like elkskin, is very soft

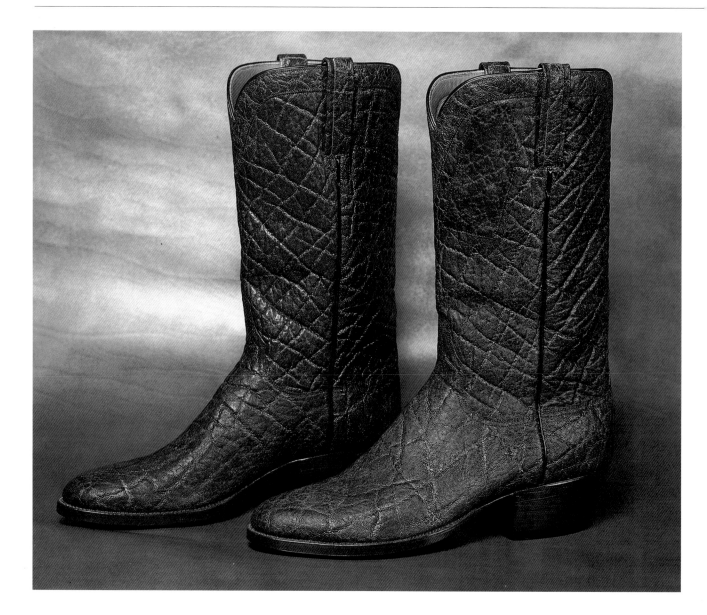

and supple. Wearing a pair of these boots is almost like slipping your foot into a soft glove. Deerskin and elkskin are both available in dozens of colors, but are not too popular with bootmakers because they scratch, scuff and tear very easily. If you decide to get a pair of elkskin or deerskin boots made, you should have a fairly rigid lining, so that the top of the boot will stand up. Most deerskin and elkskin boots today are found in the dress or fashion market.

Eel: Most eel comes from Korea and the Philippines. The skin is thin and fragile and like alligator, eel should be used for dress boots only. It comes in a wide variety of colors and should be cared for like alligator.

Elephant: Africa was the source for this skin. Elephant came in all colors. The skin requires simple, saddle-soap cleaning and conditioning with light olive oil or Vaseline. However I know cowboys who have had elephant boots resoled nine or ten times with no maintenance at all. The skin has a crackled, dullish, hard finish and sort of looks like the surface of Mars. Elephant is the most durable skin. It is no longer available.

Gallapava: Sounds a lot prettier than turkey, but that's what it is. It looks a lot better than chicken-leg boots, which I have also seen. In fact it's very nice and closely resembles ostrich, only with smaller bumps. The skin is from North America. It comes in many

colors, but is recommended for dress only. Unlike ostrich, the skin is somewhat fragile. It should be cared for like alligator.

Goat: More commonly known as kid, goat is a very fine-grained leather, similar to French calf, but with a little more stretch. Skins of young goats or kids are used. Most kid comes from Spain and Morocco. Kid was used extensively by bootmakers between 1900 and 1950, especially for women's dress boots. It will take a high shine and is always soft and comfortable. It also resists drying out over the years, if cared for. However it tends to scuff and peel easily, which is the reason why calf became more popular in the 1960s. Use a saddle-soap wash, or a damp cloth, followed by neutral or colored creams and a light buffing with a soft cloth and natural-bristle brush to maintain kid.

Horse and Mule: These skins are used very little, but do make a rugged work boot. They usually have a duller, oil-tanned appearance, which resists scuffs and scratches and are normally hard to find in colors other than gray, brown and black. The skins come from North America and France. Maintenance consists of a light washing with saddle soap or a damp cloth, followed by a light oiling with olive oil or a neutral boot cream.

Kangaroo: Aside from calf, kangaroo is the most popular skin with bootmakers today. Although kangaroo is actually tougher than calf, it never feels that way. It's a very soft skin that is both durable and flexible. Most inlay work is done with kangaroo because it is generally thinner than calf. Kangaroo is available in a myriad of colors and is cared for the same way as calf—a light, saddle soap or damp-cloth cleaning. After the boot has dried well naturally, apply a high-quality boot color cream and buff with a rag or natural-bristle brush to bring out the sheen. Not surprisingly, all skins come from Australia.

Lizard: These skins come from all over the world—North America, South America,

Asia, Africa, Central America, Mexico, along with many Pacific islands. There are too many species of lizard to mention. The ones most commonly used for boots are horned, ring-tail, and various iguana species. Lizard has become very popular because of its durability in the urban workplace. It is a boot that can be worn every day or for dress. The skins are hard and retain a good sheen. They are maintained like alligator or other exotics, yet hold up over the long haul. Due to the popularity of lizard, which comes in every color from natural to turquoise, hot pink or purple, the skins are getting snatched before the lizards are very large. Consequently many bootmakers have to get a little creative when piecing larger-sized boots together. Most lizard boots have scaled, ridged lines running across them and are often mistaken for snakeskin.

Norwegian Ox: This skin is waterproof, especially when worn rough side out. It comes in a variety of colors and is a heavy, rugged, no-maintenance skin. Ox has a textured appearance on the grain side; on the reverse side it looks like heavy suede. It has a medium-sheen finish, can be maintained like elephant, and is almost as durable. This boot looks just as good walking down the sidewalk as into the corral.

Oil-Tanned: Usually a heavyweight calf is oil treated for heavy work use. Retan combat boots were first made for the military and were the forerunners of the oil-tanned boots we know today. "Retan" simply means the skin has been tanned twice, the first time with chrome tanning to make it tough, and the second time with fats and oils to enable the skins to resist water, petroleum products, etc. Many roper-style work boots are made from oil-tanned skins. They will not scuff, tear or scratch, and require no maintenance. However, if you're fashion conscious, they are not much to look at. What we are basically talking about is a tough-as-nails work boot.

Ostrich: This skin is by far your overall best choice in the exotic category. Ostrich

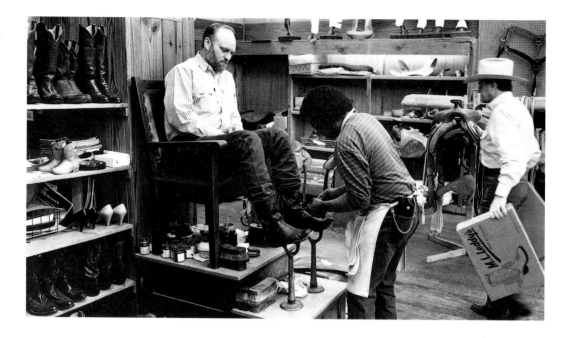

was widely used as early as 1970, but the craze for ostrich-skin boots has developed during the last ten years. It is the softest, yet most comfortable and durable, of all the exotic skins. You either love those bumps all over your foot, or you don't. If you still want ostrich, with all its advantages, but want to forego the bumps, ask for skin from the legs. It is less expensive also. A custom-made ostrich boot costs from eight hundred to fifteen hundred dollars, depending upon who is making it. Factories run them out for five hundred to a thousand dollars. Ostrich has a soft, medium-sheen finish and is easily maintained. Most Texans today swear by their ostrich boots and would rather fight than switch. Take care of ostrich like any other exotic skin. Avoid silicone-based products and dyes and try to suck with a natural oil for conditioning. If you use boot cream, choose neutral or one shade lighter than the color of your boots. Ostrich comes from Africa and Texas, of all places. In the last few years, Texas ostrich farms have become big business. The skins are still sent back to South Africa to be tanned. Nobody seems to know why. The only drawback to ostrich is the expense in farming it: a pair of live ostriches can cost up to fifty thousand dollars.

Pig: Pig has a tough skin which is usually tanned to suede. This durable, full-grained hide makes a tough boot. Pig comes in all the colors of the rainbow. The suede side, like the rough side of any skin, can only be maintained with a soft wire-bristle brush to remove dust and dirt. No polish, oils, or anything else should be applied to a suede finish. The smooth side can be treated like an exotic skin. The tiny hair holes of the pig are slightly visible, which gives the skin some texture. How pigskin is tanned depends on the thickness of the skins, so pick your skin wisely—thin for dress, heavy for work.

Shark: This is an extremely rough and rugged skin. The surface has raised sections which allow the skin to be dyed so that the higher-textured areas will be lighter than the background. This produces a pleasing, mottled effect. Shark is a long-lived skin, and is virtually scuff-proof. It comes in an array of shades and colors and also possesses water-shedding qualities. Shark is primarily imported from Japan, Central America, Australia and Mexico. Care for shark the same way as alligator. Sawfish is very similar to shark and is often mistaken for it.

Snake: Snakeskin is good for everyday urban wear or dress. The most popular

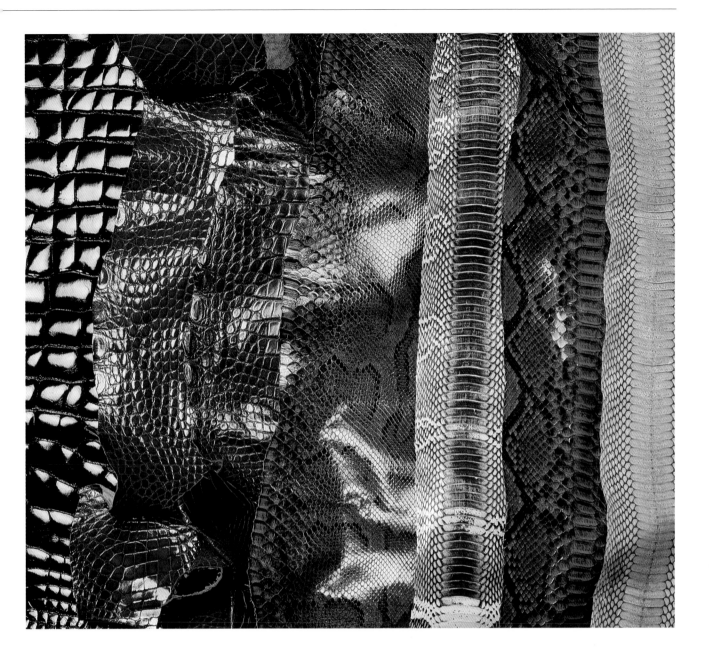

snakeskin is python. Small groupings of scales break up the larger diamond-shaped patterns. Rattlesnake and boa are also frequently used. Anaconda skin, with its looser and larger scales, is dyed solid colors because otherwise the surface is dull and uninteresting. Python is by far the most durable snakeskin. Like leather, the scales darken slightly with age. However it is important to prevent scuffing, which will raise the scales. Maintain snakeskin the same way as all other exotics.

Stingray: There is no other skin that looks more like it was imported from another planet. It is so tough, and breaks so

many needles, that not all bootmakers will work with it. Stingray is available in many colors, and has a marbled, gravel-like texture, resembling thousands of tiny pebbles glued to a leather backdrop. The skin is maintenance free, durable, and can be worn for work or dress. It is also great for puddle jumping because it is waterproof.

Whale: Like seal and walrus, whale is no longer available. The skins were very similar to elephant except they were never considered as pleasing to the eye. Whale is tough, durable, and waterproof, but I am sure we are all glad that it can no longer be used.

Exotic (left to right): black alligator, chocolate alligator, dark brown crocodile, python, cobra, python and cobra.

THE BOOT FACTORIES

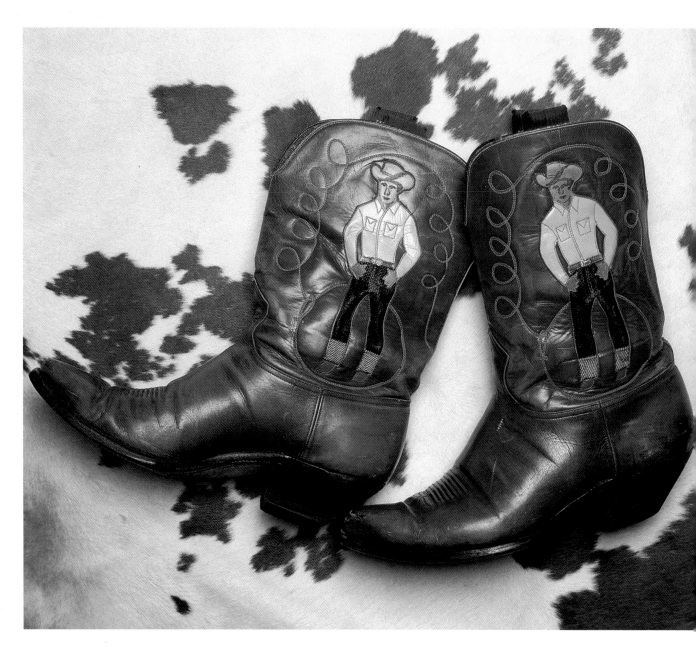

A pair of boots made in the 1950s by Justin for a Levi Strauss salesman. The leather cowboy has blue denim inlaid jeans.

For the past hundred years, factories have successfully supplied the worldwide demand for boots that custom bootmakers could not possibly have satisfied. The original families who started the boot factories—Justin in Spanish Fort, Texas; Hyer in Olathe, Kansas; Enid Justin in Nocona, Texas; Tony Lama in El Paso, Texas; and Lucchese in San Antonio, Texas—are still around today. The branches of the family tree of people and companies in the boot business are so interwoven that it would take a genealogist years to chart it all out.

JUSTIN BOOT COMPANY

H. J. "Joe" Justin's frontier spirit pulled him away from his home in Lafayette, Indiana in 1879. Traveling on the train bound for Texas, Joe got as far as Sherman, which was then the end of the line. He spent his last five dollars to continue his journey on a freight wagon. That trip carried him to Spanish Fort, Texas, a typical frontier settlement close to the Red River and the Chisolm Trail. Joe worked in a barber shop but soon learned to repair boots. In no time he made his first pair of boots at home, shortly thereafter opening a shoe repair and boot shop. Cowboys passing through town could order boots from Joe and pick them up on their way back down the trail. Materials were needed to fill these orders, and a local storekeeper offered to stake Joe thirty-five dollars. That money started Justin boots as we know them today.

Annie Allen, daughter of the town physician, married Joe in 1886. Together at night, they would cut out boot tops by kerosene light. Annie helped stitch the tops and also thought up a made-to-measure boot mail-order kit, which had never been attempted before. The kit contained a brown paper with a twenty-inch ruler and a chart diagraming foot and boot parts and how to measure them. There was also a handwritten letter, stating the prices of the few leathers that were then available for boots. At that time black calf, retan or kangaroo were about all one could get.

When word came that the railroad would be extending west only eighteen miles south of Spanish Fort to Nocona, Texas, the Justins, along with the entire town, pulled up stakes and moved. Their business began to boom. By 1908 Joe had brought his two sons, John and Earl, into the company as full partners, and it became H. J. Justin & Sons. Joe would travel to railroad towns, advertising in advance of his arrival. The quality reputation of Justin boots made these trips very

Cardboard advertisement with a 1950s boot attached.

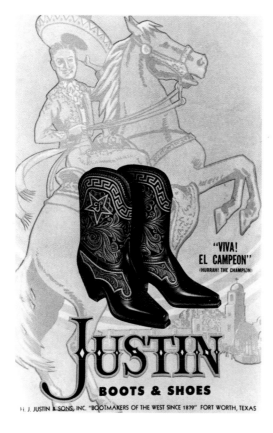

1940s Justin catalog cover.

VIVA! EL CAMPEON (HURRAH! THE CHAMPION)

H. J. JUSTIN & SONS, INC. "BOOTMAKERS OF THE WEST SINCE 1879" FORT WORTH, TEXAS

successful. He would always return with stacks of orders for more boots.

By 1907 the business was a huge success, and the headquarters was moved to a larger building. By then the boot shop had more than ten bootmakers. In 1911 new equipment and machinery increased the output of the factory twofold. An average pair of boots from Justin cost eleven dollars. The

In 1991 Eddie Kelly retired after forty-two years as production manager and boot designer for Justin Boots in Fort Worth.

business in 1915 did a staggering $180,000 in sales from thirty-six states, Australia, the Argentine Republic, Brazil, Central America, Canada, Mexico and Cuba. In 1916 Joe's health was poor, and at this time he turned the business over to John and Earl. He died in 1918.

By 1920 the business had steadily increased its boot inventory. The most expensive pair of boots in the catalog cost thirty-eight dollars, including postage. All of the boots were tall tops, made from black calf, kangaroo or retan. They had high underslung heels and black pull straps of a heavy material that were sewn inside the boot and that stuck up two inches beyond the leather tops. Only one pair in the 1920s catalog sported the new style of leather pull straps sewn down the outside of the boot. A few boots with one or two rows of white stitching and a few fancy collars inlaid with hearts or diamonds or initials were included. Although six different toe styles were offered in the 1920 catalog, all the boots had either round toes or one-and-a-half-inch-wide boxed toes.

John and Earl Justin decided they were outgrowing Nocona and started looking toward Fort Worth. They needed better railroad services, a larger labor pool, a larger bank, and post-office facilities. So in 1925 the sons moved Justin Boot Company to Fort Worth; most of the bootmakers went with them. Their sister, Miss Enid Justin, decided to stay in Nocona and continued in the boot business as Nocona Boot Company, where she remained president until 1981.

In 1948 John's son, John, Jr., bought the controlling interest of Justin Boot Company from his uncle. John began to realize the public was looking for something a little different. With the increasing public interest in singing-cowboy movies, rodeos and dude ranches, John, Jr., started to see the cowboy boot in a different way than his father could ever have imagined. He bought blue, green,

red and yellow leather and began combining contrasting colors, and adding wing tips and fancy collars to many of the boots. Styles changed rapidly, and soon Justin not only offered the popular boxed toe of the forties and fifties, but introduced the new pointed toe. These boots were a far cry from the calf and retan black tall-top boots for which Justin had been famous for more than fifty years. From this point on, for years to come, Justin catalogs would feature nine- and ten-inch-tall boots for women—called "little gypsies"—and for men, with square toes or very narrow box toes, high underslung heels, and multicolored cutouts of inlaid designs. Short-top boots reached their peak sales between 1948 and 1955.

As chairman and chief executive officer of Justin Industries, John Justin, Jr., has brought under his corporate control not only the Justin Boot Company and Acme Brick Company, both of Fort Worth, but also Northland Press of Flagstaff, Arizona; Featherlite Building Producers of Austin, Texas; Nocona Boot Company; Chippewa Shoe Company; and Trade Wind Technologies of Phoenix, Arizona. Justin's most recent acquisition is the 1991 purchase of Tony Lama Boot Company of El Paso, Texas. With Tony Lama, Justin and Nocona combined, Justin Industries produces a staggering 3.5 million–plus pairs of cowboy boots annually. The majority of these stay at home in the United States. The rest go to countries all over the world. France is the number-one buyer in foreign sales, followed by Japan,Germany and Italy.

Justin Boot Company has come a long way from the days when Tom Mix would have his train stop in Nocona on his way back to Hollywood from the East so he could pick up his latest order of Justin boots. And further still from the time of a story John Justin, Jr., tells: "My grandfather died when I was very young, just one or two years old, but I heard a lot of old boot stories from my

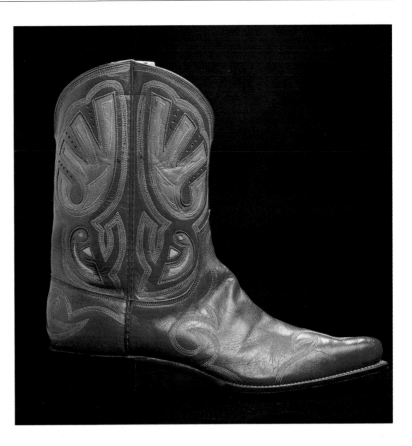

father. Once there were a couple of guys that bought some boots. They gave him a check and it was hot. Well, they caught the guys because they were cattle thieves and they hung 'em over in Wichita Falls, so my dad went up there and got the boots back."

This colorful calf boot with intricate inlay and bordered stitching was shown in a 1946 Justin catalog. The vamp and counter are delicately stitched.

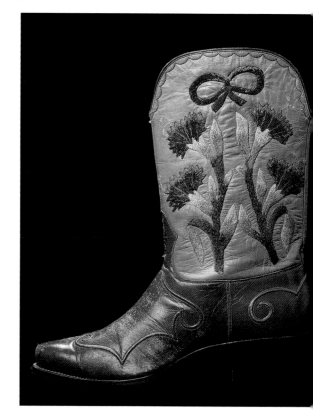

Silk embroidered flowers on a soft kangaroo vamp with raised string work make this boot a real beauty. Originally made in the forties as a gift for Mrs. J. Justin, Sr.

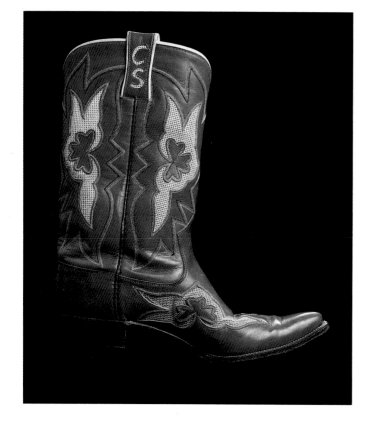

From the 1930s–50s, summer boots boasted mesh inlays for coolness. These were advertised as "ventilated" boots.

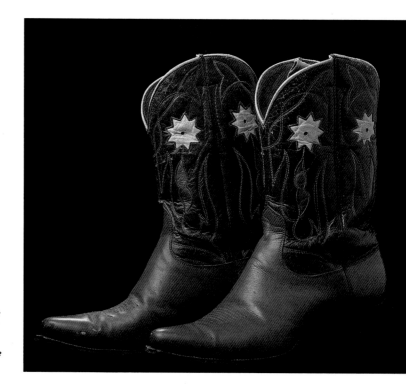

This simple inlay pattern, available until about 1955, sold more than any other Justin inlay boot in the company's history.

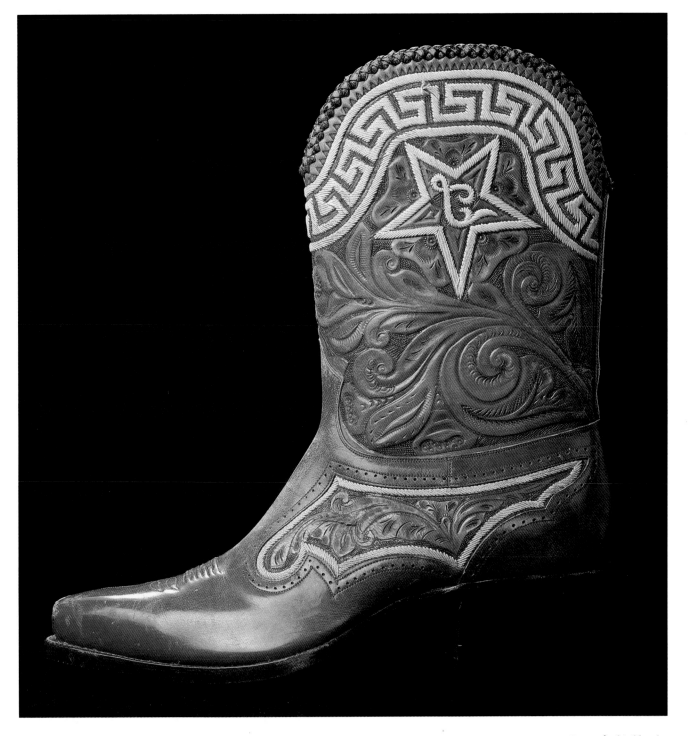

One-of-a-kind hand-tooled boot with silk-laced lone star and Greek key collar.

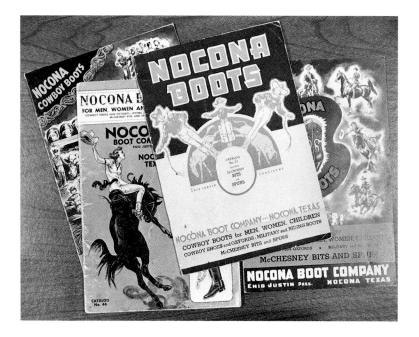

NOCONA BOOT COMPANY

In 1925, when Enid Justin's brothers moved Justin Boot Company's headquarters from Nocona, Texas, to Fort Worth, Enid chose to stay behind and continue on her own. Her brothers, who had taken all the equipment and most of the bootmakers, left Enid with eight bootmakers and the original thousand-square-foot building in Nocona. With a loan of five thousand dollars and her true Texas pioneer spirit, Miss Enid Justin started Nocona Boot Company, becoming one of the few women at that time in the United States to own her own business. In 1926 she hit the rutted cattle roads of Texas and headed for the one-horse towns and ranches in her Model T Ford to take boot orders from cowboys, ranchers and oilmen. Each trip saw increasing sales, and soon Miss Enid and her company had acquired a reputation for quality boots.

In early 1930 Miss Enid purchased the company that made the now-famous and highly collectible McChesney spurs and moved it from Gainesville, Texas to Nocona. Nocona Boots grew and prospered even through the depression years. In 1939 Miss Enid got the idea to sponsor a reenactment

of one of the Pony Express routes through Nocona to San Francisco. There were fourteen cowboys and one cowgirl entered in the race. Miss Enid became legendary for her civic contributions to the Nocona area. She supported 4-H Clubs, the Jaycees, the Boy Scouts, and municipal councils, as well as donating playground equipment and creating scholarships for Nocona children.

In 1947 the new Nocona factory was built on "Boot Hill" in Nocona. Although still in its original location, the current Nocona factory has bulged to 165,000 square feet.

H. Joe Justin, Miss Enid's nephew, worked with her as vice-president of Nocona Boots throughout the years. At the age of eighty-eight in 1981, Miss Enid finally retired as acting president and chief executive officer of Nocona. At this time Nocona merged with Justin Industries, and Joe Justin became the acting president until 1984. Upon his retirement Vice President and General Manager Steve Pickens became the president of Nocona Boots, which is part of Justin Industries today. Miss Enid continued to serve as honorary chairman of the board and consultant for Nocona Boots until her death in 1990.

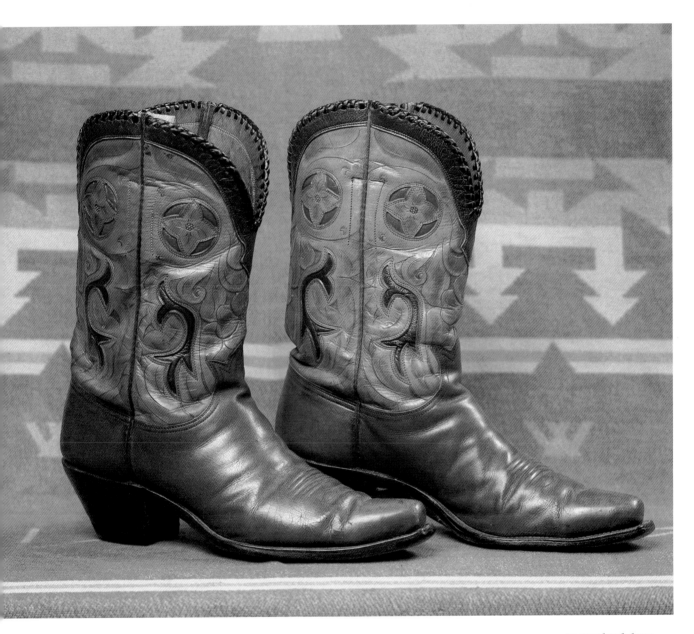

Hand-tooled tops with red-and-green inlay designs, valued at $600. Made by Nocona in the 1940s. Tyler and Teresa Beard collection.

NOCONA BOOTS

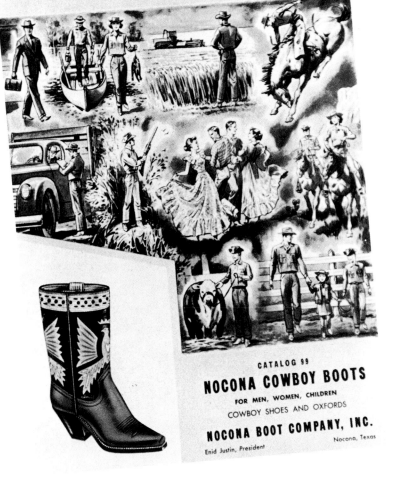

CATALOG 99

NOCONA COWBOY BOOTS

FOR MEN, WOMEN, CHILDREN

COWBOY SHOES AND OXFORDS

NOCONA BOOT COMPANY, INC.

Enid Justin, President

Nocona, Texas

"Miss Enid" Justin in the 1940s, sporting her own boots.

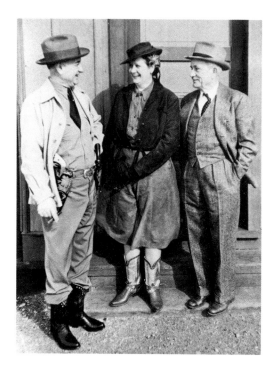

Under Steve Pickens Nocona now manufactures more shoe boots than any other boot factory, due to the fact that in 1987 Guess Jeans, traveling around Texas shooting magazine layouts, found two old pairs of Nocona shoe boots (the shoe boot had first appeared in Nocona's 1930s catalogs) in a western-wear store in Big Springs, Texas. When this ad hit the market, people, especially models and rock stars, began calling from all over the world, wanting to know where they could buy this unusual footwear. The response was so overwhelming that Nocona started making the shoe boot again. In 1992 Nocona sold more than fifty thousand pairs of shoe boots in black and brown calfskin, deerskin, lizard and ostrich.

Today Nocona produces over four hundred thousand pairs of boots a year. Besides being famous worldwide for their quality boots and shoe boots, in 1985 Nocona, under Steve Pickens's direction, also launched the enormously successful "Hero Boot Box Campaign," which featured twelve original works of art printed onto boot boxes. The most famous depicts a rattlesnake crawling up the leg of a boot wearer who is brandishing a sharp Bowie knife. This image is still the third-highest-selling poster in the world, surpassed only by *Star Wars* and Farah Fawcett.

A 1950s brown lizard vamp and heel make a nice contrast with the soft handtooled pictorial top. Courtesy of Nocona Boots.

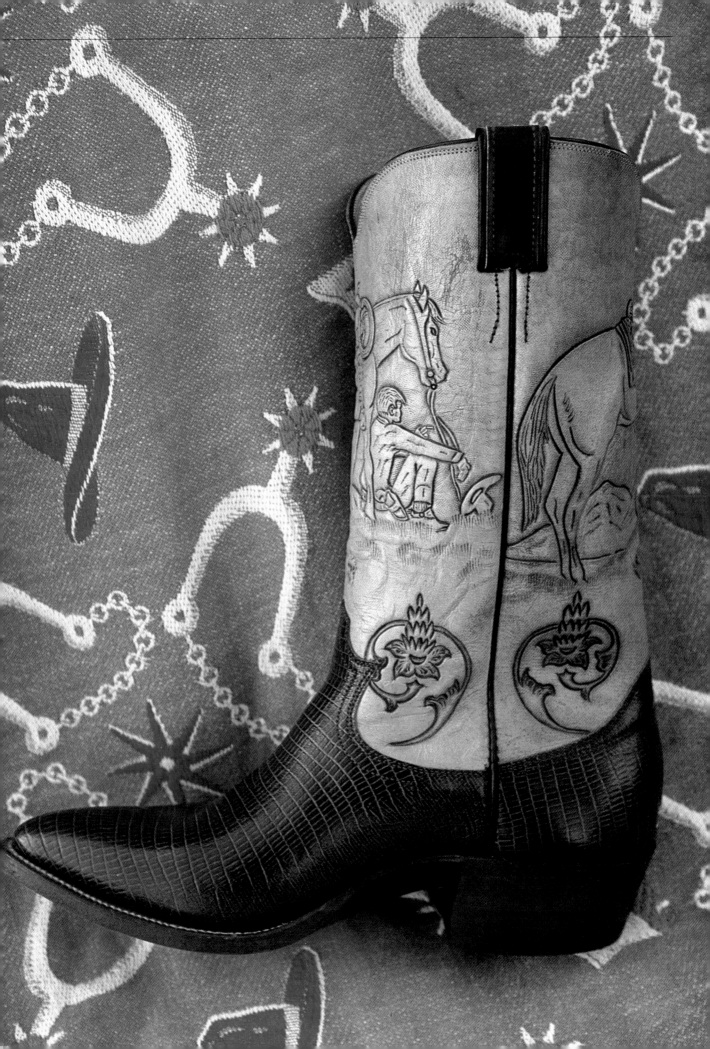

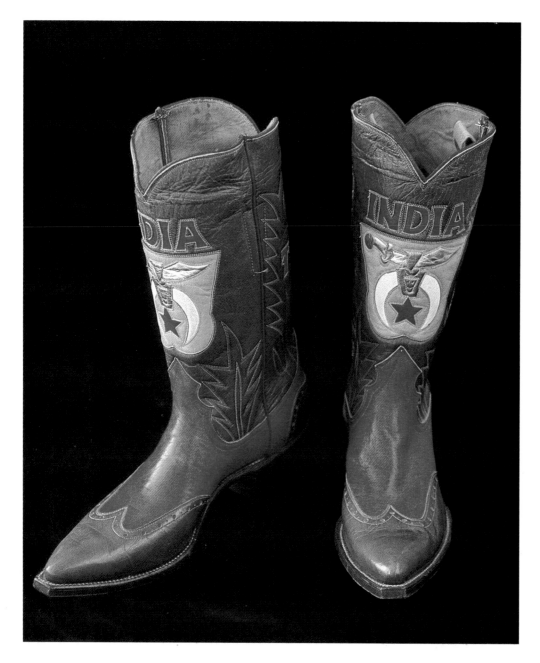

*S*triking red-and-green kangaroo Shriner boot. Courtesy of Nocona Boots.

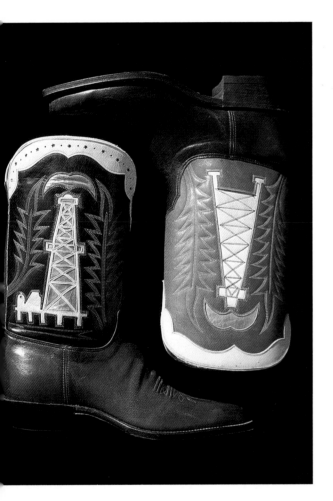

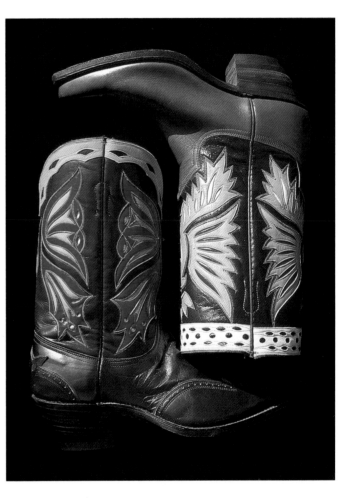

Two derrick boots with very fine inlay and overlay work topped with white collars. Made by Nocona in the 1940s–50s.

These spread eagle and butterfly boots were both made by Nocona.

TONY LAMA BOOT COMPANY

Tony Lama, who is of Italian descent, learned the shoe business while growing up in Syracuse, New York. From 1900 until 1912 he worked as a cobbler for the U.S. Army at Fort Bliss in El Paso, Texas. After his discharge from the army, Tony opened his first shoe and boot repair in El Paso in 1912. He was twenty-five years old. Gradually West Texas ranchers began to walk in with cowhides and ask him if he would build them a pair of cowboy boots. In his first year of business, Tony estimates he made about twenty pairs of boots for ranchers. His reputation for quality spread throughout Texas, New Mexico and Arizona.

By 1930 western-wear stores in these three states were asking Tony Lama to build boots to sell in their stores and his boots began selling as fast as the stores could get them on the shelf. After World War II Tony's repair work for the U.S. Army plummeted because the U.S. Cavalry was eliminated by the government. However this time also marked the beginning of the golden era of cowboy-boot making. All things western were undergoing a great revival due to rodeos, dude ranches and singing cowboys. Tony Lama was soon able to add scores of bootmakers to its ranks and business boomed.

In 1948 President Harry Truman had Tony Lama make him a pair of kangaroo-bottom boots with kidskin tops, fully inlaid with gold and silver metallic leathers. Soon politicians, movie stars, ranchers, rodeo champs, athletes and even popes were having their boots made by Tony Lama.

In the 1970s Tony Lama was still being run and managed by various family members. In 1974 Tony Lama, Sr., died, and Tony

Vintage boots, a leather cowboy hat, and three current boot styles—all by Tony Lama. Photo by Marty Snortum.

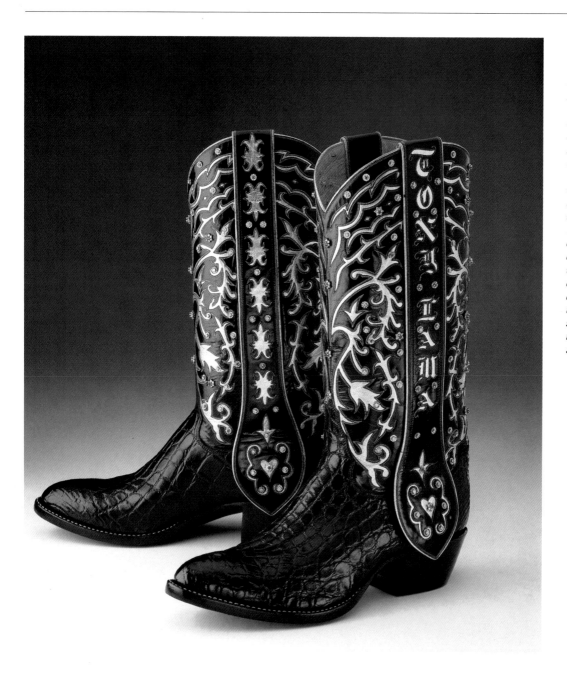

The El Rey III took three months to construct. These black alligator boots have English calf tops inlaid with 24k gold and are encrusted with 384 diamonds and rubies in 218 settings. The El Rey I were designed in 1951 by Tony Lama, Sr., and valued at $5,000; then they were stolen in 1953 while on tour in Florida. The El Rey II were valued at $10,000; those were also stolen while on tour in 1970. The El Rey III are valued at $32,000 and come equipped with their own 24-hour security guard when on tour. Photo by Marty Snortum.

Lama, Jr., became the president of the company. In 1977, much to the surprise of the boot industry, Sam Lucchese, the heir to the world-famous Lucchese Boot Company, was hired by Tony Lama as director of research and development. Although Tony Lama continued to make all of its most popular boot styles, Lucchese's contribution was a line of boots that were similar to early Lucchese boots—simple, yet elegant, boots with minimal stitching, made of soft French calf in black or shades of brown. Today Tony Lama Boot Company employs hundreds of people

and produces more than twenty-five hundred pairs of boots a day in their El Paso, Texas factory.

Purchased in 1990 by Justin Industries, the Tony Lama operation today employs only two of the original family: Joe is in charge of raw materials, and Rudy serves as vice-president. Tony Armando, the public relations representative with Tony Lama, reports that currently 30 percent of their sales are outside of the United States, and along with the rest of the boot companies, this percentage seems to be increasing every year.

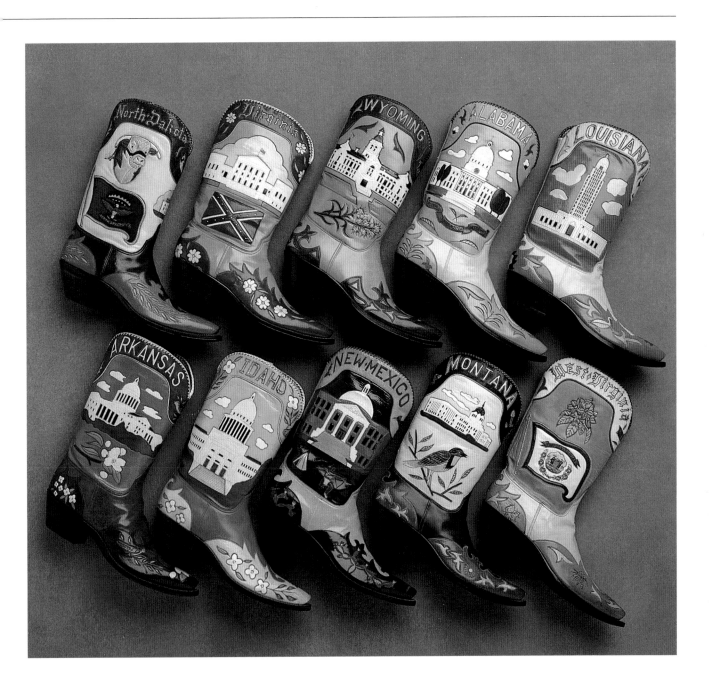

LUCCHESE BOOT COMPANY

As a sixteen-year-old immigrant from Italy in 1880, Sam Lucchese came to the United States with one of his brothers. They got jobs at Fort Sam Houston in San Antonio working as shoe and boot cobblers. The legend goes that the Lucchese family has boot and shoe making in its history going back over eight hundred years. By 1883 four other brothers had arrived from Italy. Lucchese Boots was founded in San Antonio the same year.

By then all six brothers were repairing and making boots and shoes, mainly for the U.S. Army and Cavalry. During the next ten years, the brothers scattered, some died, and Sam was left to run the boot shop. He was ambitious and by 1918, Lucchese was making thirty-five pairs of boots a day. Because the U.S. Army was in San Antonio, there were dozens of bootmakers and shoemakers and their shops in the San Antonio area. It's hard to imagine, but this was true in all the towns with military bases at the time. The army represented security.

Sam loved boots and believed that with the advent of improved machinery, it would

Ten of the original forty-eight "State" boots commissioned by Acme Boots, made by Lucchese in the 1940s. Only seventeen pairs remain in the Acme collection; the rest have been stolen or otherwise dispersed.

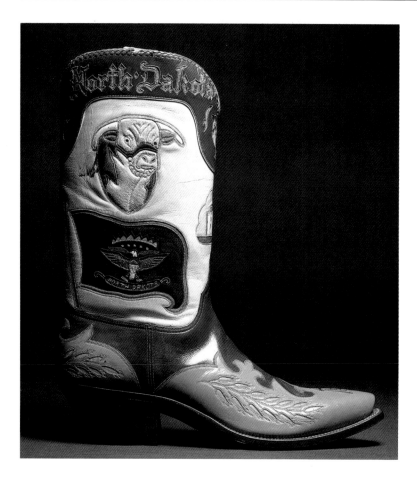

though any celebrity passing through San Antonio had to order Lucchese boots.

The reason for their popularity is that Lucchese boots have always been recognized by boot connoisseurs for their very fine lines; many of their styles feature stovepipe tops or shallow scallops and delicate and graceful stitching. Although Lucchese has made more than its share of ornate and fanciful boots, the company's reputation rests on its ability to turn out understated, yet elegant, cowboy boots.

Sam Jr., and his father, Cosimo, continued to disagree about the future of Lucchese boots and the direction the company should take. As a result, Sam left the boot company in 1957 and went to work with Acme Boot Company as a road salesman. When Cosimo died in 1961, however, Sam returned to run the family boot business in San Antonio. He inherited several growing financial problems. Through 1970 Lucchese was still producing only ten pairs of made-to-measure boots a day. Also between 1965 and 1970, Lucchese had been forced to sell its downtown location to the city of San Antonio so Hemisfair could be built. Then Lucchese began to manufacture a line of stock-last boots under the name of Jude Crispin (Jude Crispin is the patron saint of bootmakers) which met with only moderate success due to their price of one hundred dollars a pair, which at the time was considered high for factory boots. Sagging sales and the location breakup caused by the forced sale of the downtown property pushed Lucchese to the thin edge of the wedge. In 1970 Sam sold Lucchese Boot Company to Bluebell, a division of Wrangler, but stayed on with the new company.

Sam seemed obsessed with the idea of the perfect fit for everyone. He worked diligently with Bluebell for seven years, helping to design and develop the moderately priced

North Dakota, one of the "State" boots by Lucchese.

be possible to increase production in the future. His son Cosimo disagreed; he was a perfectionist and believed that no more than ten pairs per day could be produced in the Lucchese boot shop and still pass his exacting scrutiny. Sam, Jr., like his grandfather, however, believed that it was possible to increase production while maintaining the Lucchese standard. This basic disagreement was to color their relationship and the business itself for years.

Through the 1960s Lucchese was considered by many people as the finest line of made-to-measure boots in Texas. Its customer list read like a Who's Who: it included Teddy Roosevelt, Will Rogers, John Wayne, Lyndon Johnson, John Connally, Johnny Cash, the Rockefeller family, and assorted European royalty—kings, queens and shahs. It seemed as

Wrangler and Maverick boot lines. Sam left Bluebell in 1977 to design boots for Tony Lama, where he remained until his death in 1980. The Lucchese reputation suffered greatly over the next nine years due to the lack of direction and leadership in the company. Finally, in 1984 Acme Boot Company in Tennessee bought Lucchese from Wrangler, and John Tillotson was recruited at this time. Lucchese was separated to regain it's ambiance and special place in the market. Under Tillotson Lucchese has regained much of its former glory in the boot market. The company plans a clothing line and a cologne, but will continue to rely on boots for its strength. Lucchese no longer takes made-to-measure orders unless you already have your last with them. However every stock-last boot is a testament to Sam's belief that a quality factory boot is possible from Lucchese after all.

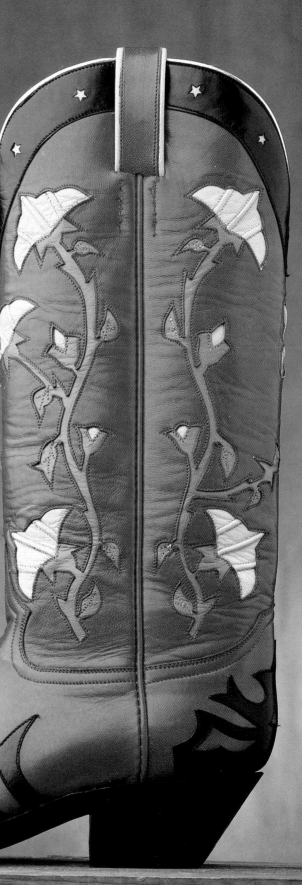

Yellow pinched roses with green inlaid stems play off the purple base with black foxing on the vamp and counter. Boots by Rocketbuster. Photo by Marty Snortum.

ROCKETBUSTER BOOTS

In December 1989 Marty Snortum, originally from Virginia, bought a floundering boot company from an Italian who had moved to El Paso, the boot capital of the world. A 1953 Cadillac hearse was traded for the company, the name, the concept, and the employees. In the old Pershing Theatre in El Paso, Rocketbuster grew from five bootmakers to more than twenty in less than two years. Why? Marty recognized the emerging interest in flashy vintage peewee boots for men, women and children. A throwback to the golden age of boots was on the horizon.

Marty describes Rocketbuster boots as "west Texas retro-moderne." They are anything but conservative: yellow, red, green, turquoise, and purple leathers cut out in intricate designs, some of them overlaid and inlaid, featuring stars, moons, cowboys, Indian heads, flowers, longhorns, cactus and even "Happy Trails" and "Ride 'em Cowboy" spelled out in leather on their tops. Folks, these boots are drop-dead, screeching-halt, western footwear. Rocketbusters stole the show in Denver, Colorado, at the annual Denver Western Wear Market after only two

"The gang's all here" at Rocketbuster Boots. Photo by Marty Snortum.

years in business. The company took enough orders to stay busy for more than a year. Rocketbuster boots can be purchased from the catalog or in stores from New York City to Japan.

Marty expects to increase his army of bootmakers to thirty-five and is looking for a larger building. The partners, Ivan Holguin and Lencho Guevva, run the business, while Marty, who acts as spokesperson for the company, designs the boots. Marty thinks "your first pair of cowboy boots is just like your first love; but by the second go-round you get a little bit choosier."

*L**one Star State boot for Texans—or anyone who wishes they were. Made by Rocketbuster. Photo by Marty Snortum.*

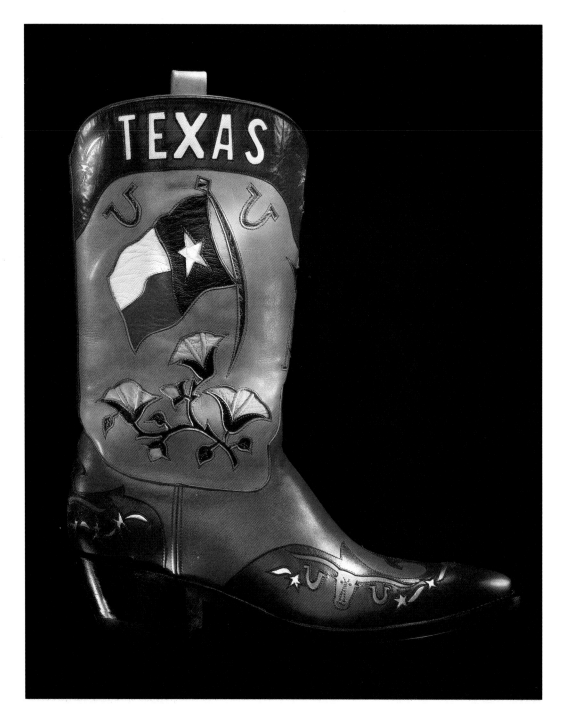

The "Cowboy Boot Book" boot, made specially by Rocketbuster.

THE BOOTMAKERS

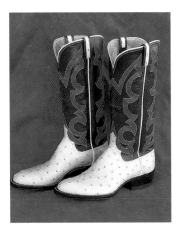

Full quill ostrich vamps and a deep blue calfskin create a vibrant backdrop for Bell's dramatic stitch pattern.

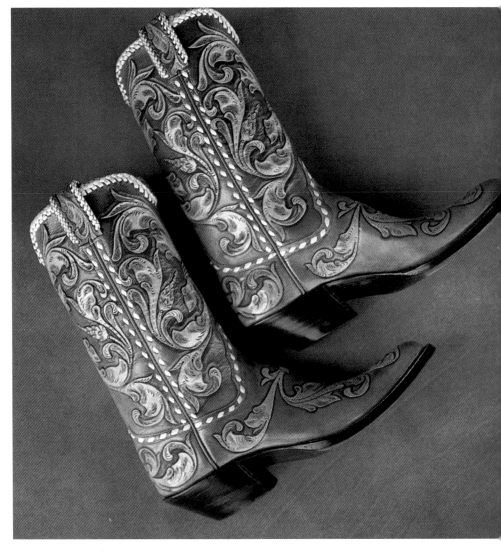

All you need now is a saddle to match. Bell made these fully hand-tooled boots while still working at Tex Robin's Boot Shop.

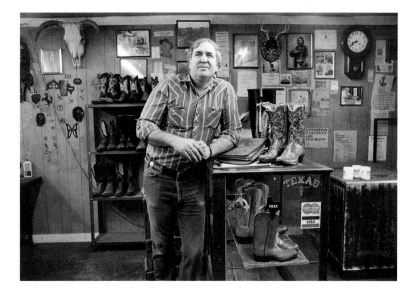

BELL CUSTOM BOOTS

Alan Bell owns one of the few one-man, start-to-finish boot shops left in Texas. Although he has had seven apprentices over the last fifteen years, he now prefers to work alone. Sometimes his wife helps him stitch the boot tops. Alan says his son will know how to make boots before he is out of high school, but he has no idea if he will stick with it. Bell observes, "It's the small stuff—attention to detail—and the fit, of course. These are the most important things in boot making: be patient and long-suffering." Like all bootmakers, Alan knows you have to love boots. "Don't expect to open a small boot shop and get rich," he warns. "The work is hard and the hours long."

Originally from Lamesa, Texas, Alan first worked in Bill Morton's Saddle Shop for three years in Blackwell. But his interest in cowboy boots led him to Tex Robins's door in Coleman, where he cut his teeth on leather from 1972 until 1977. He then opened his own shop in Abilene where he remains today. You will have to wait six to eight months to get boots from Alan because he can only put two to three pairs a week on feet. Although 75 percent of his business comes from Texas, he claims macho iron-workers and hockey players in Michigan, along with a steady stream of Californians, keep him busy. In Texas his customers are 50 percent cowpeople and 50 percent horse-people. Alan's favorite skin to work with is ostrich. "It's soft, yet durable," he explains. Alan is also one of the few bootmakers who still stains, burnishes and waxes the bottom soles of every pair of boots he makes.

The phone rings. "Yeah, Rooster, what's goin' on? I looked at that pattern—it's just what folks call the flame stitch. (pause) Well, I could run over to Pinky's. (pause) I could see what that rooster he has looks like and sketch it. (pause) O.K., you want black oil-tanned rough-out vamp, with a gold slick top; the front top is straight, back top is double scalloped, a two-row simple stitch in green, black side seam, black beading, mule ears with trim, an inlaid rooster head on the back, a skeleton key, and the initial 'N.' (long pause) O.K., Rooster, I'll call you later." Alan Bell hangs up and explains that Rooster is a cowboy on the famous Pitchfork Ranch. But what he cannot explain is the skeleton key . . . "I'll get back to you on that part when I find out."*

If only Alan Bell's shop walls could talk.

Alan Bell's meticulous attention to detail shows in this one-of-a-kind pair of Eagle boots. The tassels and candy-striped piping are Bell originals.

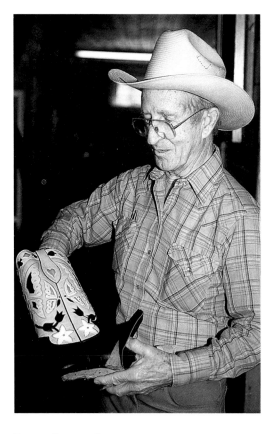

Paul Bond, rodeo-cowboy-turned-bootmaker holds a pair of old-style inlays ordered by Peter Steins, a German customer. The boots were co-designed by Bond and Rusty Cox. Photo by Bob Trehearne.

PAUL BOND BOOTS

Paul Bond has been making boots for more than sixty years. He made his first pair in 1929. Paul was a cowboy on his dad's ranch near Carlsbad, New Mexico. By the time he was sixteen, the U.S. Cavalry had him busting broncs full-time. Cowboys earned a dollar a day back then, and Paul could earn two dollars for every horse that he broke. "Those were good wages back then," Paul

Tall tops in bright colors with high underslung heels, finger holes, and vibrant stitch patterns are some of Paul Bond's trademarks. Photo by Bob Trehearne.

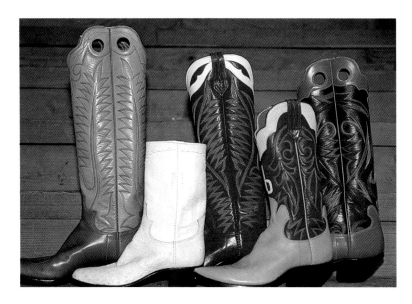

says. He did some rodeoing and horse racing before going to work in a saddle shop near his home. Paul was scoring big in the bareback event in rodeo in 1946 when an opportunity arose for him to buy into a boot company in El Paso. Soon after, he opened a shop in Carlsbad, but in 1957 he moved permanently to Nogales, Arizona, where he is today.

Paul Bond employs twenty workers who turn out twelve hundred pairs of custom boots a year. He has been advertising in the back of *Western Horseman* magazine for more than thirty years. His mail-order catalog is shipped all over the world. His boot style is recognized usually because of its taller top, high underslung heels and very fancy stitching.

Paul, who is now seventy-five years old, agrees that at one time you could tell what part of the country a man was from by the boots he was wearing. Most buckaroo cowboys in the cold country of the Northwest wore eighteen- and twenty-inch tops. Some of their boots went all the way up to the knee. Now New Mexico and Texas cowboys are also wearing tall tops, so it's getting harder to tell. Brighter colors are also appearing on cowboy boots. "I'm not talking about rodeo performers, because they usually wear plain boots. I'm talking about country cowboys wearing red, bright green and purple tops. Some want their boot tops stiff—others want 'em soft. Most North Texas cowboys want their boot tops so stiff you can't hardly bend them. I guess that's because they're doing a lot of brush popping." However, Paul points out that the standard cowboy boot is only twelve inches tall. "That's what most bootmakers make and that's what the factories do."

Paul has also noticed that in the past ten years, most Texans have been wearing wide, round toes. He explains that these same Texans were all wearing needle-sharp toes before that. "When it comes to boot toes, peo-

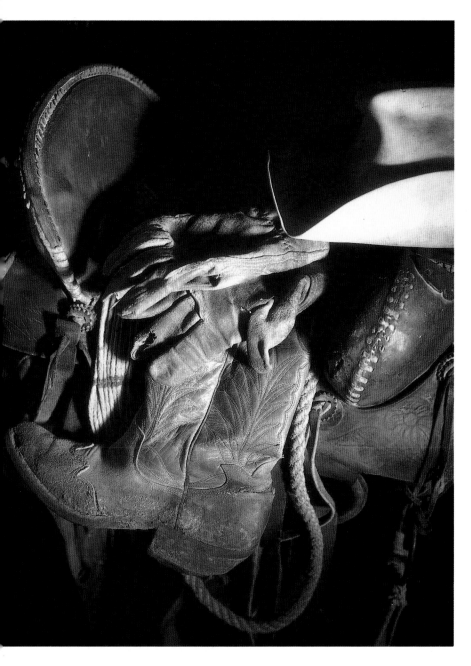

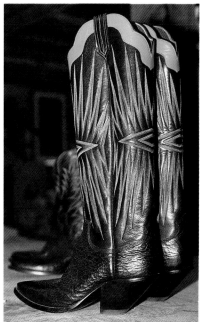

ple either order what they like or what's popular where they live," he says, "although I am seeing a trend back to the sharper toes. The same care goes into every boot we make, tall or short, sharp toe or round toe, for businessman or cowboy—they get what they ask for."

Paul's favorite skins are calf and kangaroo. Shark and buffalo are also great for rugged wear, and, as Paul points out, all Texans love ostrich. It's a durable hide but is still usually worn for dress. Margaret, Paul's wife, who is a fifth-generation Texas rancher herself, helps with the boot designs. When they get crazy,

they head for her ranch in Wichita Falls, Texas. Like most bootmakers, Paul can reel off celebrity customers with ease: Charlie Daniels, Waylon Jennings, Willie Nelson, Crystal Gayle, Barbara Mandrell, Monty Montana, Ralph Lauren, Herschel Walker, and the late John Wayne, just to name a few. Paul is quick to point out, however, that "our first love is making boots for ranchers and cowboys. Not much has really changed out here. Ranchers and cowboys love cattle and the country life. It's simple and satisfying. I make a lot of boots for those folks."

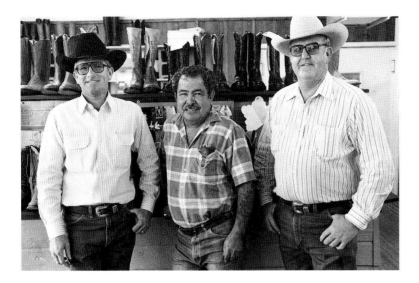

RUSTY FRANKLIN BOOT COMPANY

History repeats itself: Rusty Franklin bought the same shop in 1987 that his granddaddy, M. L. Leddy, had bought back in 1936 when he had first moved to San Angelo. Rusty's dad, Jim Franklin, went to work at M. L. Leddy's in 1947. He married Joyce Leddy, M. L.'s daughter; then along came Rusty and later, Wilson. Rusty started out at Leddy's as a kid, sweeping floors and shining boots. He learned the boot business from the ground up, not only from the boot-maker's bench, but also from the sales floor. Working alongside his dad and younger brother Wilson, Rusty made his way up to co-owner and president of Leddy's.

Then in 1986 Rusty sold his interest in M. L. Leddy Boots back to his mother and brother, who are the sole owners today. Rusty brought his cousin, Rod Franklin, with him from Leddy's when he started his own company. Rod helps with inlay designs and in the running of the business. Shop foreman Eugene Lopez was previously with the Walt Weaver Mercer Boot Company. When Rusty bought out that shop, Eugene stayed on. "Eugene was the jewel in the Weaver operation," Rusty says. "His skill and integrity are vital parts of this business. The three of us represent over one hundred years in the boot trade, and I feel we are the most effective trio with regard to artistic skills, craftsmanship and customer service. You just can't find a better boot company anywhere in Texas."

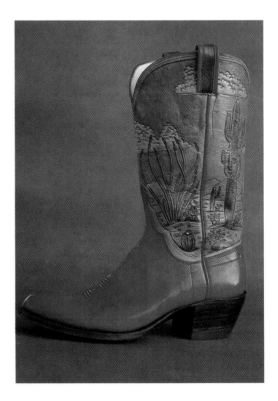

This hand-tooled painted desert scene is for folks who just can't get enough of those wide open spaces. Tooling by Bob Dellis.

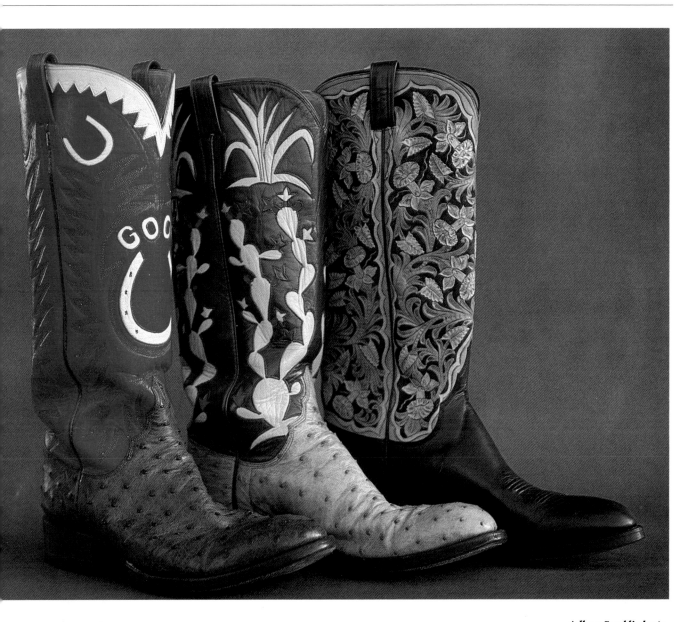

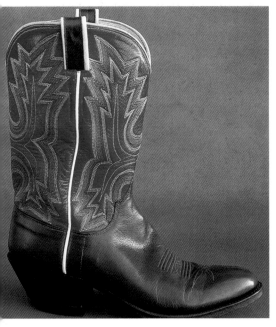

A colorful little Franklin boot with mixed colors of piping on the side seams and tops. An optical illusion is created by the radiating stitch pattern.

All are Franklin boots, left to right: "Good luck" boot top is reminiscent of a 1930s or forties boot; the ostrich foot gives it a more contemporary look. Popular cactus design on an ostrich foot with a round toe combines style elements from the 1940s and today. Multi-stained hand-tooled top with a black calf foot and straps serves as a dress boot under your Levi's or a Wild West show-stopper over your britches. Tooling by Bob Dellis.

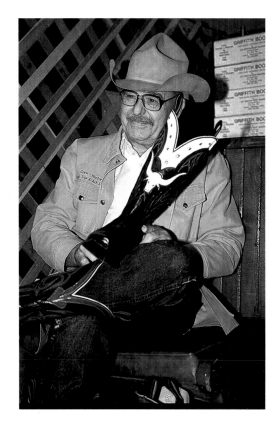

Jay Griffith, bootmaker and boot historian, is holding a black calf boot with a turquoise collar and inlaid longhorn. Jay prefers the old-timey cloth inside pull straps. Photo by Bob Trebearne, Tempe, AZ.

JAY GRIFFITH BOOTMAKERS

Jay Griffith has been making boots for over sixty years. He is also a boot historian who will talk about cowboy boots as long as anyone will listen. Plain and simple, Jay loves boots.

Although there is some debate on the subject of who made the first boots, Jay claims, "In 1875, C. H. Hyer and Sons opened a boot shop in Olathe, Kansas, and designed the first cowboy boot. H. J. Justin started up in 1879 in Spanish Fort, Texas. But from these two men descended hundreds of one-man boot shops that spread the cowboy boot across the West."

Jay remembers watching a bootmaker in Snyder, Texas, at age thirteen. He offered free labor in exchange for the chance to learn to build cowboy boots. In 1934 Jay made his first complete pair by kerosene light at his grandparents' ranch using crude tools. Then, in 1938, he opened his first shop in Ratan, Texas. The next year a move to Tucson found him working for the Western Boot Company. After World War II Jay ended up in Guthrie, Oklahoma, where his shop is today. Jay Griffith Bootmakers turns out about ten pairs a week, with three full-time bootmakers. Jay points out that in a 1908 Hyer Boot catalog a pair of alligator boots cost $11.50. Today the same pair made by Griffith costs $3,600.

You always hear that cowboys died with their boots on because they were so tight they could not ever get them off! To tighten a boot's fit, cowboys would slosh around in horse troughs and then wear the boots till they dried—the same principle as shrink-to-fit-Levi's. But Jay offers an easier solution for breaking in a new pair of boots: "Mix a half cup of warm water with a tablespoon of liquid dishwashing detergent. Soak two small sponge parts, placing one inside the toe of each boot to wet the sole of your boot inside where the ball of your foot and toes go. Then wear 'em till they are bone dry."

Detail of a ten-row Griffith stitch pattern. Photo by Bob Trebearne, Tempe, AZ.

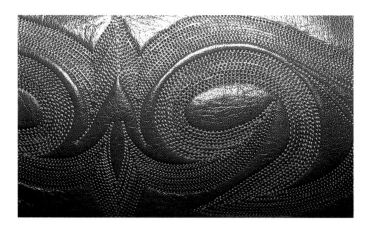

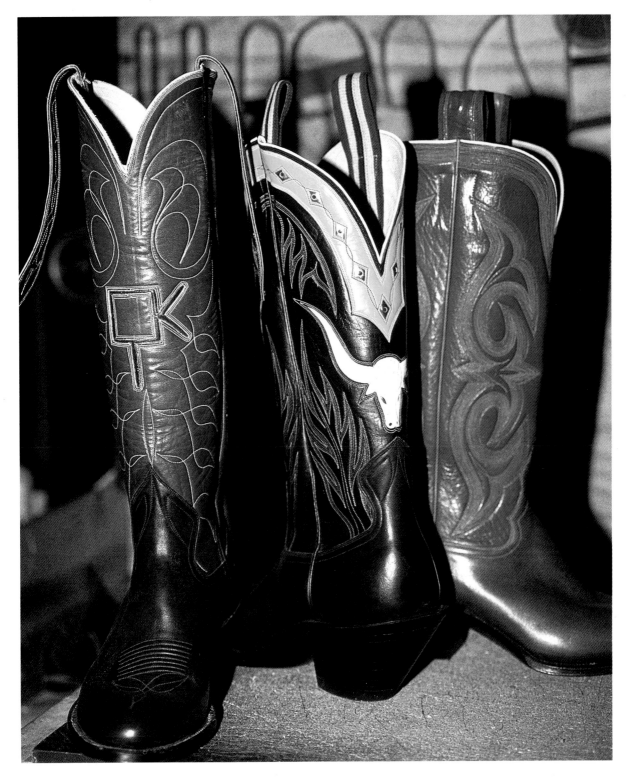

*T*hree boots by Griffith that any cowboy or cowgirl would be right proud to wear. The green boot has a ranch brand emblazoned over a turn-of-the-century "Old Man Rodermund" stitch. Photo by Bob Trebearne, Tempe, AZ.

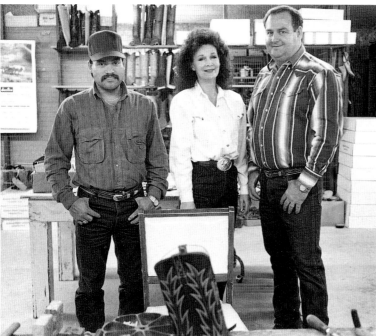

KIMMEL BOOTS

Eddie Kimmel is not sure why he was thinking about making boots while he was still in college. Once out of school, though, he went to work in the ceramic tile business. Nineteen eighty was a slow year and one day, while sitting in a local cafe in Gustine, Texas, Eddie started talking to the owner of a warehouse full of boot-making equipment that previously had been Blue Diamond Boots. Eddie told him he had always wanted to make boots. The owner handed him the keys to the building and said, "Have at it." After Eddie had been making boots one year, the owner decided to sell all of his equipment and stock to a boot company in El Paso. Eddie stayed in Comanche, buying all new equipment and building a shop wedged between the home and the horse pasture on his property.

He learned to make boots and fit lasts from the bootmakers he recruited at Blue Diamond. Eleven years later Kimmel Boots is thriving. The backbone of the company is making boots for working cowboys and ranchers in Texas. Eddie's wife Kathy says, "Ninety percent of our boots are for Texans." The other 10 percent of Kimmel's boot busi-ness is mainly limited custom work for stores in California and Billy Martin's in New York City. In the past few years, Eddie has also been making shoe boots for Martin's and other stores on the east and west coasts, and in Canada.

"Some folks will fly in to the little Comanche airstrip to pick up their boots, or we have truckers as far away as New Jersey who see a Texas driver's boots then will stop by the next time they are passing through to order boots," Eddie says. He and Kathy, who runs the business operation, are not sure who will take over the shop someday. They are both in their early forties and still have plenty of time to try and convince their son Justin to carry on in the boot business. Kimmel Boots currently has six other employ-ees; three are full-time bootmakers. Chava Guevara, the shop foreman, has a keen eye and a steady hand for intricate inlay work. While Juan cuts and stitches tops, Gonzalo is the bottom man. Eddie fits all the lasts, die-cuts most of the leathers, and does whatever is needed to keep things flowing in the shop.

What else does the future hold for Kimmel Boots? "I might open a boot-making school right here in Comanche," Eddie says.

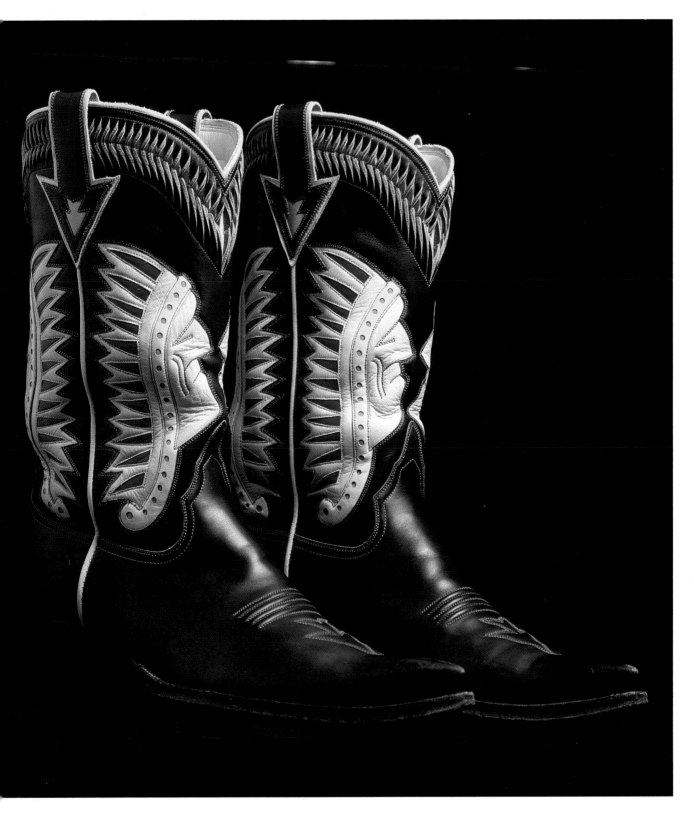

Over 150 hours of work went into this boot. The silhouette with full feathered Indian headdress was copied from the original vintage boot design. The collar, or "gill work," was taken from a one-of-a-kind boot made by retired bootmaker Shorty Golden, of Belton, Texas. Eddie, Tyler, and Chava collaborated on the additional arrow pull-straps, arrowhead toe bug, and (not visible) teepee on the heel with smoke coming out of the top. Tyler and Teresa Beard collection.

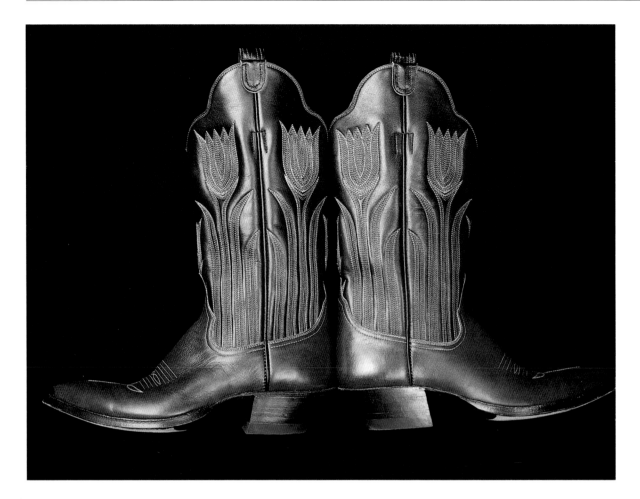

I bet you never thought a brown-and-black boot could be this visual. The "tulip stitch" was an early Tom Mix favorite. Boots by Eddie Kimmel, Tyler and Teresa Beard collection.

Facing eagles in four colors of calfskin with a green heart set in a fancy key-hole collar. Boots by Eddie Kimmel. Tyler and Teresa Beard collection.

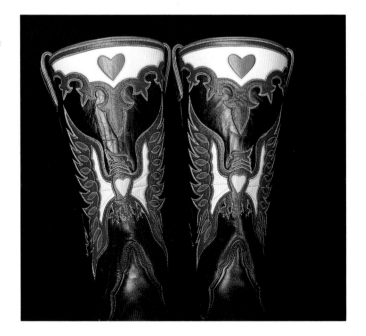

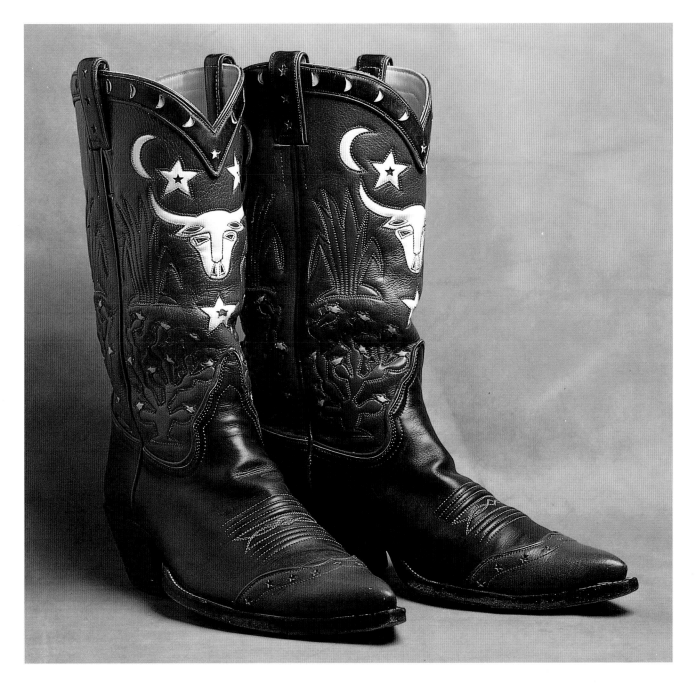

Kimmel made these cactus and longhorn boots. The green piping around the wing tip and tongue, vamp sides, and counter is an unusual touch. Tyler and Teresa Beard collection.

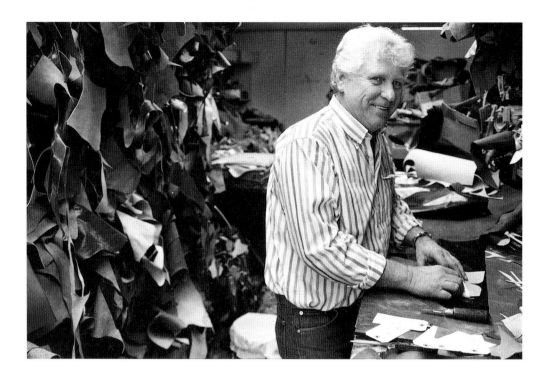

James Leddy choosing leathers for upcoming boots.

JAMES LEDDY

James was a nephew to M. L. Leddy. He grew up in Tulsa, Oklahoma, and by the age of eleven, he was shining shoes; at twelve he was stitching boot tops. James moved to Abilene, Texas, in 1953 to partner with Clifford Leddy, another uncle, in a shoe and boot-repair venture. This union lasted eleven years. Then James moved to Brownwood, Texas, to work with A. J. Malouff. After six months he moved again to San Angelo to work for his dad's brother, M. L. Leddy. But in less than a year, James opened his own shop. He worked there for five years until 1970, when Cowtown Boots in El Paso, Texas, offered him a job designing boots and working as shop foreman. He soon found out that Cowtown did not want to make the quality boot that James was used to, so he returned to Abilene in 1971. "I guess I really like to work by myself, run my own show," he observes.

James Leddy has been in Abilene ever since and operates the business with his ex-daughter-in-law, Janie Benson, who has worked with him for seventeen years. "Janie can do it all—she likes top work the best. My wife Paula stitches tops and helps run the business. Then in the shop I usually have three or four bootmakers full-time. Nolan McCleary has been with us three years now. He's a good hand," James says.

James also employs the talents of Evelyn Green, who worked for Willie Lusk off and on for forty-five years—mainly stitching tops. At home, on her ancient Singer sewing machine, Evelyn stitches boot tops with the delicate, sweeping flame pattern attributed to Lusk. Evelyn says, "Going to work with James and his wife after Willie died in 1976 was like having a second family. They are very special people and have been good to me."

"Things have leveled out since the *Urban Cowboy* era when twenty-four pairs a week were going out the door," James observes. Now nine or ten pairs a week are average. Seventy percent of their boots go to customers within a hundred miles of the shop, 20 percent to various other towns in Texas, and 10 percent go out of state. James makes boots for numerous Nashville country-music stars—George Jones, Hank Snow, Faron Young, Jimmy Dean, Conway Twitty,

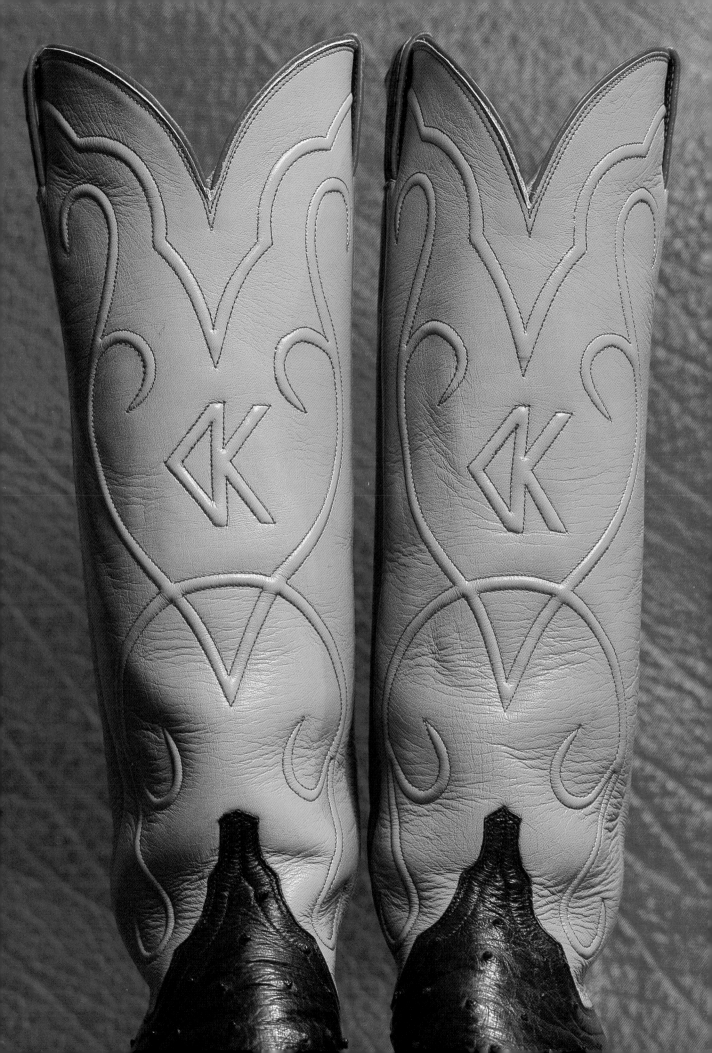

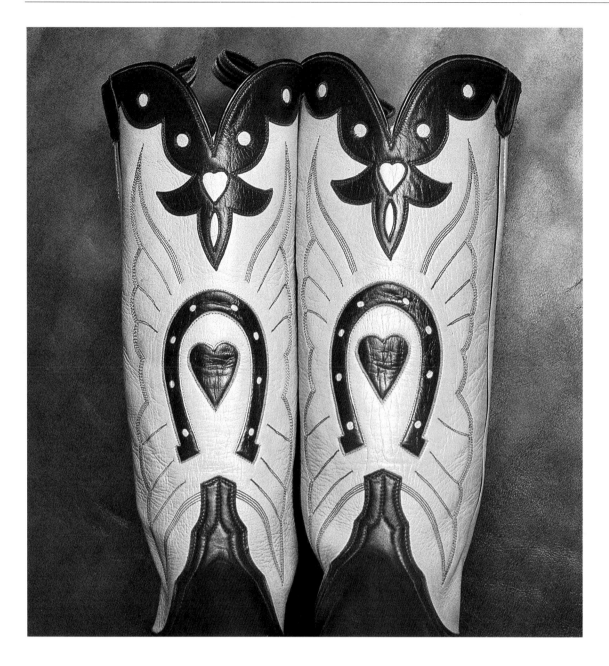

Horsesboes and hearts are old cowboy favorites. Add wing stitching and a lace collar and you have one fine pair of James Leddy boots.

Vern Gosdin, Buck Owens and even Doc Severinsen. "I guess Mel Tillis is my best customer," James comments. "He has sixty-two pairs of boots from me, and we make all the boots for his twelve-piece band every year."

Squeezed in between James Leddy's boot shop and his repair shop is Art Reed. He and his wife make saddles and chaps and take in repairs. In this meandering cluster of buildings, you get a real sense of pride and craftsmanship and the quality shows in everything they make. Yet I can't help wondering who's going to carry on James Leddy's tradition of fine boot making in Abilene when he decides to hang up his apron.

*A*ll by James Leddy: (left to right) black calf boot with a variegated stitch; muted benedictine color vamp with a rich green top shows variegated stitching; black-on-black with a single design of "raised string" (cotton string cord sewn between the inner and outer layers of leather, creating a raised or padded effect).

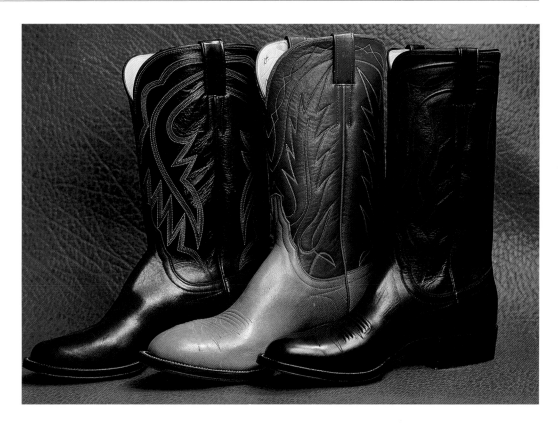

A snazzy gray ostrich and black patent leather needle-nose shoe boot for Hank Snow. By James Leddy.

M. L. LEDDY

About 1918 Martin Luther Leddy, better known as "M. L.," the eldest of eight brothers, decided to head to Brady, Texas, near the family farm because the cotton crop had died due to a drought that year. He first learned to repair boots in the back of Skaggs Saddle Shop. One day a rancher wandered in and asked if M. L. could make him a pair of boots. He did. They fit. The man ordered another pair, and M. L. was in the boot business. In 1922 M. L. Leddy bought out the saddle shop and brought five other brothers off the farm to town to help out. In 1936 M. L. Leddy moved to the west Texas ranch town of San Angelo, where he purchased the old Mercer Boot Shop. The brothers came and went; several of them went on to manage other Leddy stores.

Arch Baird bought his first pair of Leddy boots in 1927 from the Brady shop; in 1941 he went to work for M. L. and became the shop foreman and an investor in the company in 1943. Arch worked at Leddy's for more than forty years and attributes Leddy's success to quality workmanship and personal service. "Bootmakers have always been proud to work at Leddy's," he comments.

Robert Castleberry started with Leddy's in 1946, making heels, stacking one layer of leather at a time. One day in a pinch, he broke all records and built sixty-four pairs. Whew! Robert remembers his first pair of boots, "whittled back on the ranch from scrap wood. I was always fascinated with boots." He points out that boot styles change regionally because a rancher or customer may ask for a certain heel or toe or stitch pattern. In the shop at Leddy's, even today, you hear, "He wants an Alton Barnett heel." For Barnett, a broncbuster forty years ago, Leddy's made a high, extremely underslung heel for digging into the stirrups. Or you might hear, "Put a Henry Clark toe on it." "Old Henry was the first man in this part of Texas to wear a rounded toe," Robert explains.

Leddy boots are recognizable from fifty feet away. They really have not changed in appearance or construction for the past fifty years. They have three basic stitch patterns:

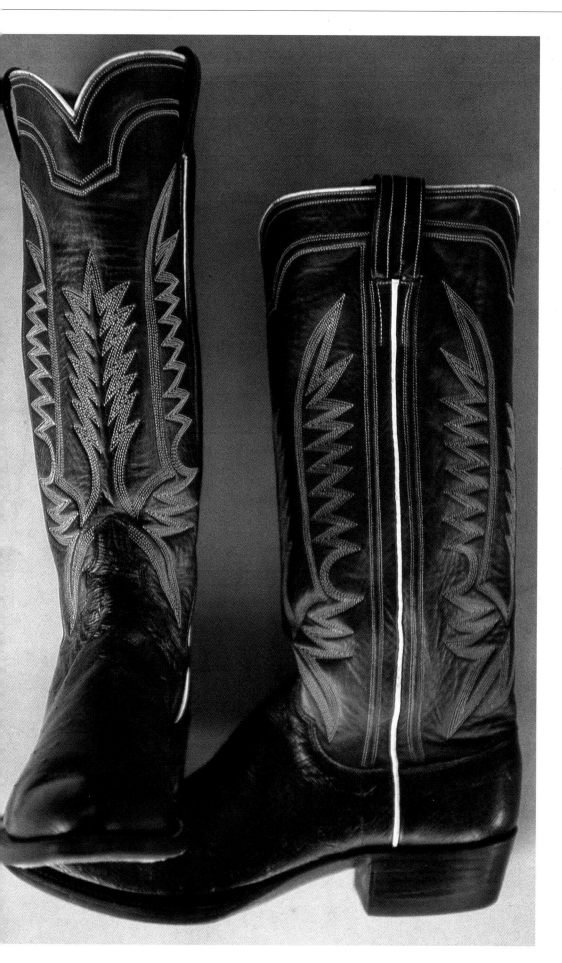

Number 10, an original design from the Brady shop; Number 12, designed by Dahl Tate, the "top man" for Leddy's for better than forty years; and Number 13, which is a marriage of an old Justin and a Charlie Garrison pattern. Dahl Tate reminds us that a pair of Leddy boots still costs a west Texas cowboy a month's wages.

At twenty-one Jim Franklin came to work for M. L. Leddy's as a sales clerk and married Joyce Leddy, M. L.'s daughter. Over the years, Joyce and Jim bought out controlling interest from the other brothers. They have two sons, Rusty and Wilson. Rusty has his own boot shop in San Angelo, and Wilson currently manages the Leddy stores in San Angelo and Fort Worth, which are both full-service western-wear, boot and saddle shops and custom western tailors, catering to locals, tourists and the cutting-horse crowd. In the 1950s San Angelo, Texas, boasted more than eighteen bootmakers. Only two of those original boot shops have survived, M. L. Leddy's being the larger and more successful. Leddy boots have been a Texas tradition for more than half a century.

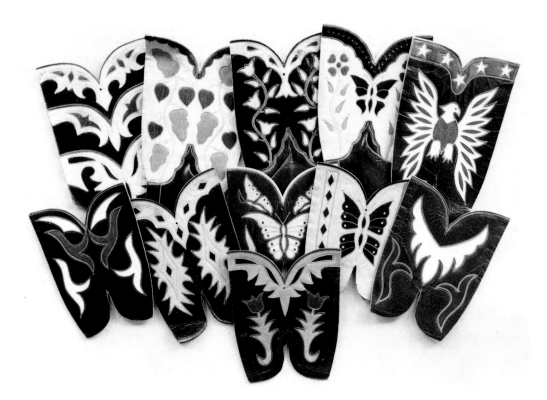

A variety of old inlay patterns still available at M. L. Leddy's.

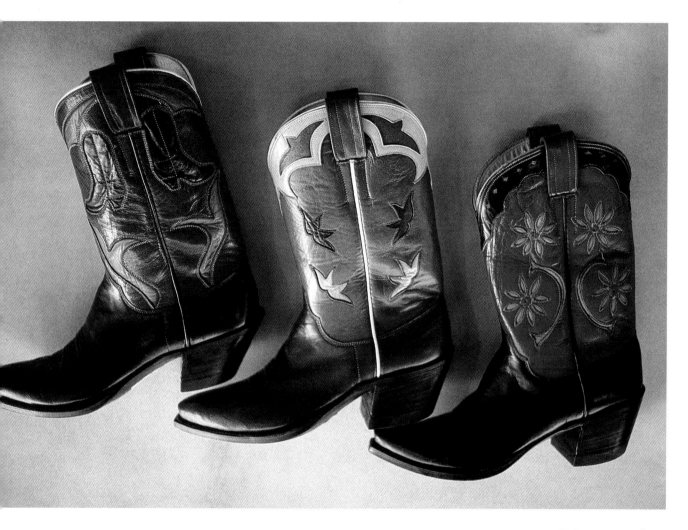

*N*ew peewees using
old M. L. Leddy
inlay patterns.

Dave Little measuring a last.

A "good luck" boot for Texans or anybody who loves sharp boxed toes, flashy wing tips, heel foxing, metallic leathers, and plenty of attention.

LITTLE'S BOOTS

Dave Little's grandfather, Lucien Little, founded Little's Boot Company in San Antonio in 1915. At that time, most of the work consisted of making shoes and repairing shoes and boots. But one man in the shop knew how to make cowboy boots, and he taught Ben, Dave's father. Dave is a third-generation bootmaker. Eight to twelve other bootmakers work in the shop, the number varying from year to year. Dave says that they produce three to five pairs of boots a day. "We were always known for the traditional western boot: one-quarter-inch sharp box toe and a two-inch underslung riding heel," he says. "But now we do it all. Low heels, high heels, fancy inlays, conservative black French calf, alligator—you see everything in our shop."

Dave's daughter, Sharon Little, came to work full-time in 1990. She plans to take over the running of the business gradually from her father, who is currently working his way into semiretirement. The man in the shop who is always smiling is shop foreman Ruben Diaz. His brother, Alfonso, worked for Lucchese for eighteen years and is now Dave's number-one bottom man. Juan Ortiz is the head top man.

Like Alan Bell, Dave Little still finishes his soles in three different stains, followed by ink and then waxing and buffing. The finished sole has a smooth mirror finish resembling waxed wood. This attention to every detail has earned Dave a reputation as a perfectionist. He is currently at work on a standardized-size boot mail-order catalog, which will feature several different styles of boots with a variety of heels and toes in any choice of skin, along with belts to match. "People are really beginning to order belts to match their boots," Dave observes. "Any color of calf or inlaid belt, red ostrich, or alligator—we can do it." He is emphatic, though, that made-to-measure boots will always remain the shop's specialty.

If you're in San Antonio, Texas, be sure to stop by Dave Little's. The shop features belts and more variety of boots than any other shop in the state. There are a range of styles, beautiful inlays, exotic skins, and stacks of unusual boot designs and stitch patterns to choose from. In 1992 Dave made the incredible Absolut Vodka boots seen in national and international magazines and on billboards.

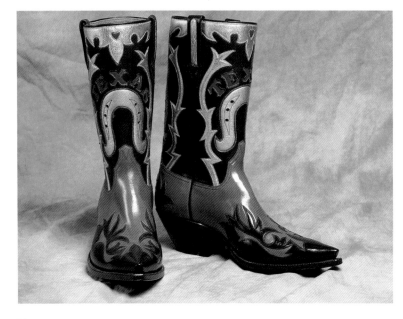

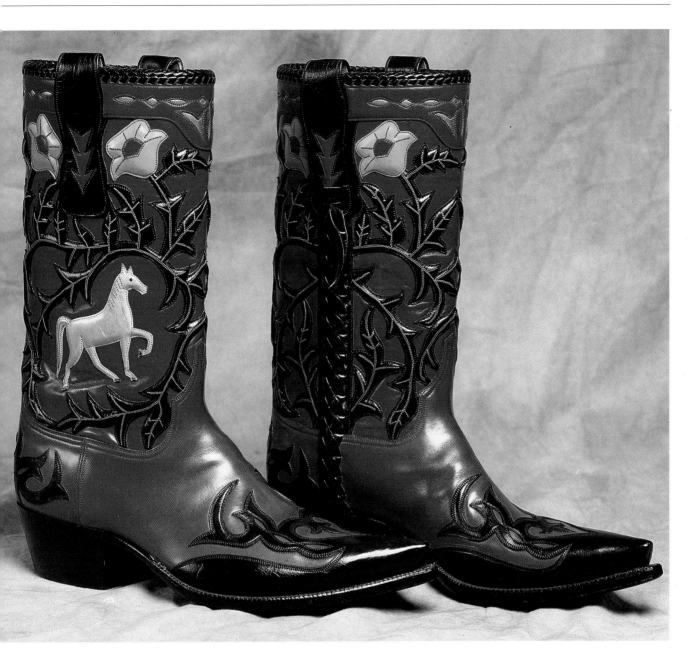

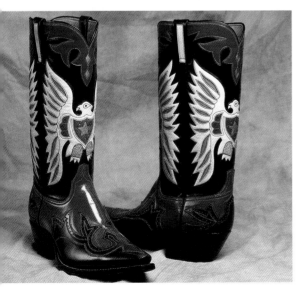

This pair would look great with your Bermuda shorts and polo shirt at the next Fourth of July company barbecue picnic. By Dave Little.

Once you see this boot you can never forget it! Heavy laced inside seams, laced stovepipe tops, wing tip toes, and raised horses and flowers are throwbacks to earlier boots done near Raymondville, Texas, by Torres and Rios. Boots by Dave Little.

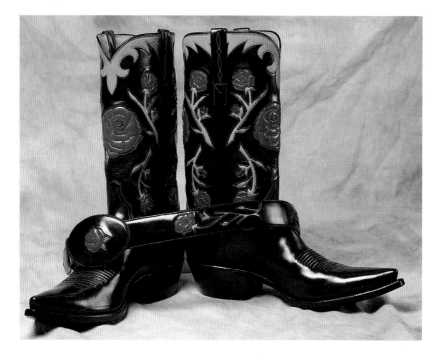

A sleek, full roses-and-vines pattern on black calf with a sharp box toe. Made by Dave Little.

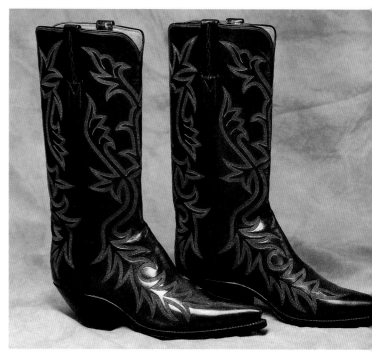

Elements of this boot echo early 1940s bootmakers on a conservative day. This boot could be worn for dress with no hint of what lurks above the ankle. Boot by Dave Little.

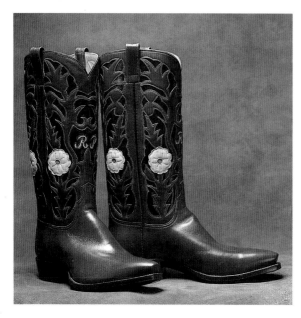

A two-piece top is difficult enough, but continuous flowing rows of stitching that never stray their path are very tough to execute. By Dave Little.

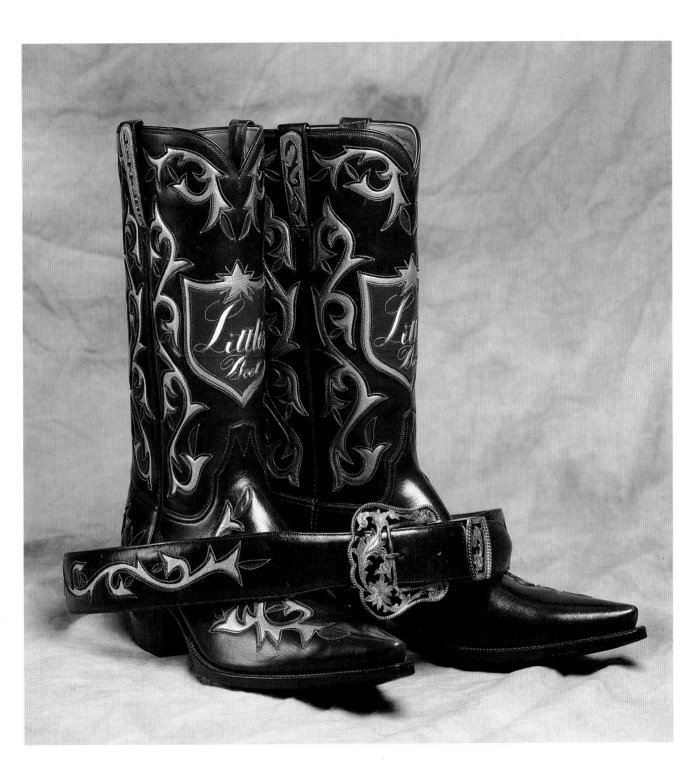

A boot and belt combination that conjures up Louis XIV. Gold and red inlay and overlay on a brown French calf backdrop. Made by Dave Little.

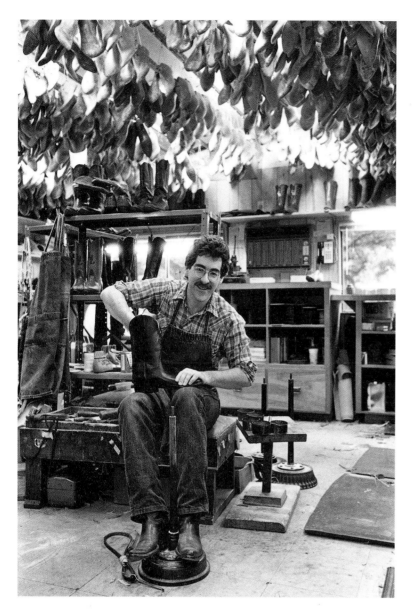

Lee Miller at work on a boot with a legacy of boot making hanging over his head in the form of wooden lasts.

LEE MILLER / TEXAS TRADITIONS

Lee was born and raised in Rutland, Vermont. As a child he once tried to alter the toe shape on his Acme boots with a handsaw. An older Lee found himself drawn to the shoe and boot department of his family's clothing store. Fascinated with feet and footwear construction, he went to work for a local shoe-repair shop. Lee knew he wanted to work with his hands but needed to be more creative. He decided to take the two-year boot-making course in Okmulgee, Oklahoma. After school he worked in Utah for a bootmaker. Then an opportunity arose for Lee to come to Texas; the legendary Charlie Dunn needed a bootmaker. "The moment I saw the boots Charlie was making, I knew I had to stay in Texas and work with him. His boots were beautiful," Lee says.

In 1986 Lee and his wife Carrlyn bought Charlie's boot shop. Today Carrlyn does all the paper work and phoning, while Lee runs the shop with his two bootmakers. Max Fernandez, who prefers top and inlay work, started with Charlie in 1979, and José Coyoy is the bottom man on soles, heels, and finishing. Lee works on whatever needs to be done in the shop but prefers measuring feet and fitting the lasts. With Lee this process becomes almost a ritual. Following in the bootsteps of Lucchese and Dunn, Lee spends thirty to forty-five minutes with your feet. He measures, then remeasures. He surveys every bump and blood vessel. He then makes an ink impression of the bottom of the feet with a giant ink pad, followed by a contour gauge, which measures the top of the feet. Drawn out it looks like a lie-detector graph. Lee then compiles all of these measurements into a master chart to make the last.

Lee fancies box toes, French calf or kangaroo skins, graceful stitch patterns and restrained inlays. But at the same time, Texas Traditions makes some of the most intricate inlay boots in the West. Leather roses, bluebonnets, and prickly pear cactus with inlaid script initials in gold and silver, trimmed in leather barbed wire are just a few of Lee's specialties. He also made the historically correct boots that Tommy Lee Jones wore in the miniseries *Lonesome Dove.*

The standard wait for a pair of boots from Lee Miller is currently fifteen months, explained by Miller's meticulous attention to detail. "I think every part of the cowboy boot should be beautiful, not just the tops," he says.

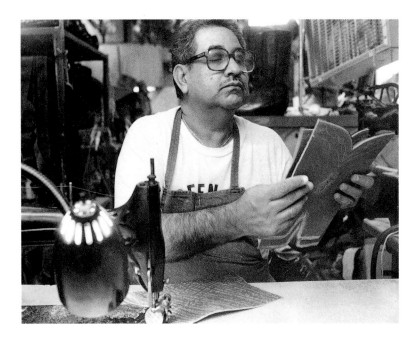

*M*ax Fernandez, at Texas Traditions, scrutinizes every step of his own work.

A two-tone stovepipe boot with a skillful gingerbread collar design with tiny stars. By Lee Miller.

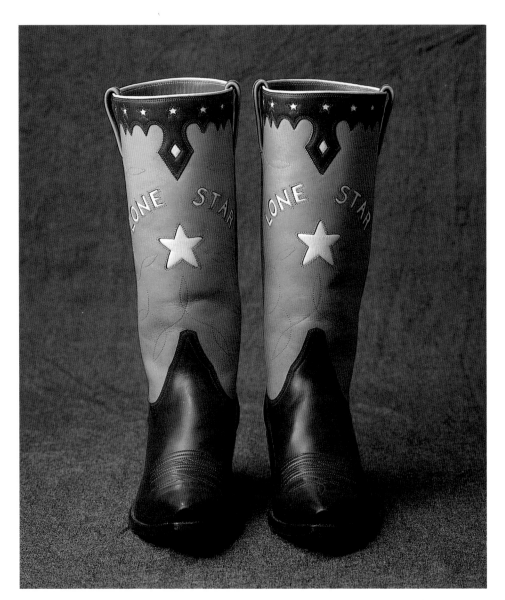

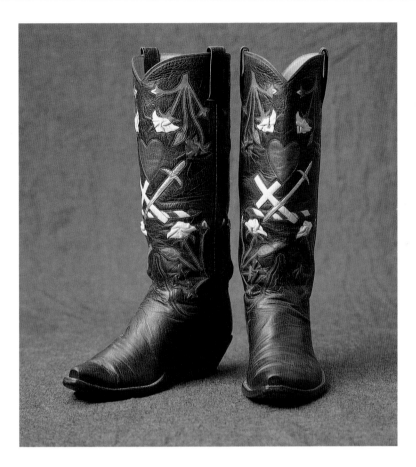

"Crusades" boot, a family crest in red, white, green and brown kangaroo, features pinched rose work. By Lee Miller.

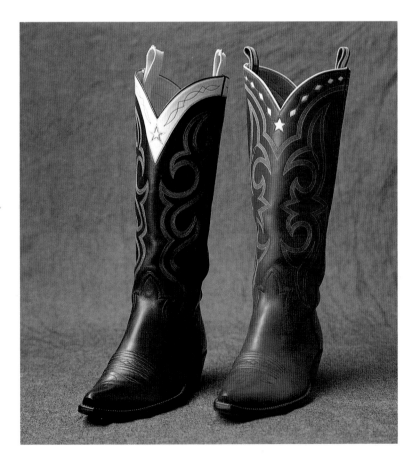

Understated and sleek, Lee loves the 1930s look: box toes, simple collar inlay, and inside cloth pull straps. By Lee Miller.

JACK REED

Jack Reed began making boots after a bareback rodeo accident left him unable to do heavy labor. He started in Hamilton, Texas, where he was born and raised, as a repairman in Trujillio's Boot Shop. Over the next few years, Jack worked in Lampasas with Ray Jones, with Lucchese in San Antonio, and with Rios in Raymondville. "Back in those old days you would stroll into a boot shop with your little bag of tools, and all they would ask you to do was make a good waxed string with a hog-hair end. That string is what you use to sew the welt on. If you made a good one, they would hire you on the spot," Jack recalls.

Jack finally decided to go out on his own in 1949 in Waco, Texas, where he was studying civil engineering at Baylor University. "I starved out after a while and had to start making boots full-time," he says. Jack landed in Ruidoso, New Mexico, briefly, and then went on to Ellisville for one year. Jack explains, "In those days you moved around a lot, looking for your best spot." In the interim he took a job with a construction firm as an engineer, traveling for five years in Africa and South America. Jack finally returned to boot making after seventeen years of engineering. In 1974 he opened a new shop in Henderson, Texas. "That old east Texas pine pollen drove me to ole' dry Lampasas," he says.

Today sixty-nine-year-old Jack Reed operates the only one-man boot shop left in Texas where the entire boot, including stitching the tops, is created by one man. Usually one-man shops employ their wives or outside people to do all the stitching. Reed averages one pair of boots per week and insists that if a lone bootmaker tries to make more than two pairs per week, he is cutting corners and the product will suffer. "Some folks like to play golf or fish, but I enjoy the 372 steps of boot making," he observes. Jack also teaches young bootmakers from all over Texas the finer points of traditional boot making in a one-week, forty-hour crash course. "I still use lemonwood pegs and do a lot of other things the old way," he says. "The pegs come from Germany; they swell up in the sole and hold that boot together tight like rivets. Maple just doesn't swell as much."

Jack has organized the Boot and Saddle Makers Roundup, an annual event in Burnet,

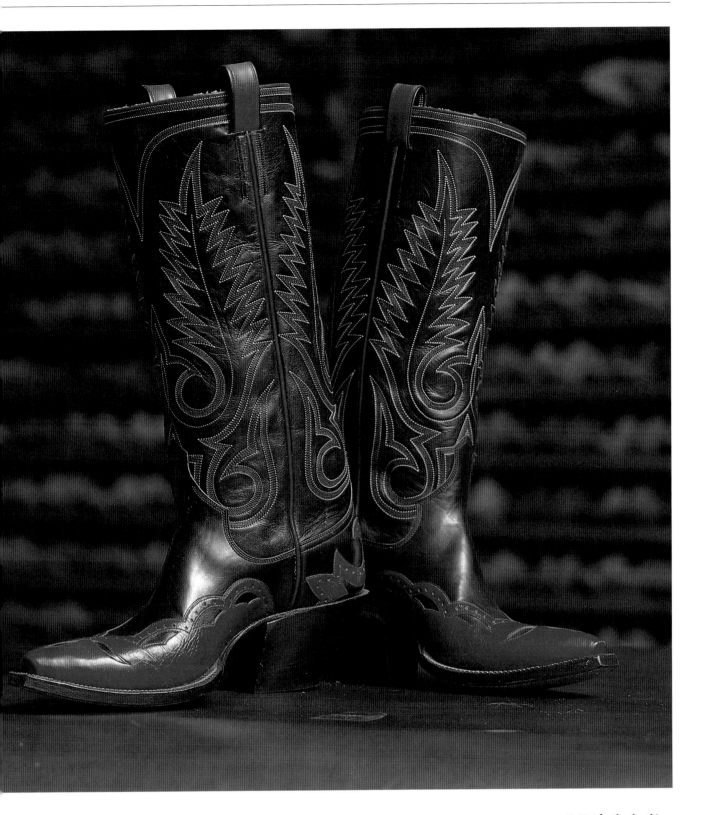

Not for the shy, this tall-top black calf boot sports red foxing on the toe and heel, high underslung heels, and bold stitching that could kick you sideways. Boot by Jack Reed.

Texas. It's a chance for craftspeople, young and old, to see each other's work, swap stories, and exchange ideas. Jack talks a lot about retiring, but his customers won't let him. Although he makes boots mainly for ranchers, cowboys, and Texas professionals, Jack is able to execute fancy inlays with the same ease and perfection displayed in all Reed boots. "I've got four sons, but none are interested in boots. If it doesn't have a steering wheel or wings on it, they have no interest," he says dryly.

Full python, sixteen-inch-top boots with a black calf collar and round toes. By Jack Reed.

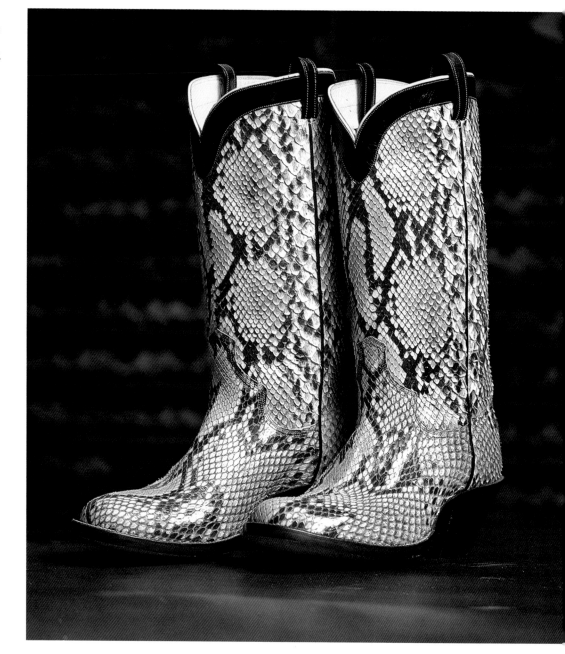

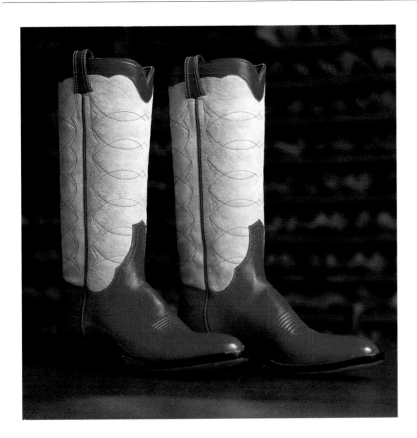

*F*ire-engine red vamps show off a soft cream top with an elegant one-row figure-eight stitch pattern in red thread. Red piping and collar set off the whole boot. By Jack Reed.

*R*eed made this boot for a customer in Maryland. The box toe and yellow, red and turquoise inlay are reminiscent of the 1950s.

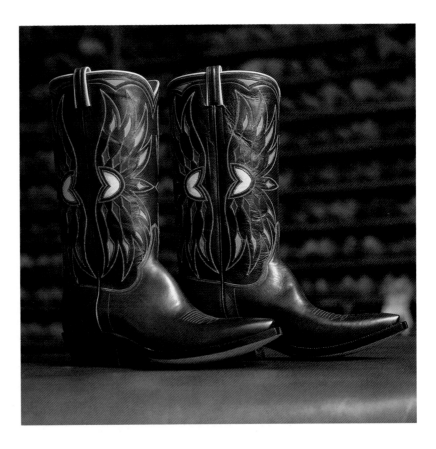

BO RIDDLE

Bo Riddle makes boots in Brentwood, Tennessee, near Nashville. Trained as a fiddle player, Bo decided to make custom boots while continuing to play music. His grandfather made boots for the Confederacy during the Civil War. Bo attended Oklahoma Technical College in Okmulgee, Oklahoma, and started making boots in 1976. He opened his first shop in Birmingham, Alabama, then moved to Brentwood in 1982 in order to be near the Nashville seat of country music. "I view my boots as individual works of art," explains Bo. "They are one-of-a-kind leather creations."

His customer list reads like a country-western concert billing: Larry Gatlin, Sweethearts of the Rodeo, Becky Hobbs, Kix Brooks, Daryl Pillow, and most recently Marty Stuart, who has started wearing his "killer" boots. At thirty-one, Riddle can remember his boot beginnings as a kid, when he made moccasins out of old tire inner tubes. Bo prefers making flashy inlays, overlays and one-of-a-kind creations. A lot of color, texture, and artistic mastery go into all of Bo Riddle's boots.

*B**o working on a pair of black-and-red "Rosebud" boots. "The boots I am working on now for Marty Stuart have 380 pieces of leather per boot." Photo by Randy Janoski.*

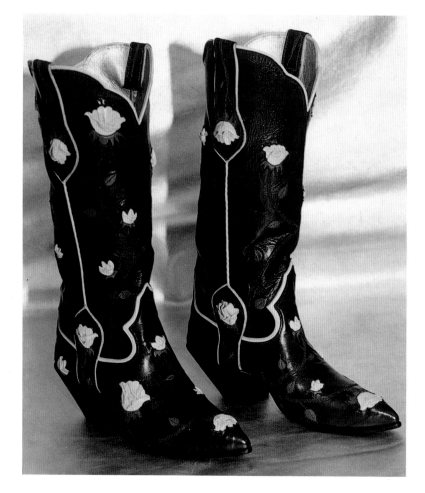

*W**e have plenty of bootmakers pinchin' roses, but Bo took it a little further by placing the leather buds all over the boot. Most unusual are the reversed half mule ears facing each other from the bottom and top. Photo by Kim Stanton.*

*B**o has his own style. The inlays creeping out from the side seams and elongated collar are Riddle trademarks. Photo by Kim Stanton.*

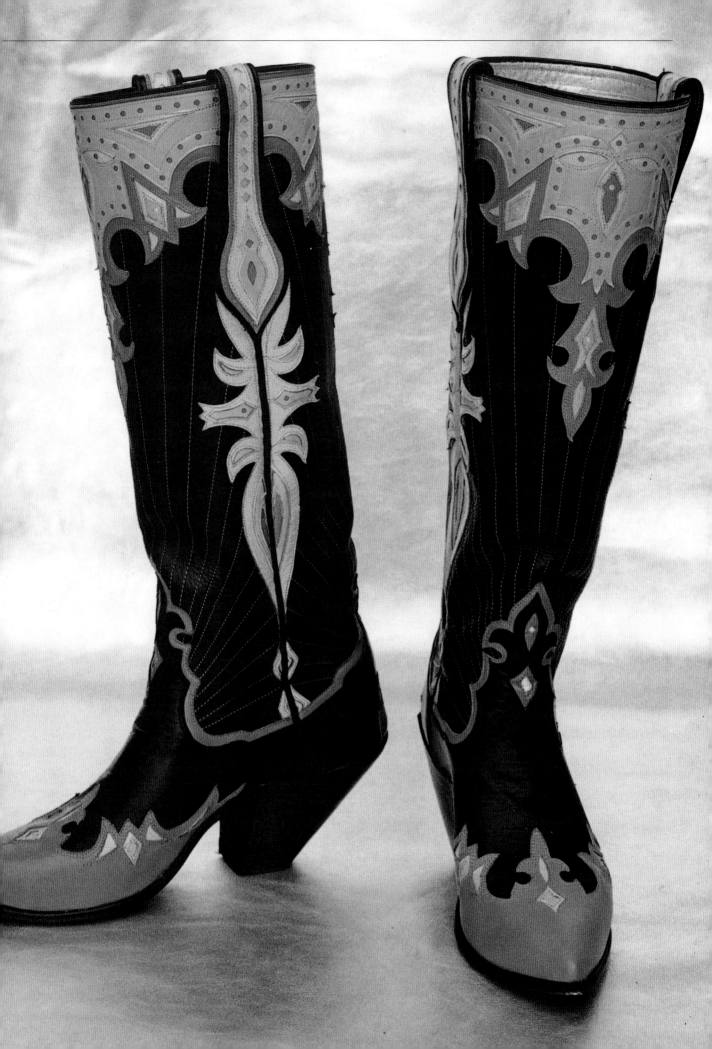

Paul Wheeler is proud that his son Dave has chosen to carry on a family tradition in boot making.

WHEELER BOOTS

While most children of bootmakers reject their father's profession because it is not a lucrative career, Dave Wheeler is an exception. His father, Paul Wheeler, who started making boots in 1947, passed along his skill to his son. Today Paul has a boot and shoe-supply company right across the street from Dave in Houston. Although both Wheelers have combined their boot making expertise with an artistic flair for design, Paul's work was more reminiscent of the "golden age of boot making" between 1940 and 1960. Dave is part of the new breed of bootmakers helping to create a renewed interest in tradition, mixed with whimsy and fantasy.

Customers come to Dave with ideas for their boots that most makers would shy away from. But Dave treats his boots like a leather canvas. Nothing is too strange or difficult for him to attempt. Inlaid chili peppers, a customer's intricate company logo, a re-creation of a Hawaiian shirt pattern in multicolored leather, state flags, animals, flowers, or a favorite automobile from your youth: Dave can put anything on a pair of boots. But like most bootmakers, his bread and butter is conservative calf, ostrich, kangaroo, and alligator boots for Houston's locals and elite. Paul's wife Dorothy, their daughter Anna, and Dave's wife Janis oversee the company's business side and manage the phone, the shipping, and the repairs.

Dave made Robert Duvall's boots for the *Lonesome Dove* miniseries and furnished boots for the DeKuyper Cactus Juice ad, which featured rows of vintage and fancy bootwear toe to heel, and can be seen in *Rolling Stone, People, GQ,* and *Playboy* magazines. Dave loves what he makes, and it shows. Along with four other bootmakers, he continually turns out fine and beautifully crafted boots for Houston, Texas, and customers all over the world.

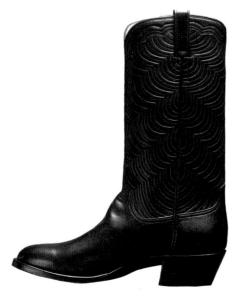

An understated yet beautiful black-on-black calf boot. Dave named this pattern "The Wave."

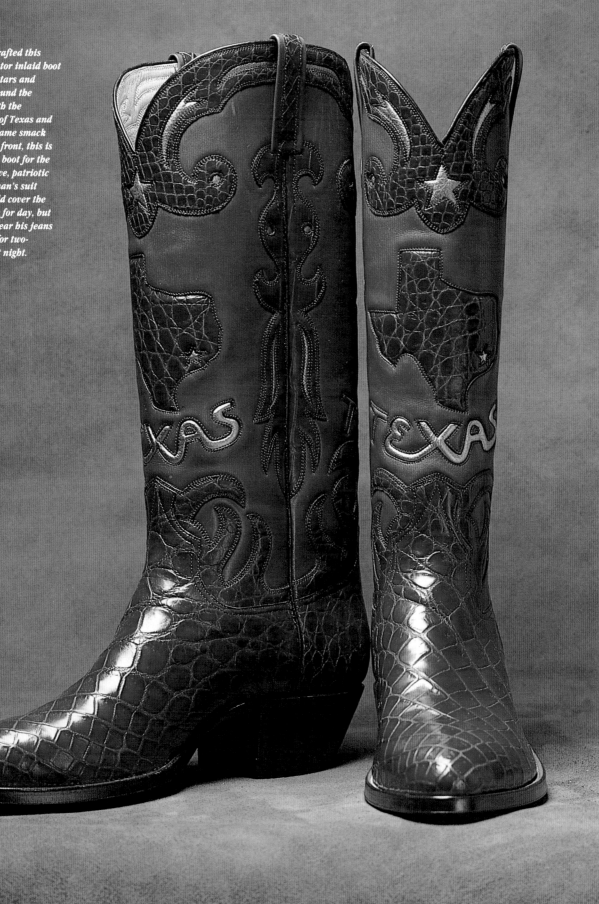

Dave crafted this alligator inlaid boot with gold stars and comets around the collar. With the silhouette of Texas and the state name smack dab on the front, this is the perfect boot for the conservative, patriotic Texan: a man's suit pants would cover the fancy work for day, but he could wear his jeans tucked in for two-stepping at night.

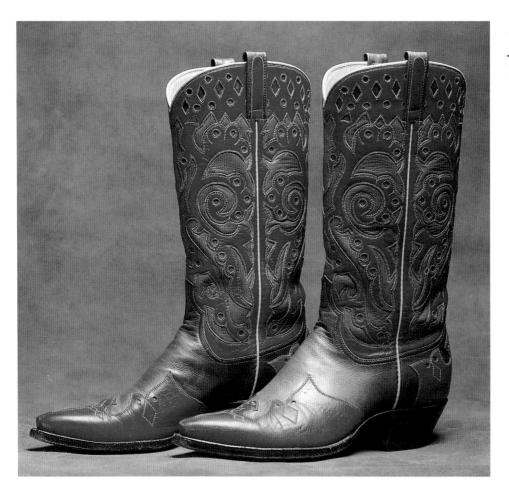

Stunning laced paisley effect with wing tip foxing in the vamp and counter. Made by Dave Wheeler.

All eyes would be on the wearer of these Salvador Dali–inspired boots by Dave Wheeler. Collection of Michael Von Helms.

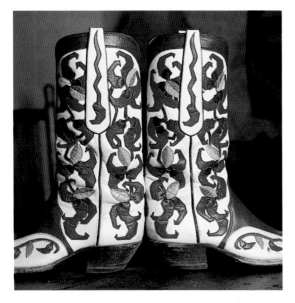

"Chili Peppers," a collaboration between Von Helms and Wheeler, is an example of a "sky's the limit" boot design.

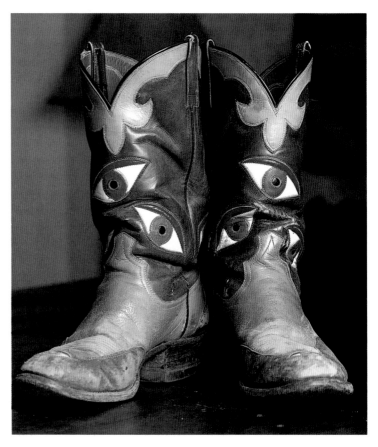

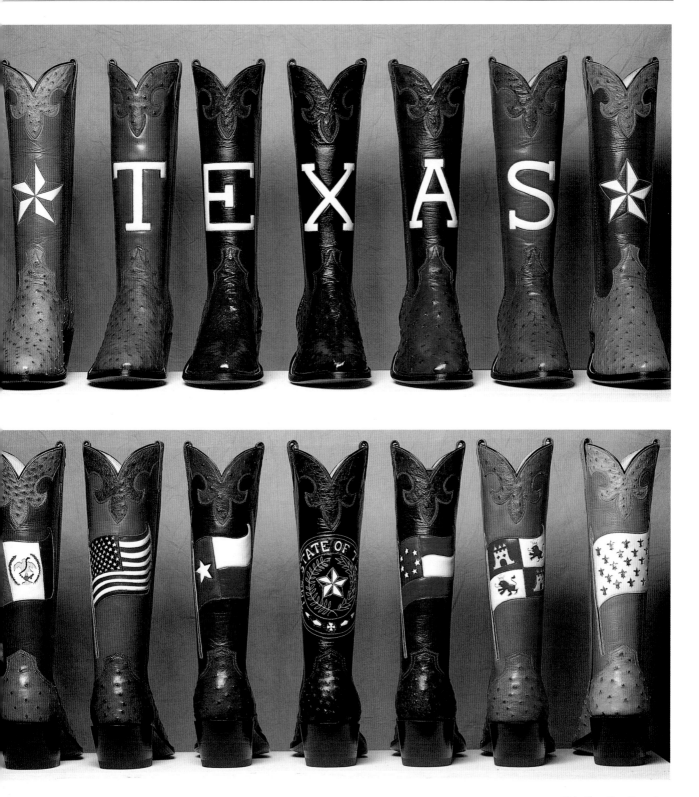

*"Six Flags Over Texas"
boots by Dave
Wheeler. All these
beauties have ostrich
vamp and collar and eye-
crossing flag detail.*

Boot Collectors

"To a collector, a good story can be worth more than the boots themselves."

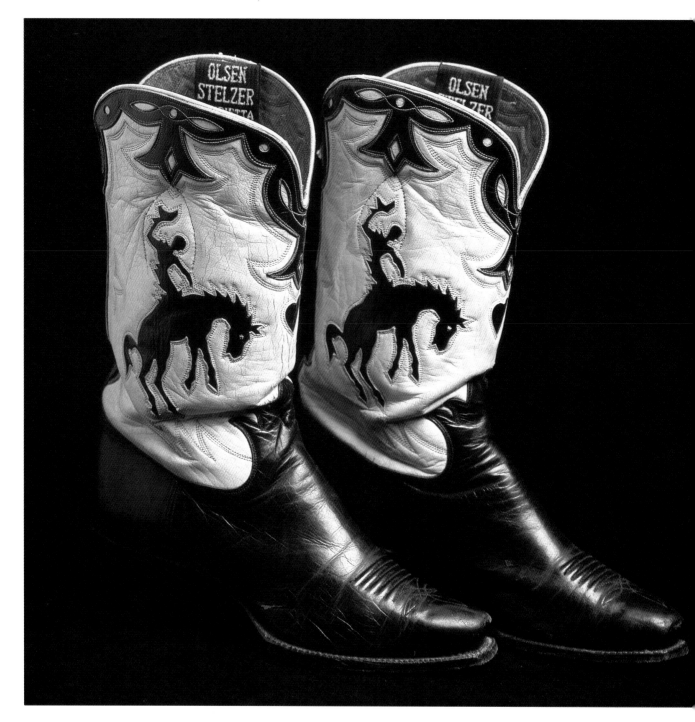

A nother vintage boot collector's prize. Olsen-Stelzer was the first boot company to feature broncs and oil derricks in their catalogs. These fetch up to $1,000 from collectors. Note that it is rare to see a black-and-white boot from the 1940s. Tyler and Teresa Beard collection.

TYLER AND TERESA BEARD

We wear boots every single day, regardless of what we are doing. Back in 1987 we had over 150 pairs in our collection and began to feel like we were running the official boot museum of Texas because people stopped by just to look at our boots. We realized boots were taking over our lives and decided to divorce ourselves from a hundred pairs. In addition we collect boxes, advertising, catalogs, and just about anything else to do with boots and their makers.

Collecting boots is like collecting any art: you soon fine-tune your taste. We collect early handmade children's boots, hand-tooled pictorial boots, and have always admired the bucking broncs, oil wells, clean designs, materials and craftsmanship of the Olsen-Stelzer Boot Company, in Henrietta, Texas, from 1934 until 1977. On the other side of the boot bench, we search for early Ray Jones, known for his tough-as-nails working cowboy boots. Currently we are looking for one-of-a-kind, truly eccentric boots for our collection. Although we feel like we know all the boot collectors and enthusiasts across the country, there are probably a few quiet ones out there. We would love to know about you, so call or write us in Comanche, Texas.

A few years ago Teresa and I had gone to San Angelo to pick up some boots. In Charlie's Café Teresa jabbed me in the ribs to look at the boots on an old cowboy, a pair with full Indian profiles, replete with headdresses, on both sides in five colors of leather. The boots were falling apart, with more cracks and wrinkles than the cowboy's face. We tried to explain that we collected old cowboy boots. He said he had the boots made in San Angelo in 1938, but could not remember who made them, and he quietly told me they were not for sale. I knew if I didn't get them, they would be tossed out in the garbage when he died, so I offered a hundred dollar bill for them. As quickly as I made the offer, the boots were off his feet and in my hands; he finished his BLT and coffee and walked out in his stocking feet.

The Beards at home with their boots. Tyler and Teresa are both wearing boots made by Eddie Kimmel.

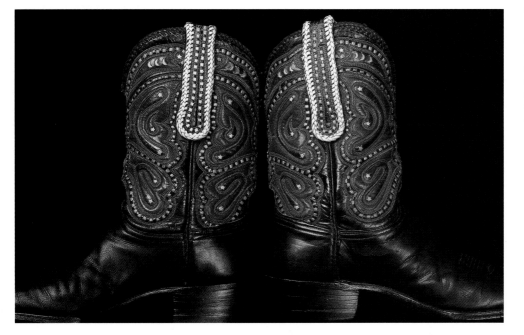

Whoever ordered this boot must have said "lots of lace." A very unusual design of tiny stars, moons, and abstract butterflies. Maker unknown, Tyler and Teresa Beard collection.

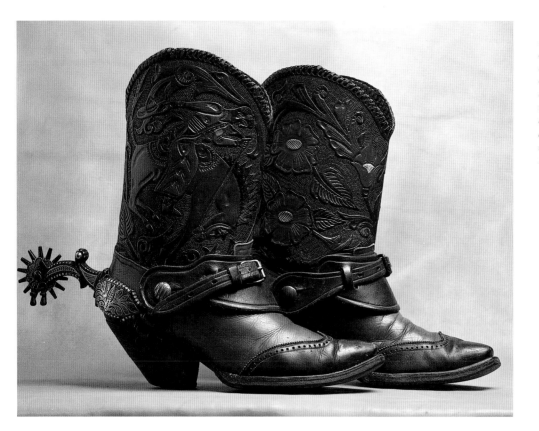

Asymmetrically designed 1940s South Texas boot; hand-tooled and painted scene of a cowboy on a bucking bronc with flowers and vines. Garcia-style spurs compliment this one-of-a-kind pair. Maker unknown, Tyler and Teresa Beard collection.

Tyler and Teresa collect children's boots. The Roy Rogers red-green-and-white boots in the middle are the ones Tyler wore as a child. Second from the left are children's boots made by Justin in the 1930s.

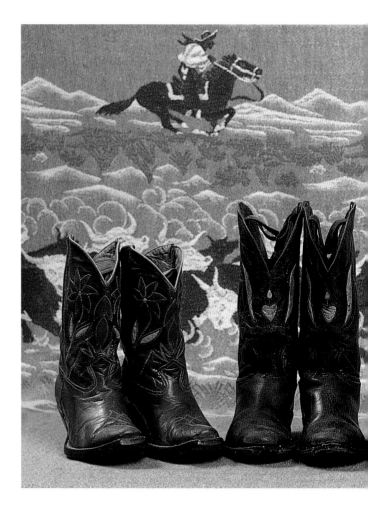

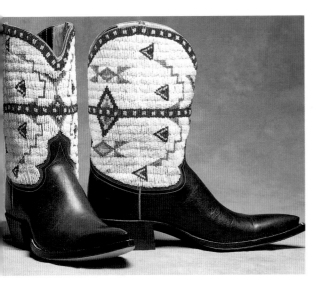

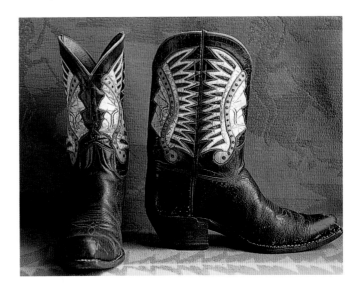

A totally unique beaded boot top, probably made in the 1950s or sixties. A new foot was attached just recently by Eddie Kimmel. Tyler and Teresa Beard collection.

This is the original Indian-bead silhouette boot, now being copied by numerous bootmakers. Maker unknown, Tyler and Teresa Beard collection.

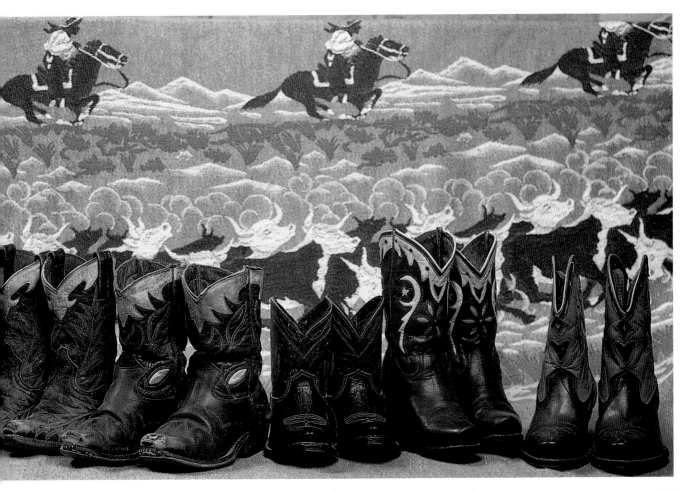

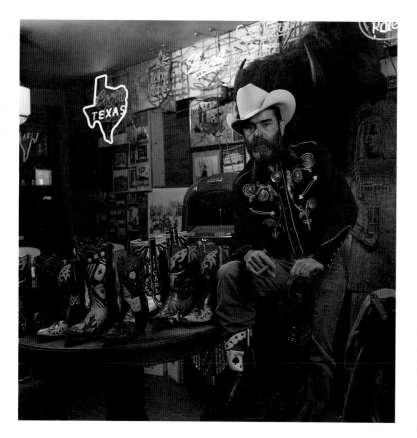

*J*im Goode at his Kirby Street location, dressed in his usual style, with some of his Dave Little creations on his foot and on the table.

JIM GOODE

*J*im Goode is as famous in Houston for his barbecue restaurants as he is a lover of all things Texan and western. Jim sports a full beard down to his chest, a cowboy hat, boots, and fancy western shirts, usually from the 1940s and 1950s. He is definitely one of a new breed of Texas eccentrics—an entrepreneur who does it his way—keeping Texas history and tradition alive.

Jim started out as a commercial artist, working in Houston from 1969 until 1977. He used to eat in an old barbecue joint on Kirby Street. One day the woman who owned it decided to get out of the business and Jim bought it. That was in 1977. The Kirby Street spot, better known as Goode Co. Barbecue, is one of his two barbecue restaurants in Houston and is a trip back to the Texas of the 1930s and forties. The place is old, but stylish. The walls are solid with Texas and cowboy memorabilia, photos, old beer ads, boots and saddles, chaps, longhorns and anything that strikes Jim's eye. Beer and pop are iced down daily in old soda cases, and the barbecue has been voted one of the best in the state over and over again. It is so good that Jim has catered barbecues in London, Paris, and Spain, flying over four thousand pounds of barbecue, a chuck wagon, the barbecue pits, mesquite wood from Texas, beans, potato salad, jalapeno cheese bread and pecan pie. (Those pies, shipped all over the world in wooden boxes with a branded star on the top and some of Jim's personal Texas philosophy included, will knock your boots off. It's the best pecan pie ever.)

Jim's bootmaker is Dave Little in San Antonio. His boots have very ornate inlays, with decks of cards, longhorns, cactus, even Goode Co. Barbecue on the front of one pair. Jim prefers the ten-inch-top boot from the 1950s, with a lot of flash and lacing.

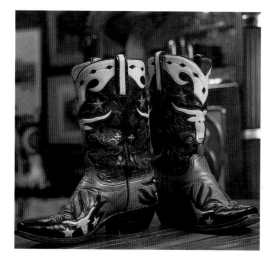

*A*lways a favorite, this boot was originally made in the 1930s by Dave Little's father, Ben. The design is as popular today as it was then. Jim Goode collection.

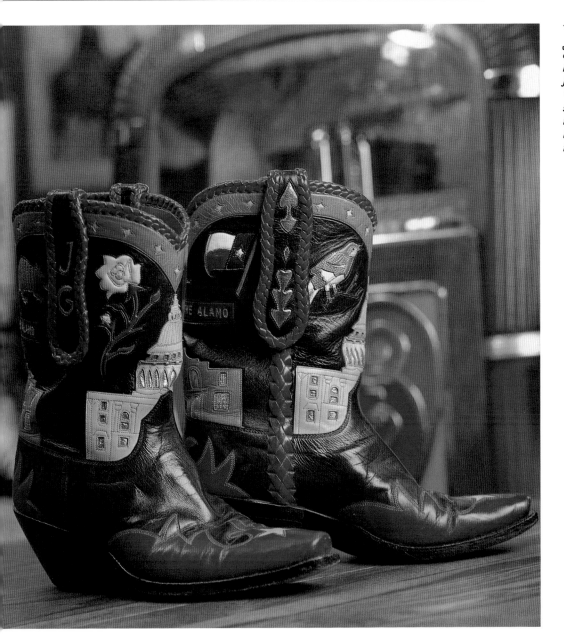

Jim designed this Texas boot and Dave Little executed it. A Texas historian and patriot, Jim had the motto "Remember the Alamo" stitched on the back of these boots above the leather inlaid replica of the mission.

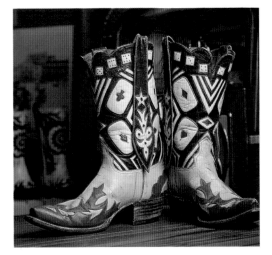

There are dozens of variations on the "playing card" boot theme. This is the best I have ever seen. The black-and-white diagonal inlay V's are very unusual. The multi-scalloped top with a collar of dice is a nice touch, and the mule-ear straps complete the picture. You could expect to pay over $1,000 for this pair from a vintage boot store. Maker unknown, Jim Goode collection.

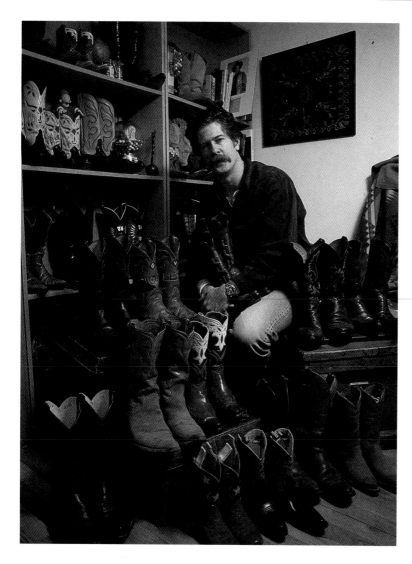

When he's not selling boots at Billy Martin's, Gary van der Meer is at home daydreaming about and designing next season's boots.

GARY VAN DER MEER

As manager of the world-famous Billy Martin's Western Classics in New York City, Gary sees a lot of boots. He is the lucky guy who gets to design all of Billy Martin's boots. He also handles custom-boot orders for customers all over the world. He chooses the leathers, stitch patterns, and inlay designs, pulling from vintage boots, old catalogs, and his own imagination.

Gary is definitely a boot maniac. Over the years he has accumulated over seventy-five pairs of boots. When Gary heard that we were doing this book and would be traveling all over Texas to interview bootmakers, he immediately canceled a vacation to Honolulu to go with us.

When the news of the Imelda Marcos collection surfaced, Gary was amazed at how one person could have so many shoes. How many shades of brown could there be? At the time he owned seven or eight pairs of boots, one pair of black penny loafers and five pairs of running shoes, and thought this was all anyone could ever want. Now, years later, even with all the boots he has, at any given time he is ordering, designing, or thinking about four or five new pairs.

Gary guesses his interest in boots started when he was a kid in Pennsylvania. He used to watch Chuck Connors of "The Rifleman" on TV. He and his brother chased each other around on the hardwood floors so much, running on the heels of their square-toed boots, that they actually wore flat areas along the sides of the heels. Gary says, "For me boots have never been a choice. There isn't any other option. My dad still yells at me every time I tell him I am ordering a new pair of boots. A lot of people just don't understand, but although I don't have a picture of Imelda Marcos on my wall, I now know the answer to the question of how many shades of brown there can be. As many as you can afford."

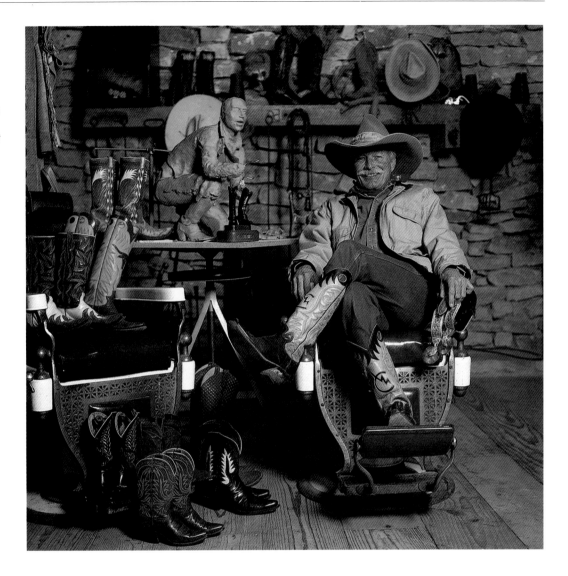

DAN COATES

Dan is a native Texan who now lives in Granbury with his wife Judy. They are gracious people who are into all things western. Dan started back in the 1950s as a rodeo announcer, like his dad, Dan Coates, Sr., before him. On the Lightning C Ranch, Dan and Judy have longhorn cattle, buffalo, a pet goat, a log cabin guesthouse, and an authentic western saloon. Every April Dan and Judy hold their rodeo reunion party on Dan Coates, Sr.'s birthday. It's a get-together for rodeo folks, young and old, famous and not so famous, who all attend to dance, socialize, exchange rodeo tales, and enjoy trick roping for halftime entertainment.

The saloon also serves as Dan's sculpting studio, where he is always at work on a new bronze or other project with a western theme. The walls of the studio are covered with cowboy gear and dozens of original rodeo photographs from Wyoming to Madison Square Garden. These photos were mainly given to Dan and his dad by their friends in the rodeo.

Dan has worn boots all his life, along with his dad, who, now in his eighties, still wears boots over his jeans right up to the kneecap, featuring colorful collars, stitch patterns and his initials. These boots have come from many makers, but retired Shorty Golden, from Belton, Texas, made some of Dan, Sr.'s wilder boots back in the fifties and sixties. Dan and Judy also have a museum-quality collection of spurs and some vintage boots to go with them. Texans just don't get any better.

Mark Hooper with a shelf of his vintage boots. Photo courtesy Mark Hooper.

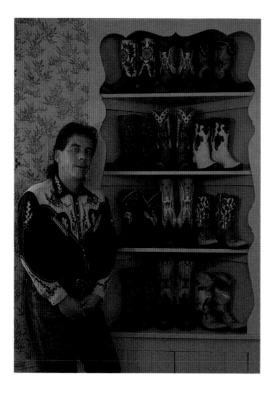

were. About two weeks later they sold, and I was filled with remorse. A few days later, I purchased my first pair of vintage boots, which also did not fit. I knew I was in deep trouble, and four years later, I was the proud owner of over a hundred pairs of vintage cowboy boots.

"After great consideration, and with the growing popularity of vintage western wear, I sold the first lot, keeping only boots with figural work. Later I sold others, along with more commercial factory boots, keeping only the models that interested me. My focus was primarily visual, my taste questionable. After all, if Imelda Marcos had a problem, at least all her shoes fit.

MARK HOOPER

"One day at a flea market," says Mark, "I saw a pair of boots with eagles—tall, black stove-pipes, given as an award by the National Indian Rodeo Association. They did not fit, and after great agony, I decided I didn't need them, no matter how great they

"My days of playing cowboy are over. I am thirty-six years old now, and it might be somewhat unseemly. I live in a city and I do not run cattle. I ride a Chevy pickup, not a horse. Yet I have discovered a way to indulge the child in me—collecting boots. My advice to a beginning collector is to act now. Already good vintage boots are disappearing. Remember, a thing of beauty is a joy to the heart; a thing of beauty by a great artist is an investment."

Two pairs of colorful peewees with fox toes and inlay and overlay work. Note the quilt stitching on the wing tip and counter fox. Mark Hooper collection.

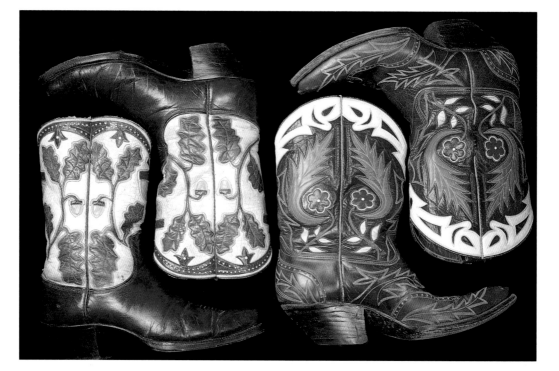

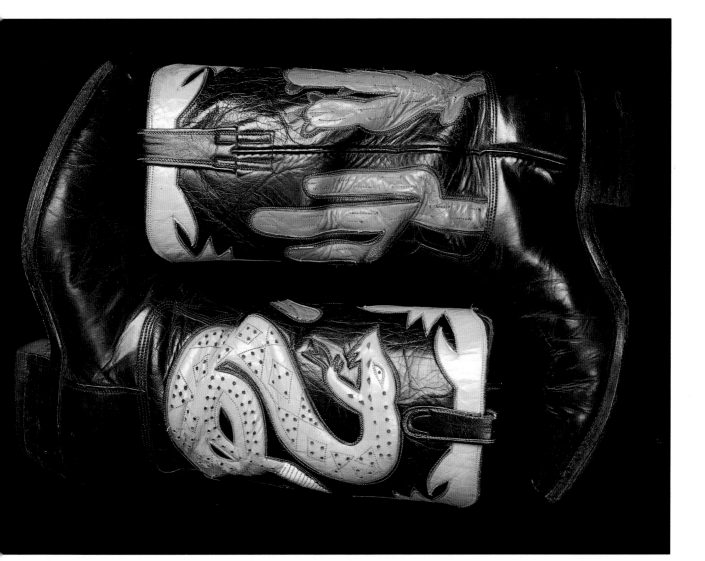

Not for the squeamish, the snake-and-cactus boot design has been around for more than sixty years. This asymmetric example is probably vintage 1950s. The snake is stuffed with cotton fluff to create a lifelike image. This boot has been heavily reproduced in the last few years. Maker unknown, Mark Hooper collection.

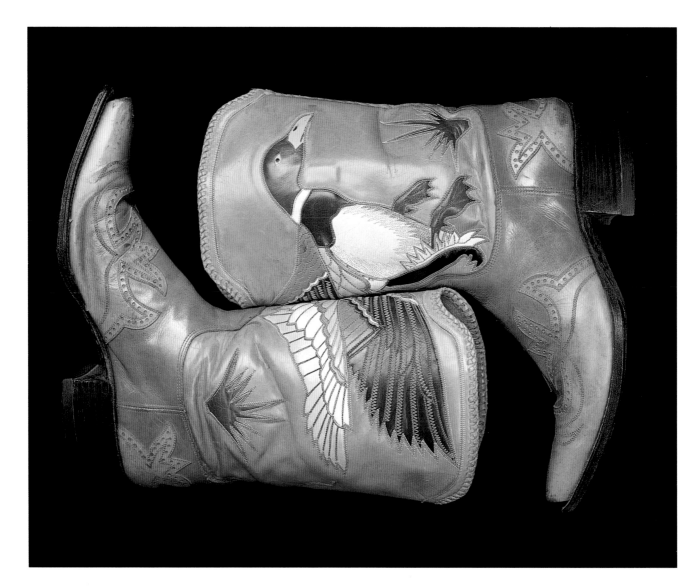

This is a one-of-a-kind you will never see again, a true folk-art pictorial boot designed with a wraparound mallard duck. One can only speculate on this boot's origins. Maker unknown, Mark Hooper collection.

A pair of vintage boots of this caliber could set you back $1,500. These one-of-a-kind, fox-toed flashy peewees from the forties or fifties show off three-dimensional flower petals in yellow and red, and a gold stovepipe top with highly unusual pull straps cut out to resemble leaves. The quilt stitching on the vamp is unusual in the way it connects over the vamp to the boot shaft and becomes part of the overall design. The 1940s-vintage embroidered rodeo shirt almost looks like it was made for those boots. Boots from the Mark Hooper collection, maker unknown. Shirt from the collection of Tyler and Teresa Beard.

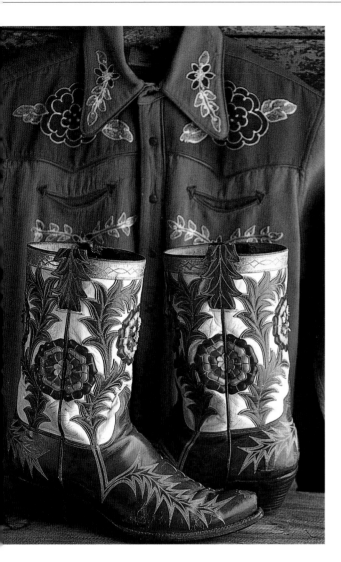

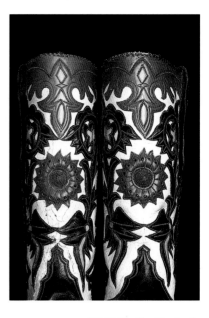

"Valley," or "border," work such as this was mastered and done most frequently by Rios Boot Company and Torres, located in Raymondville, Texas, from the 1930s to 1950s. From the Mark Hooper collection.

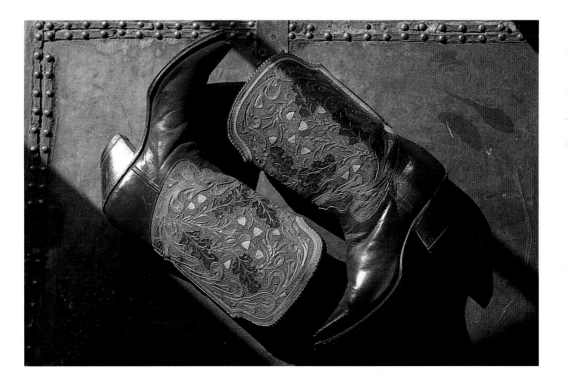

Hand-tooled and painted boot tops are currently experiencing a revival. These are an exceptional example of a bootmaker's artistry. Maker unknown, 1940–50, Mark Hooper collection.

John tends to his seventy-five pairs of custom-made and vintage boots with the watchful eye and care of a museum curator.

JOHN TONGATE

Most men in the West eventually get around to checking out the boots another man is wearing. John Tongate is no exception. The first time I met John, I turned around and noticed that he was staring at my feet. We happened to be in a vintage-boot store at the time, and have been friends ever since.

John grew up in Illinois and Ohio. The Midwest was not exactly cowboy country, but John, now fifty-one, remembers growing up in the 1940s and fifties with western movies and singing cowboys—the mythology was everywhere. His first pair of cowboy boots were part of a kid's western outfit an uncle from California sent him as a Christmas present. John later ordered his first adult pair of boots from a mail-order catalog advertised in *Western Horseman* magazine. The company was Austin Hall Boot Company.

To John boots have always been a symbol of the West. After several trips, John finally moved to Texas. He claims it was for a job, but many of us believe that it was purely to be closer to the bootmakers. That was ten years ago, and John now has over sixty pairs of custom boots, made by more than fifteen Texas bootmakers. He averages five new pairs a year, and observes, "If I live to be ninety, I will have 250 pairs of boots."

Although John loves old boots, he has fewer than ten vintage pairs. His true interest in old boots is having them copied. John says, "Boot making is the art that I support. It's my personal contribution to contemporary craftspeople."

Ramirez Boot Shop in Odessa, Texas, faithfully copied for John an old boot they had made more than forty years earlier. Colorful inlaid flowers, stems, and butterflies stand out on a cream-colored backdrop of calfskin. John Tongate collection.

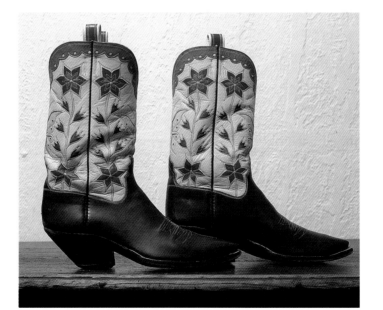

John commissioned some of the old Lucchese bootmakers (now working at San Antonio Shoe Company) to recreate this boot from an old photograph, down to the last stitch and topped off with white leather lace around the stovepipe tops.

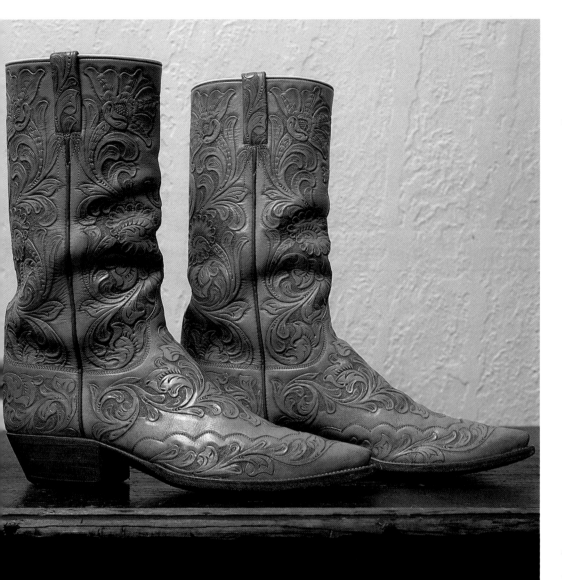

Hand-tooled natural leather darkens slightly and develops its own patina. Tooled by an old saddlemaker in San Antonio and put together by Dave Little. John Tongate collection.

Delicate swirls and curlycues with precision stitching are trademarks of James Morado of Houston. John Tongate collection.

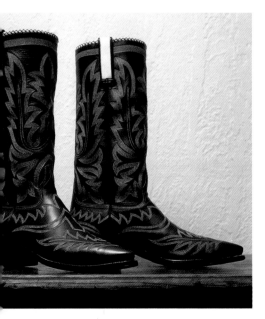

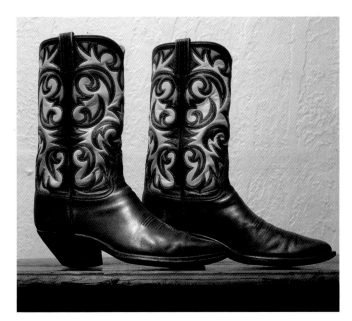

JACK PRESSLER

Jack Pressler, of Santa Fe, New Mexico, is not only a boot wearer and collector, but also deals in vintage cowboy boots. Jack was hooked when he wandered into a local used-book store five years ago just to pass some time. The 1981 *Texas Boot Book* caught his eye. This book has been the boot bible for the last twelve years and was the catalyst for Jack to hit the trail in search of old cowboy boots. He began buying up all the old boots he could find. At that time there was very little interest in old, used cowboy boots, and Jack remembers buying two pairs of decent boots at one garage sale for ten cents a pair.

Not long after, he started shipping boxes full of boots to shops in Los Angeles when vintage cowboy boots became popular with the movie crowd. This arrangement continued until boots hit big locally, when he started selling out of his own home. People who were flying into Santa Fe to vacation would call him from all over the country. They wanted to come try on boots, and buy what fit. Now Jack concentrates on keeping local shops, as well as out-of-state ones, supplied with as many vintage boots as he can find.

Not all old boots are good, in Jack's opinion. He is most interested in the fancy, flashy, colorful styles that were popular from the 1930s through the 1950s. These have intricate inlays and overlays of different colored leathers in shapes from stars, steer heads, moons and lightning bolts, to butterflies, arrows, flames and cactus.

Searching for boots has put Jack on the road, logging many miles through the western states. When he comes across a pair of extra-special boots, he hangs onto them, and his collection now numbers over thirty. Naturally he has gotten to know kindred spirits. They share stories of their latest editions, and exchange photos and information about early bootmakers. They even do a little trading now and then. Jack recently sold two pairs out of his collection to another collector. He knows the guy, who doesn't live far away, so he can go visit his boots whenever he wants. He has never really liked much new stuff.

Recently Jack, who does colorful paintings that incorporate boots, has collaborated on two or three pairs of boots with Rocketbuster Boots of El Paso, Texas. Jack takes elements of old boots and adds some of his new ideas, then paints them. Rocketbuster then copies Jack's boots from his paintings and features them in its catalog. This gives him some involvement in the design and making of a new boot that will someday be collected as a vintage boot by someone like himself.

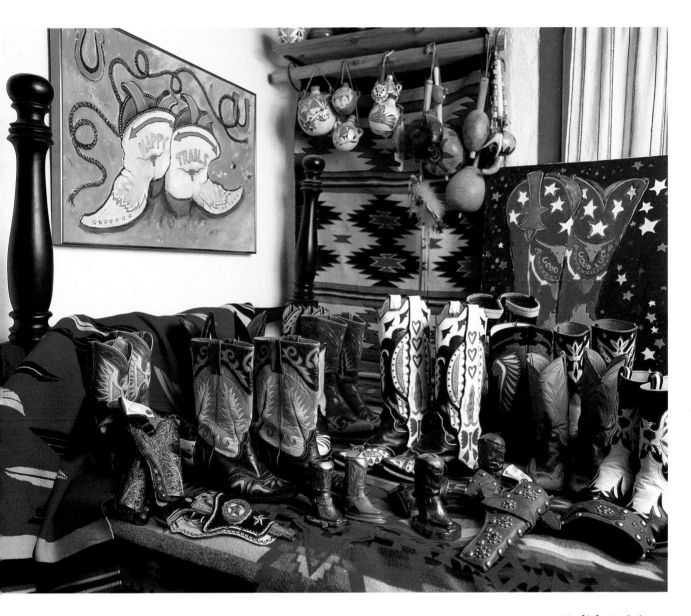

*J*ack's boot paintings, along with a portion of his ever-changing collection of vintage boots.

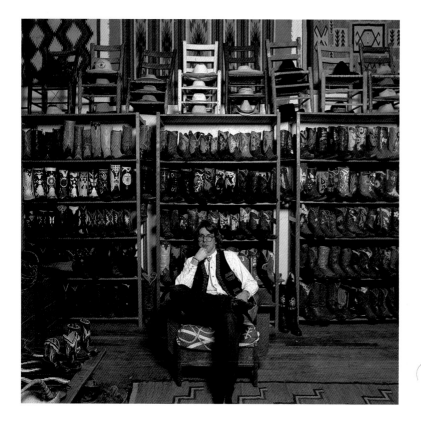

*Evan Voyles, boot
fanatic and
historian, with his wall
of boots.*

EVAN VOYLES

"I started buying vintage boots strictly to wear ten years ago," says Voyles, "when my old pointy-toe ranch boots finally fell apart and I couldn't find any new boots like them, nor afford custom-made. Then about seven years ago, I went out on the road to search for stories, images, heritage, adventure and folk art, but I got sidetracked by vintage cowboy boots. The very day I returned to Texas, I bought a pair of boots that were both too flashy and too small to actually wear. At the moment of that purchase, I think my obsession for collecting boots was born. I found in boots craftsmanship, visual appeal and strength of design. They were clearly folk art and I immediately became intrigued with finding who made them. If the boots were folk art, then the heritage, stories and images were out there somewhere, and the adventure lay in going out to find those boots and the people who made and wore them.

"From that point on, vintage cowboy boots took over my life. As I learned more about how boots are made, I developed a deep respect for bootmakers. As my collection grew, I became, as most addicts do, a dealer in order to finance my habit, selling factory-made vintage boots so that I could buy more handmade vintage boots for my collection. My collection now numbers over 250 pairs, including virtually every style and design produced in and around Texas between the late 1930s and the 1960s."

Another example of a valley or border boot, referring to the Mexican border where dozens of bootmakers have been working for more than sixty years. A hair-on bull pictorial, laced side seams, and flowers were frequent design elements from this period. Evan Voyles collection.

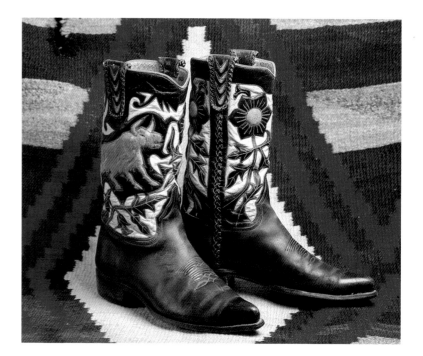

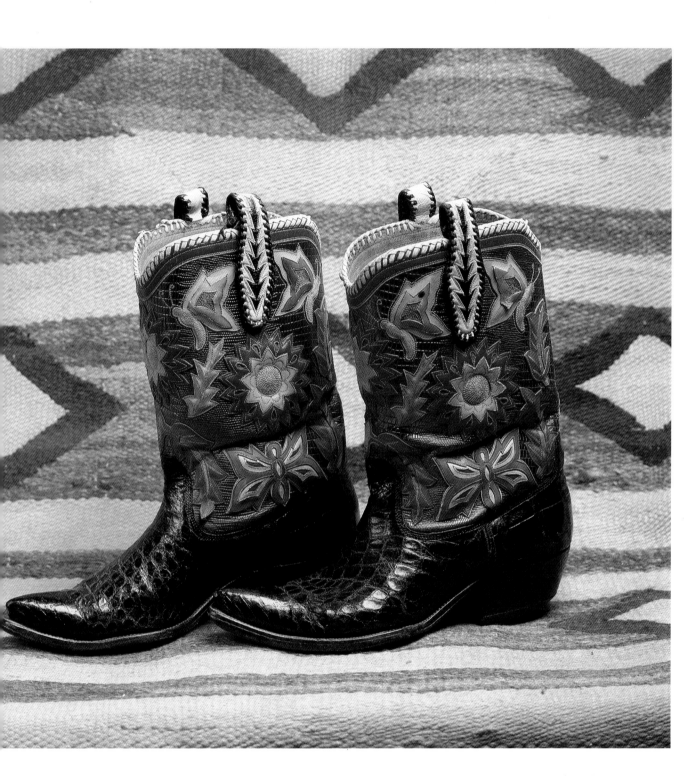

The tops were made by Rios Boot Company in Raymondville, Texas, probably in the 1950s. There are five layers of inlaid & overlaid leather in areas. The foot was replaced with alligator at a later date. You could expect to pay $800-1,000 for this boot. Evan Voyles collection.

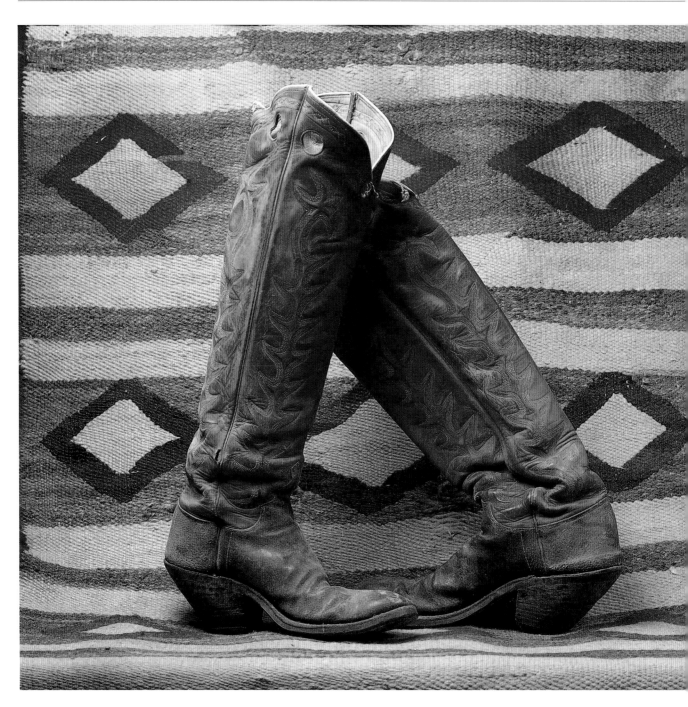

Knee-high working-cowboy boot, 1970s, has a twenty-inch top, underslung heel with "windows." Maker unknown, Evan Voyles collection.

Fully pegged-bottom boots, possibly by Hyer Boot Company, Olathe, Kansas. These were found in an abandoned Butterfield Stagecoach station. The groove worn into the sole of one boot likely resulted from constant contact with the brake pedal on a stagecoach. Boots of this style were made from the 1880s until roughly 1920. Evan Voyles collection.

This 1950–60 black-and-white boot has mule ears with fringe down to the ground, laced stovepipe tops with foxing on the foot and heel. This style of Texas "Rio Grand Valley" boot, whose origins certainly came north with Mexican bootmakers, is currently experiencing a revival. Evan Voyles collection.

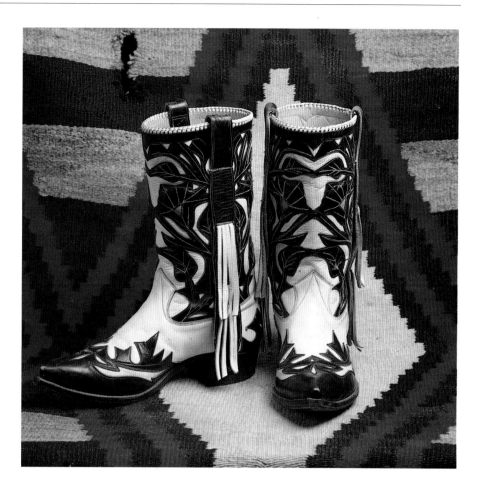

A fine example of a three-quarter box toe with a fanciful overlay eagle design in multi-colored stitching. Rios Boot Company, Raymondville, Texas, 1950s. Evan Voyles collection.

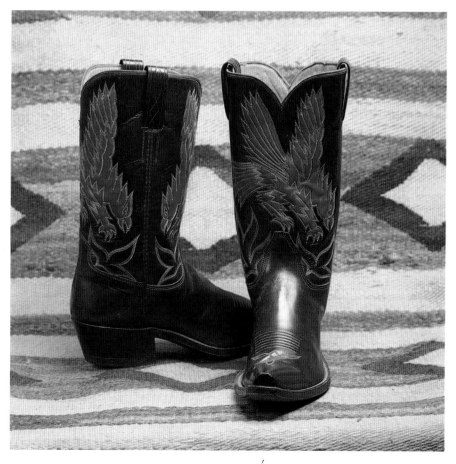

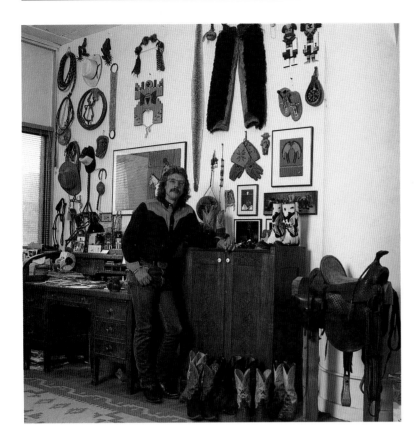

*J*im Arndt in his
Minneapolis office,
surrounded by cowboy
and Indian collectibles.
Jim is frequently
recruited by advertising
agencies to photograph
subjects requiring his
personal knowledge of
western artifacts and
cowboy boots.

JIM ARNDT

*J*im has been wearing cowboy boots and
working as a photographer in Minnesota
for the past twenty years. His first pair of
boots was given to him on a Christmas trip to
Boulder, Colorado, when he was five by his
uncle. In 1967 Jim bought his next pair. They
were rough-outs from a saddle shop in
Minnesota. Through a mail-order catalog
from Austin Hall Boot Company in El Paso,

Texas, Jim acquired five new pairs. This first
custom boot was a peewee, with a black calf
vamp, red top, black scallop and the initial
"A" branded on the front. While on a job in
Portland, Oregon, he spotted some wooden
lasts hanging in the window of a boot-repair
shop. He wandered in and met Bill Crary,
who has now made more than nine pairs of
boots for Jim. All of these have Jim's business
logo on the front, which is a flying A with
two bars. Jim says he would probably order
boots from every bootmaker in Texas if he
had the time.

His favorite pair changes from month to
month, but in a fire, he would probably grab
his 1940 Olsen-Stelzers. The other makers
are still alive, Jim points out. Cowboy boots
keep Jim in touch with his love of the cow-
boy and the West. As a kid, he always
wanted to be in the West, but he sighs,
"Somehow I got stuck in the Midwest." His
love of boots and their makers has spilled
over into his business, where he has pho-
tographed boots for Billy Martin's greeting
cards in New York City, and rounded up the
boots for the DeKyper Cactus Juice ad,
which showed more than twenty-five vintage
and custom models lined up toe to heel.
Finally Jim shot 95 percent of the pho-
tographs for *The Cowboy Boot Book*. He
wears boots every single day on the job or
just kicking around.

*M*ore of Jim's
collection.

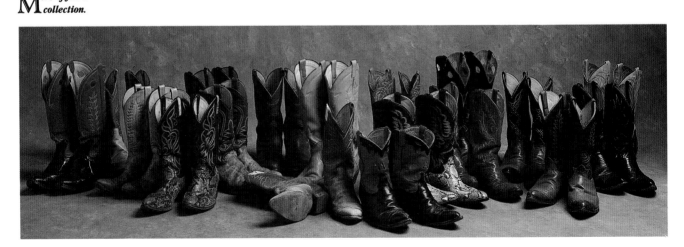

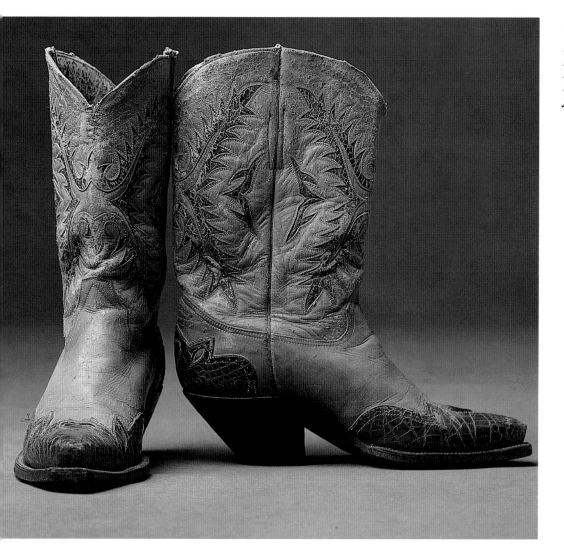

Some cowgirl danced a million miles in these "old yeller" boots. Even in unwearable condition, vintage boots can be worth $150 -200. Jim Arndt collection.

This is just part of Jim's boot wardrobe that bears his flying "A" business logo. Jim likes a tough, working-style cowboy boot with all the flash and dash up top.

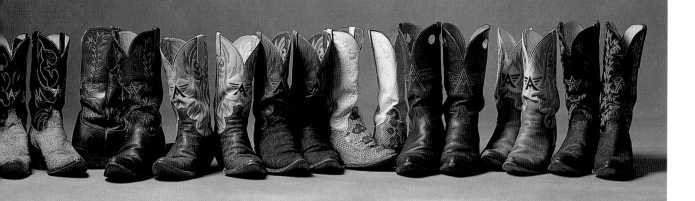

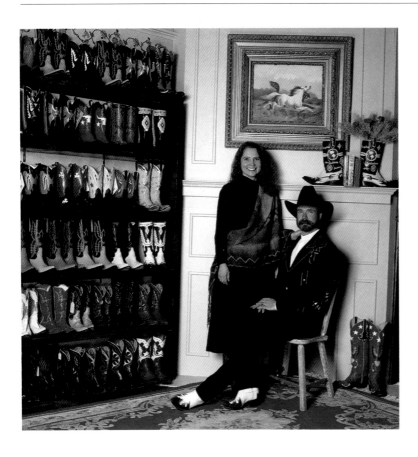

RON AND LINDA LINTON

In 1953 Ron's dad, Donald George Linton, was regional sales manager for Oldsmobile in Texas. Donald designed the now-legendary Oldsmobile boots, a black-and-white pair with Oldsmobile model names, symbols and logos inlaid all over their tops. There is a good possibility that seeing his dad wear these boots had a lasting impact on Ron because he and his wife Linda have always loved fine cowboy boots. Linda chose to wear a pair of boots under her gown at their wedding, and Ron wore the Oldsmobile boots.

In 1990 Ron and Linda Linton opened a retail store called P. T. Crow Trading Company in Albuquerque, New Mexico. When they first started, they sold a variety of Indian crafts and southwestern items. They also had a small collection of some of the original Rocketbuster boots in their windows and a 1948 DeSoto parked outside to attract attention. The store was primarily used to display their own jewelry for wholesale and retail customers. Within a couple of months, however, the store had evolved into a specialty shop featuring handmade and vintage boots, which they acquired from their travels and vintage-boot collectors and dealers. The store now contains the most diverse collection of Rocketbuster boots in the country, thanks to the Lintons' close connection with the owners.

Many customers come in and want to mix and match colors, and perhaps combine the top of one boot with the bottom of another. This is fine with Ron and Linda. Nocona Boot Company of Nocona, Texas, has been bringing out some of the company's original classic designs and producing small quantities of vintage-style boots from the forties and fifties, and P. T. Crow can select personalized colors and style combinations. Rios of Mercedes, a specialty boot company in Mercedes, Texas, also supplies P. T. Crow. So besides designing new jewelry for the store, Ron and Linda now spend a lot of time designing boots for customers and themselves.

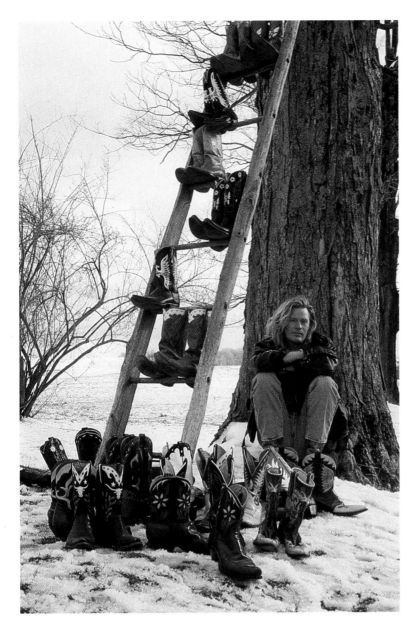

DARYL HALL

Daryl is the Hall in Hall and Oates, a rock-and-roll legend. He is also a boot wearer and collector. He remembers wearing his first pair of boots at age three. His grandfather was a sculptor and carver, so as a child, Daryl learned to appreciate fine workmanship and artistic ability. In the 1960s he began wearing cowboy boots, which were all off the rack at first. Then in 1983, after he saw the *Texas Boot Book,* his tour manager arranged for layover time at all concert stops in Texas so that Daryl could order custom boots. Charlie Dunn made his first pair, which was a copy of some boots Gene Autry had made in 1938. Then the Wheelers in Houston and Dave Little in San Antonio made pairs for Daryl and his girlfriend. Most of Daryl's boots are copies of vintage boots featured in the *Texas Boot Book.*

Daryl now estimates his boot collection at around seventy-five pairs. For a while he only wanted custom boots, but now he has begun to collect vintage pairs—but only if they fit, he insists. Most of his boots reveal great artistry in design and construction. Daryl says the appeal of cowboy boots, for him, is their fine craftsmanship and the fact that boots can be as personal as you like, but still functional.

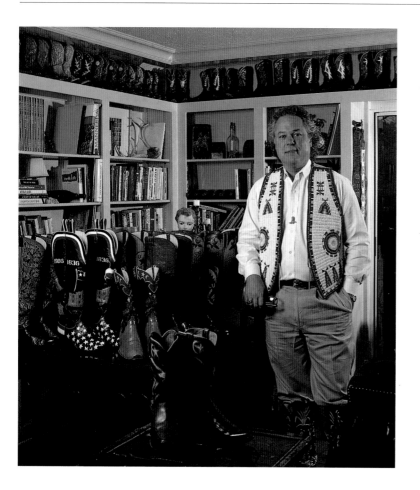

HARRY HUDSON

Harry remembers picking out his first pair of cowboy boots in 1961. His second pair was hand made by Eugene Lopez, who is now the shop foreman at Rusty Franklin Boot Company in San Angelo, Texas. Harry now owns more than thirty pairs of custom boots, all made by Eugene at Rusty's or by Lucchese Boot Company.

About 1975 Harry also began to accumulate vintage boots, along with his sizable Wild West collection of cowboy artifacts and memorabilia. Today Harry has over sixty pairs, most of which are lined up on a built-in, backlit shelf that completely encircles his living room. But there are boots all over the house—every crevice, cubbyhole, even the dining-room table is covered with boots.

Among his treasures is a group of boots made in the 1940s, fifties and sixties for a well-known Dallas rancher, oilman and lawyer. This guy only wore the best. The boots all bear his initials and were made by Lucchese in San Antonio, Texas.

In 1984 Harry's wife Susan suggested that a restless Harry open a small shop in Dallas to carry the same sort of merchandise that he loved to trade in. Two Moons Trading Company specializes in Wild West-style items, says manager and sole employee Gloria Turner, who has been with Harry since the beginning. Two Moons carries old and new boots, buckle sets, belts, chaps, saddles, spurs, western artifacts and memorabilia. If Harry has not got it, he will have it custom-made.

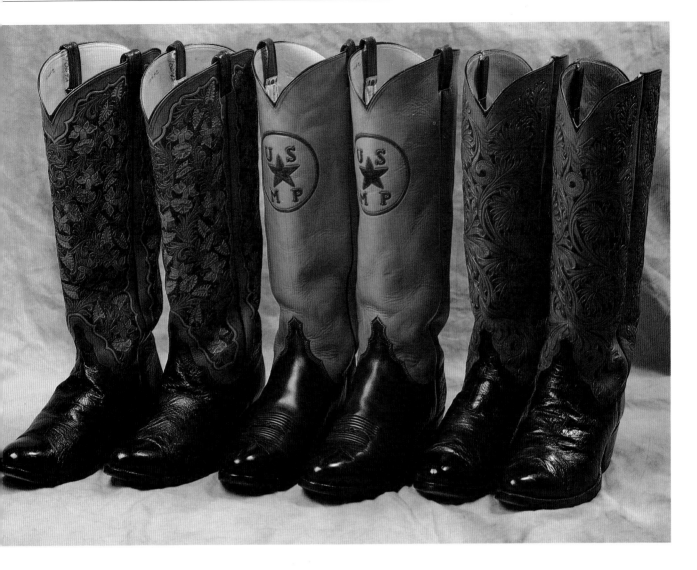

*T*hree beautiful
examples of tall-top,
hand-tooled boots. Harry
Hudson collection.

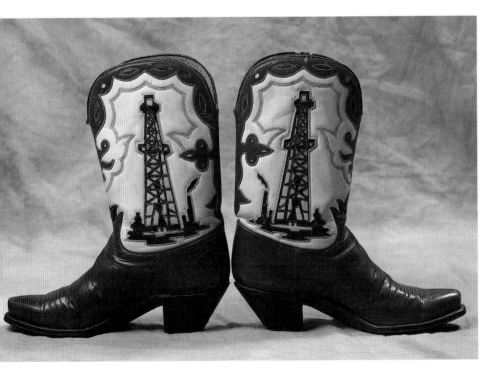

*O*ne of the most
sought-after
vintage boots would be
this 1940s Olsen-Stelzer
derrick boot, valued at
$1,000. Harry Hudson
collection.

GALLERY OF "KILLER" BOOTS

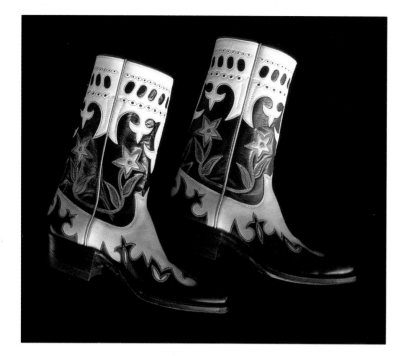

*S*uperb example of a 1930–40 classic Olsen-Stelzer lace-collar inlay and overlay boot. Tyler and Teresa Beard collection.

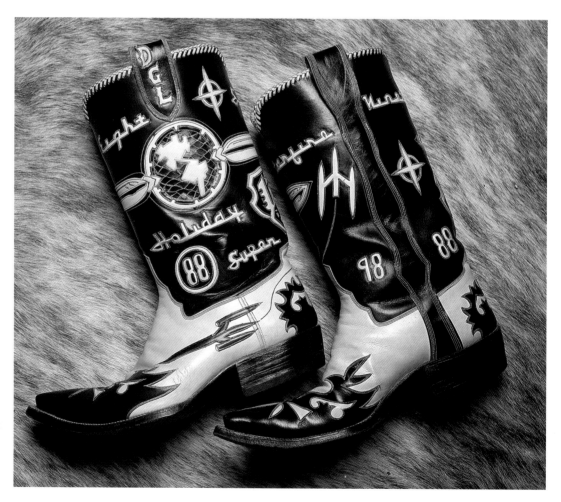

*D*onald Linton, regional sales manager for Oldsmobile in Texas, designed these wonderful boots for himself. Maker unknown. Ron Linton collection.

A "killer" pair of stovepipe
overlay, fifteen-inch,
yellow/black boots with sharp toe
and decorative variegated stitch.
Maker unknown. Tyler and Teresa
Beard collection.

"Flame" boots designed by John Oates (Hall & Oates), executed by Dave Little in 1983.

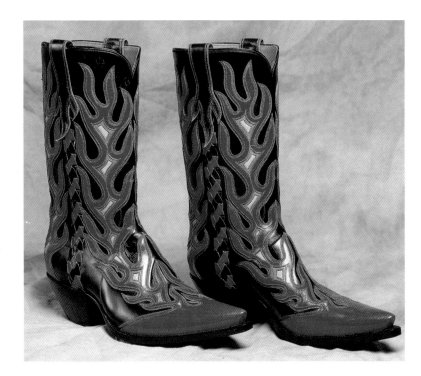

Seven heavenly wild toes by Dave Little. The center boot is stitched. The remainder are very ornate wing tips.

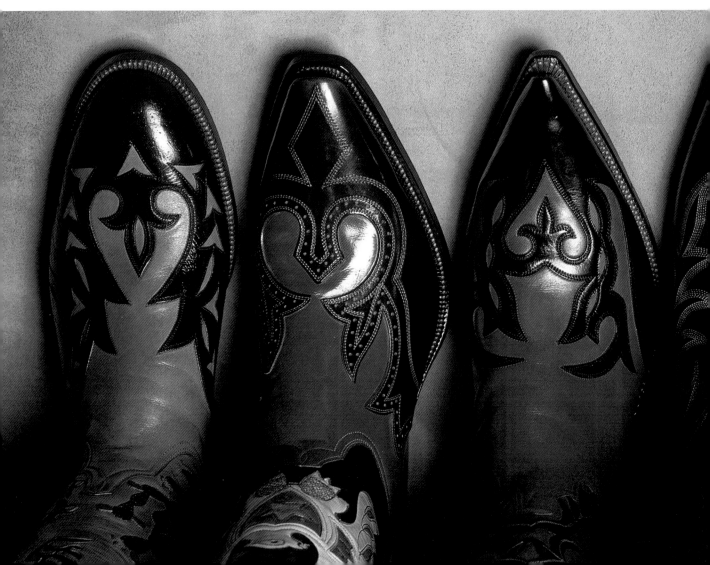

One-of-a-kind saddle boots with blue foxed heels, mule ears, buck lacing around the tops, inlaid and overlaid saddle on the sides and a horse head on the fronts. Maker unknown, 1950s–60s. Courtesy of The Corner Store, Minneapolis, MN

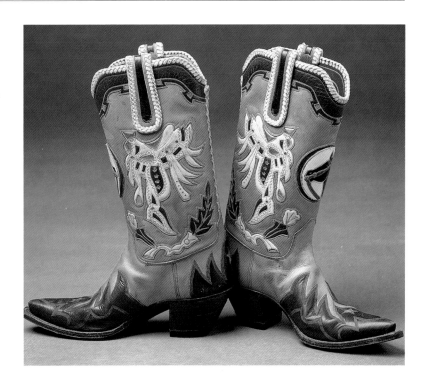

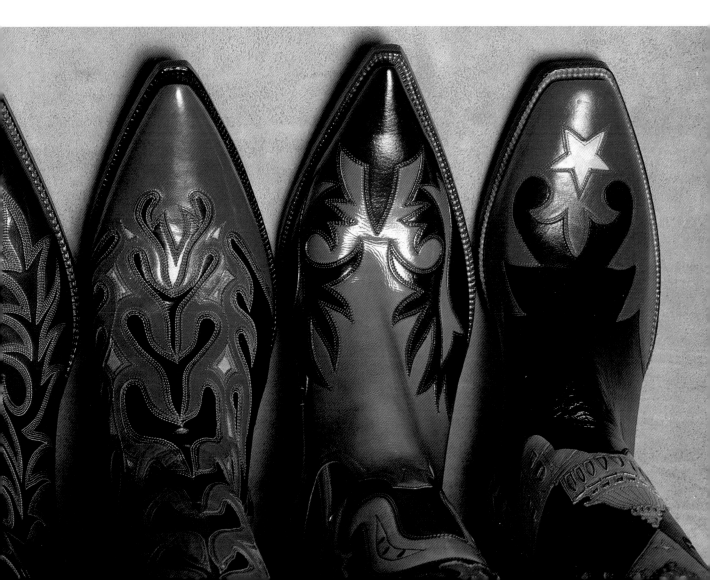

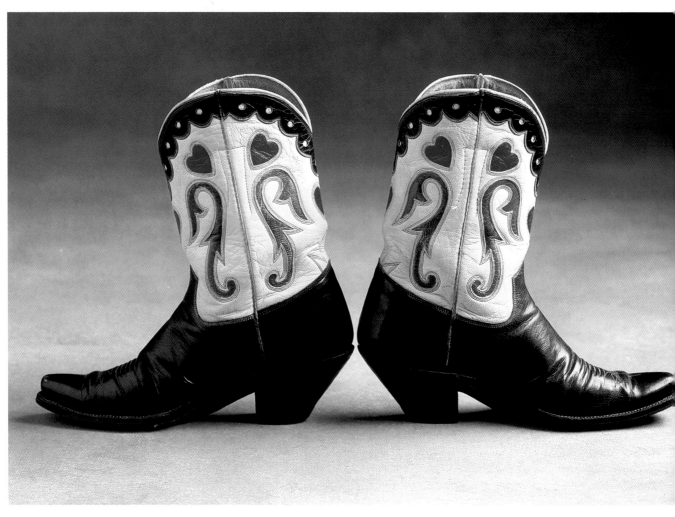

O lsen-Stelzer, 1940s.
Jim Arndt collection.

H and-tooled and tinted
peewee boots, c. 1930–40,
with a cowboy on a bull and
flowered designs on the reverse
of each boot show this unknown
bootmaker's artistic flair. Tyler
and Teresa Beard collection.

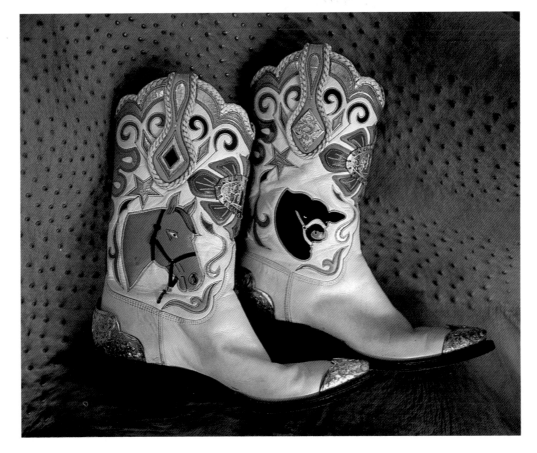

T his 1960s rodeo boot is
not for the timid. Maker
unknown. Private collection.

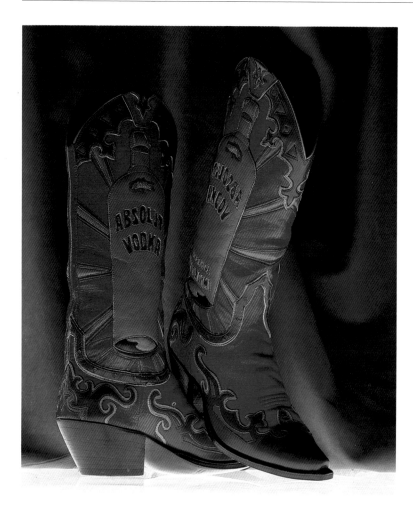

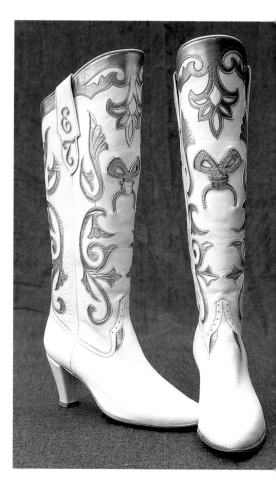

One of the four amazing pairs of boots made by Dave Little for Absolut Vodka's national advertising, 1992. Designed by Joyce Michel and Danna Cullen, New York City. Photo by William Taufic, NYC.

Elizabeth Taylor was the recipient of these wedding boots from Dillard's Department Store chain headquartered in Houston, Texas. They were given in honor of the release of her White Diamonds perfume and were constructed by Houston bootmaker Rocky Carroll, with the assistance of jeweler Barbara Noelle, who applied the 8.09 carats of diamonds to the white calf boots with gold filagree trim and "E.T." inlaid on the pull straps. Dolly Parton saw these and ordered a pair just like them—minus the diamonds.

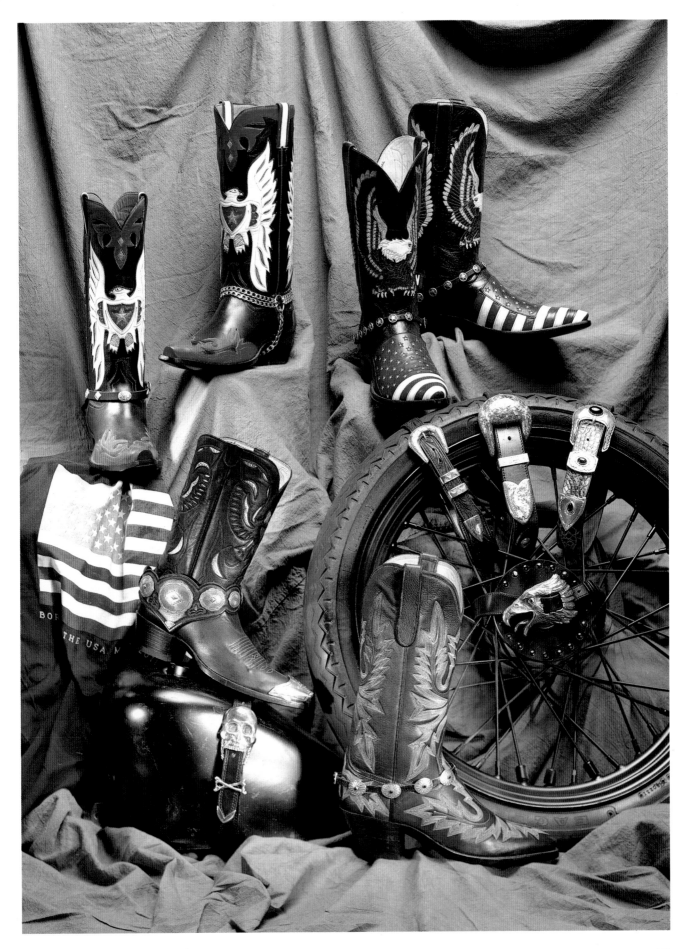

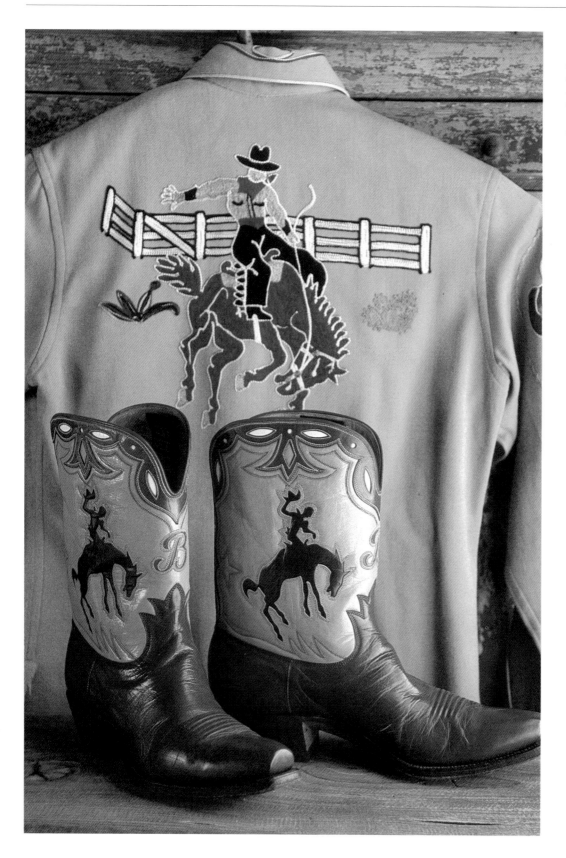

Nocona Boot Company first introduced the shoe boot in the 1930s to allow square dancers more flexibility of the ankle. They stopped production in 1984. Then in 1987 Guess Jeans was shooting an ad campaign in Big Spring, Texas, when they found several old pairs in a western-wear store. Guess used the shoe boots in the ad and was bombarded with phone calls wanting to know where shoe boots could be purchased. This interest prompted Nocona to reintroduce shoe boots to their line. In 1991 Nocona sold tens of thousands of shoe boots for men and women in calf, elk, lizard, and ostrich. Boots and shoe boots in this photo are courtesy of Billy Martin's, New York City. Photo by Studio 7, Albuquerque.

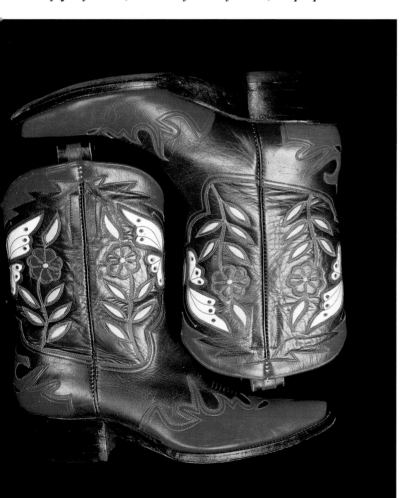

This style was abundant in the 1950s–60s in the border towns of Mexico and cost about $25.00. Tyler and Teresa Beard collection.

Famed American artist Amado Peña collects boots. He got his first pair of boots at age six and his first horse at ten. He has worn boots all his life and now prefers custom-made boots by Paul Bond. Amado and his wife, J. Boles Peña, maintain a ranch in Santa Fe, where they raise quarter horses and new paint foals and house their stable of over 100 pairs of boots.

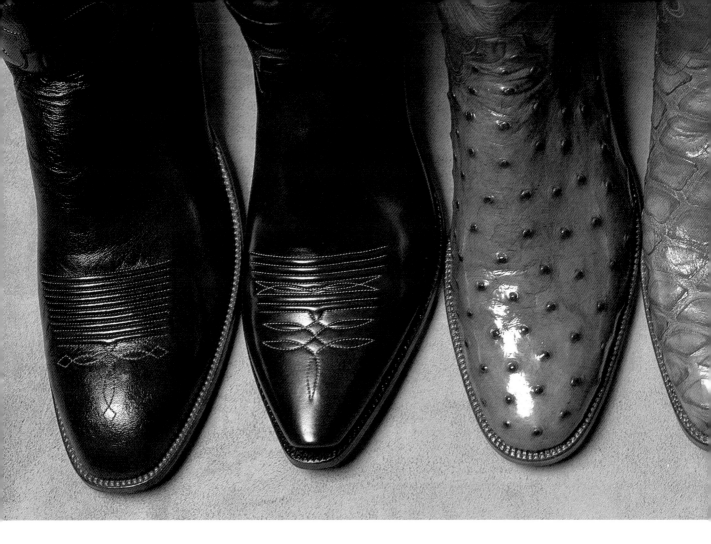

Pick your conservative toe from these six by Dave Little. The bumpy ones are ostrich; the ones in the center with diamond-shape scales are anteater. Sharp, box, "J" toe, "U" toe and French toe are shown here.

The money tree boot designed and made by Charlie Dunn and Lee Miller in 1984 for a Dallas attorney. These are all solid gold coins; the large ones are Krugerrands. Photo by Ron Dorsey, Austin, Texas.

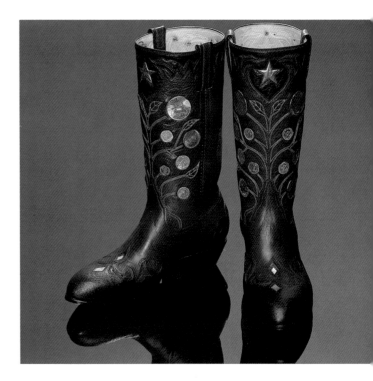

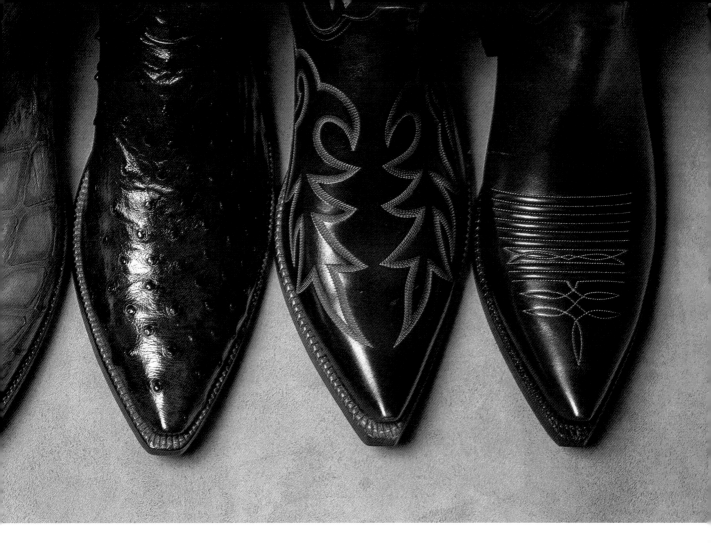

A classic boot by Ray Jones, recognized by Texans and collectors around the world as the maker of the most rugged cowboy boots. When Ray retired in 1977, he said he would make up his four years of back orders, but no more. One of his assistants, Pablo Jass, still makes the Jones style boot in Lampasas, Texas. Boots courtesy of Alan Bell.

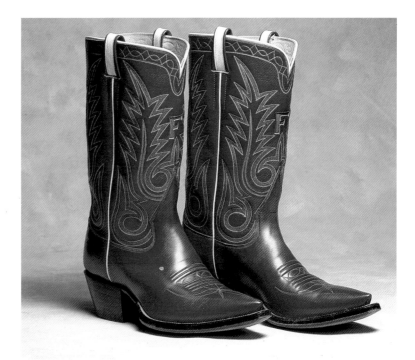

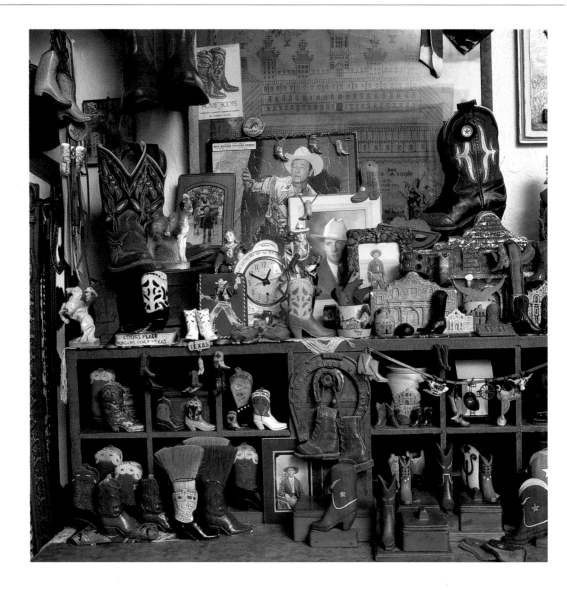

Collector John Tongate's bedroom "boot altar."

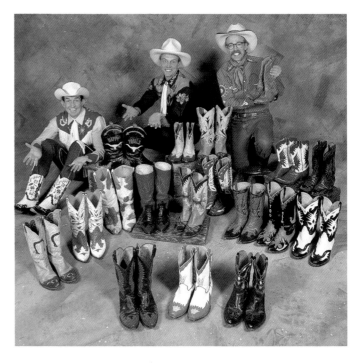

Members of the western entertainment group "Riders in the Sky"— stars of stage, TV, and radio—own some of the most colorful new boots around. The boots are gathered from a variety of makers, including Austin-Hall and Rocketbuster in El Paso, David Weaver in Houston, and Manuel in Nashville. Riders in the Sky pull the whole western look together with great-looking shirts and artistic gloves and ties. Photo courtesy Riders in the Sky.

Native Frenchman Michel Roux, president and C.E.O. of Absolut Vodka and patron for over three hundred artists and designers who have worked for Absolut, with Joyce Michel, designer of the Absolut cowboy boots. The first commission was a painting of an Absolut bottle by Andy Warhol in 1985. Absolut is the leading importer of Vodka, gleaning 59 percent of the $500-million dollar retail market.

George Strait, country-western superstar, wears a pair of his own signature endorsement boots made by Tony Lama.

Marty Stuart sitting on Nudie's Cadillac wearing Manuel rhinestone-studded jacket with drop-dead stage boots by Bo Riddle. Photo by Randee St. Nicholas.

WESTERN STORES

Basic black boot with concho ankle belt at Falconhead in Brentwood, California. Photo by Studio 7, Albuquerque.

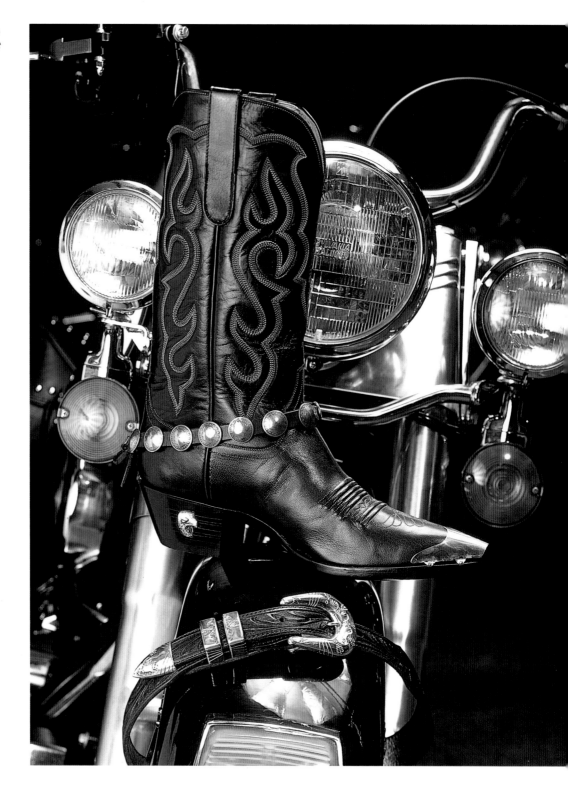

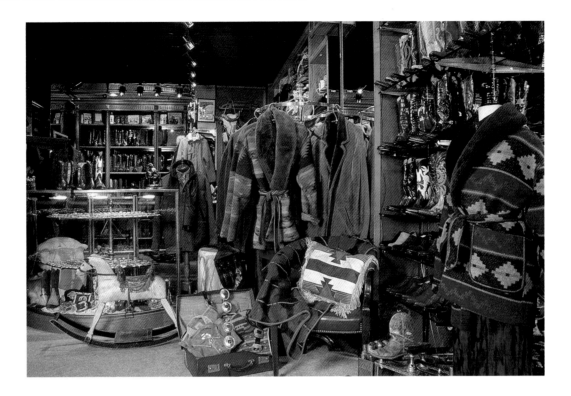

Billy Martin's in New York City. Photo by Susan Unger.

There are thousands of western-wear and boot stores all over the West from Nashville to Los Angeles. Huge chain stores in Texas and other western states, such as Shepler's, Cavender's Boot City, Boot Town, Just Justin, Thieves Market, and Wild Bill's are the supermarkets of western wear. These stores specialize in western attire and carry name-brand boots—Justin, Nocona, Tony Lama and Lucchese.

A few stores have taken western wear one step further by offering new merchandise in one-of-a-kind designs from small bootmakers as well as limited editions from the factories. These stores decorate with a random marriage of Old West meets New West and exude an air of Buffalo Bill meets John Wayne. Bring a stash of gold dust—these are upscale, uptown, high-toned dry-goods establishments.

Another brand of western store has popped up in the last ten years. Most started as antique stores, or vintage-clothing emporiums, but now cater to a clientele of devoted western-clothing and boot enthusiasts. They feature custom and factory boots made from 1920 to the early 1970s. One-hundred-percent cotton, pearl-snap western shirts, and fancy embroidered rodeo suits in gabardine and rayon from the likes of H Bar C, the legendary Nudie, and Ben the Rodeo Tailor hang on the walls like precious works of art. Prices of these gems range from three hundred to three thousand dollars. Old faded 501s, Lee and Levi's jackets, western ties with brands or horse silhouettes, bolos, 1960s rodeo buckles on well-worn, tooled name belts with "Bubba" or "Charlene" on the backs, leather-fringe and buckskin-suede coats, authentic sweat-stained cowboy hats, chaps, spurs, and western jewelry are also found in these stores. On the way out, you may be able to pick up a genuine 1958 cowgirl feed-store calendar, a 1940s copper-horse lamp, a stagecoach penny bank, or an entire set of the now highly collectible Wallace "Rodeo Pattern" dinnerware.

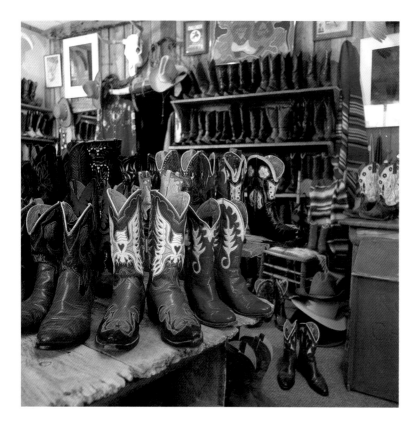

Back at the Ranch in Santa Fe. Wendy Lane, owner, sells vintage boots and one-of-a-kind custom boots in Santa Fe, New Mexico. Photo by Studio 7, Albuquerque.

KATY K

Katy personifies Dale Evans, Patsy Cline and Miss Kitty all rolled into one. She bought her first cowgirl suit from Ben the Rodeo Tailor years ago. Ben no longer outfits Gene Autry and other stars, but Katy does. Working from her New York studio and workshop, she uses her knowledge of vintage western wear to create embroidered facsimiles of shirts, skirts, and jackets. For twelve years her Katy K designs have been shipped all over the world, as well as being featured in her New York City showroom. Katy also keeps a selection of new and vintage boots on hand to complete her customers' ensembles.

FALCONHEAD

Scott Wayne Emmerich is the owner of Falconhead, located in Brentwood, California, and the principal designer of everything sold in the store. As a collector of boots, belts, and buckles, Scott blends his knowledge with the skill of his craftspeople, who share his passion for all things unique and artful. Falconhead also sells limited designs of Indian jewelry, concha belts, leather clothing and much more. The finest cowboy hats in California, creased and finished with a hand-tooled leather hatband and trimmed in silver and gold, are found here. Custom orders are welcome in anything leather, silver or gold. According to Scott, "There is no greater feeling than wearing boots, a custom belt or a buckle that you personally had a hand in designing."

So if you are going on vacation to California and you've got ten grand to spend on new western duds and you feel like you need a beaver-cashmere-chinchilla-blended-fur cowboy hat, one will set you back $5,000 at Falconhead. Ah, go on, you've had your eye on those $4,750 baby-alligator boots, and that still leaves you with enough for a hand-tooled belt. But unless you've got a charge card, you'll have to have the buckle sent!

BILLY MARTIN'S WESTERN CLASSICS

Billy Martin's Western Classics opened in 1978 on Madison Avenue in New York City and is owned by Doug Newton, who was once Martin's personal manager. The store is really a class act and attracts locals, out-of-towners, tourists from Europe and Japan, rock stars and movie stars. Billy Martin's has a beautiful, full-color catalog filled with boots, their most popular merchandise item. They also stock old Indian pawn jewelry, hundreds of belts, buckles, and a huge selection of chambray, denim, cotton, and leather clothing for men, women and children. There is a touch of the great American West in everything that Billy Martin's sells. Most of the inventory has been custom-designed by Doug and head wranglers Colette Neyrey-Morgan, Gary van der Meer, and Carroll Watts. Recently Billy Martin's knocked out an inside wall and gobbled up the space next door, tripling its size. This is an indication that western wear is here to stay—even in New York City.

Rancho Loco

Ralph Wildman and Sharon Goldberg first started offering "biker cowboy" gear to Londoners in 1983 with British partner Vicki Wertheimer. After two years they returned to Texas to develop a line of boots heavy on spiderwebs, eagles, hearts, playing cards and skulls. Most of these boots were black, white, red and turquoise inlays in assorted color combinations. Spurs, chains and black leather completed their punk western look. In 1986 they opened the stateside Rancho Loco in Dallas, Texas. Their fifties retro-rockabilly cowboy look has really caught on all over the country. They also wholesale boots, clothing, spurs, assorted leather items, fringe jackets, and the largest selection of silver toe-and-heel tips in the country. They take catalog orders from all over the world.

Back at the Ranch

Wendy Lane worked for years in women's ready-to-wear in New York City, but like so many before her, she visited Santa Fe and fell in love with the city, the light and the people. She decided to open Back at the Ranch there. Although locals shop at the store, Wendy caters to the tourist trade. She sells used cowboy boots for that "I belong here" look, faded jeans, denim shirts, western belts and buckles, and hats, varying in condition from very salty to nearly new. Wendy also has a Texas bootmaker who supplies her with custom boots. Although any style can be ordered, she prefers the nine- and ten-inch-tall peewees of the 1940s and fifties with delicate inlays, colorful stitch patterns, and narrow, square box toes. Customers are encouraged to help design their own boots. Wendy has sample boots in stock lasts to ensure fit. She also designs Beacon-blanket and serape vests for men and women, western blouses, and men's shirts, some displaying cowboy fabrics, lace, and linen yokes and applications. There's plenty of western kitsch here.

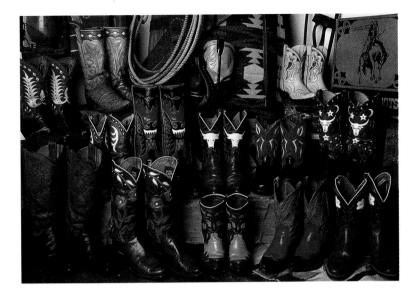

Texas

A native of Toronto, Canada, Eddy Liptrott has always been attracted to American western culture. Eddy started out by decorating his apartment western and purchasing western merchandise for friends and stores in Canada hungry for the American West, then decided to open his own store called Texas, which sells used boots, new lizard shoe boots, blankets, used 501s and Levi's jackets, vintage western wear, and everything else that suggests cowboys and Indians. He also designs coats, leather jackets and some new boots. Eddy has a fine collection of vintage peewee boots which he will not part with. "That's my only problem. I like everything so much I just hate to sell any of it," he says.

T. P. Saddleblanket

Tucked in the Berkshire Mountains resort area of Massachusetts are two stores owned and operated by Tasha and Jack Polizzi. The shops are actually little specialty department stores focused on the weekend lifestyle and featuring a mixture of cowboy, Indian, Adirondack, and Americana. As manufacturers of many of their own products, Jack and Tasha enjoy designing the new and searching for the old. The stores carry furniture, men's and women's apparel, home

An impressive collection of boots from a store called Texas, in Toronto, Canada.

145

furnishings, blanket coats, cowboy and Indian jewelry, and one of the largest selections of new and used cowboy boots in the East. A third store is due to open in Vermont.

MARK FOX

Mark Fox stumbled into the vintage boot business totally by accident; he was originally a musician. In 1988 he decided to open a store of his own in the Melrose district of Los Angeles and spent the next six months traveling all over the West to collect over one thousand pairs of vintage boots. Fox caters to the Hollywood crowd—actors, musicians, and the wealthy. European and Japanese tourists also flock to his store. There are always at least five hundred pairs of vintage boots to choose from, along with leather jackets, 501s, flight jackets, vintage Lee, Levi's and Wrangler jeans and denim

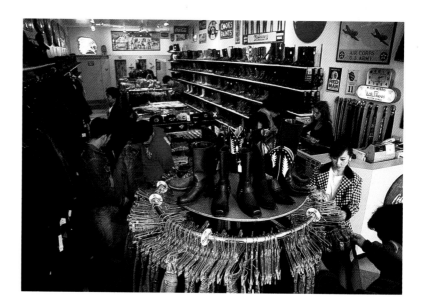

jackets, some vintage western shirts, plenty of new and used Indian and cowboy jewelry, buckle sets and belts. Mark is a true boot fanatic and connoisseur. He says, "Boots are a symbol of freedom. They inspire the outlaw, cowboy or James Dean rebel in all of us."

Vintage-boot and denim buyers browse at American Classics. Photo by David Tidwell.

AMERICAN CLASSICS

Jack Dovan from New York has been involved in vintage clothing ever since he got out of college. In 1987 he opened American Classics in the Melrose district of Los Angeles, catering to the rock 'n' roll and heavy-metal crowd. The store specializes in vintage and "make-up" boots. Jack also sells denim, leather jackets, jewelry and miscellaneous vintage clothing. He runs a wholesale business, selling bulk denim and vintage boots by the dozens to Japan and European countries as well.

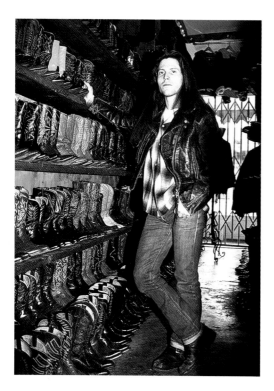

Mark Fox sells vintage boots to the Hollywood crowd. There are always at least five hundred pairs to choose from. Photo courtesy Mark Fox.

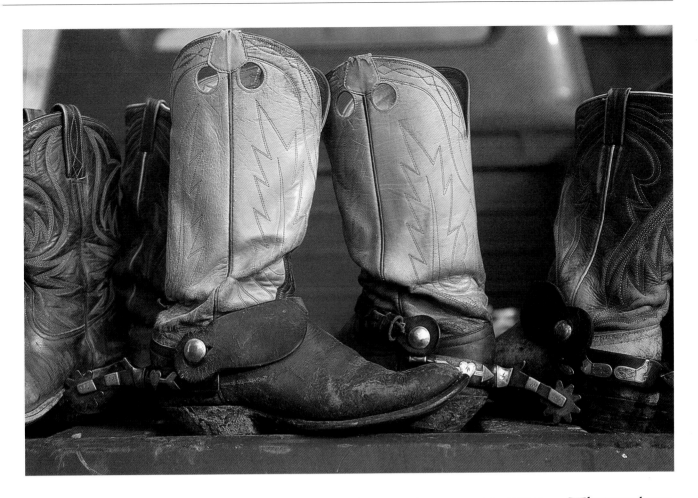

The sun goes down on these well-worked cowboy boots at the end of the day. Boots show up everywhere—even on these spurs by Carl Hall of Comanche, Texas.

Somebody loved this boot; 1950-60s, maker unknown. Photographed by Studio 7, Albuquerque for Billy Martin's.

GLOSSARY

Beading: a slender, rounded strip of leather which encircles the top of a boot. The beading is made from the same material as the piping that runs down the side of the boot.

Boot Hooks: a pair of long, strong metal hooks attached to cross handles made out of hardwood or plastic. The lower section of the hook is flat so that the inside pull straps of the boot will not wrinkle when you pull the boots on. After the hooks are inserted into the loops of the pull straps, the foot is thrust into the boot, which is pulled on using slight force.

Boot Jack: a tool which enables the boot wearer to remove boots while standing. The first boot jacks were made of wood and had a forked end to hold the heel of one boot while the wearer pulled his foot out of the other. Many early boot jacks were hinged down the middle so they could be folded for traveling. After the 1870s most boot jacks were made from molded iron. The jacks came in a variety of shapes and sizes. The most common design was a brightly painted beetle with its antennae outstretched to hold the heel of the boot. Popular with cowboys were the naughty Nellies, which depicted a woman lying on her back with legs spread to catch the heel of the boot. Designs featuring six-shooter barrels and longhorns were also widespread. Tobacco companies, boot companies and clothing manufacturers began to put their names on the jacks as giveaway advertisements. Boot jacks gave rise to the catchy expression: "Once you use a jack, you will never go back."

Boot Jockey: a curved metal plate, or today, more commonly, a plastic one. The jockey is used with tall boots, usually those over fifteen inches high, and is placed between the trouser leg and the boot front next to the shin to prevent wrinkles.

Boot Tree: a form used to keep boots in shape when they are not being worn. Also known as "wooden feet," boot trees are designed to be inserted into the foot of the boot with relative ease, to slide or spring action built into and underneath the wood. They are regaining popularity and can be easily purchased. Older ones were usually made of maple, but today cedar, because of its deodorizing quality, is more common.

Box Toe: a boot toe that is squared off at the end. Square-toed boots have been around for thousands of years. Box toes were popular with the early cowboys and remained that way through the 1950s. Bootmakers often describe toes as one-eighth box, quarter box, half box, etc. This refers to the width of the tip of the toe. After the 1950s the pointed, or sharp, toe became more popular than the box toe.

Buck Stitching: a thin strip of leather, normally in a contrasting color to the boot, which is woven over and under to create a laced effect. Although the purpose is usually purely decorative, this type of work can be used to hold layers of leather together. Buck stitching is often seen around wing-tip toes, up the sides of boots, or around their tops. Most buck stitching was done in Mexico and South Texas by bootmakers and factories in the 1940s and fifties.

Clicker: a machine like a press which pushes down on the dies to cut out various pieces of leather for all parts of the boot. It works like a giant cookie cutter. The word "clicker" comes from the sound the machine makes upon impact with the die. Once largely found in boot factories, the click machine is now also used by custom bootmakers.

Cockroach Killers: a street term that arose to describe the narrow, pointed, and sometimes hand-filed needle-nose boots worn in the 1960s and early '70s. This toe style was very popular and just about all you saw on men and women for almost fifteen years. During the popularity of *Urban Cowboy,* the toes began to round out to satisfy the more conservative tastes of the East Coast of the United States. However this type of toe, along with the narrow box, has remained the most popular one in all other countries throughout the world, and during the last five years in the United States, sharp toes have come back into vogue again. In 1991 more pointed-toe boots were sold than in any year since 1966.

Collar: a layer of leather, at the top of the boot, usually in a contrasting color or made from an exotic skin, which is cut into a decorative design. This collar is usually overlaid, but often also has fancy inlay work on it which dresses up the boot.

Counter: the leather piece above the heel of the boot which is attached by stitching to the vamp.

Crimping Boards: a narrow piece of wood, usually less than an inch and a half wide, which looks like a tall tube sock. The wet vamps of boots are stretched and nailed to this board before they are attached to the other parts of the boot. Then the leather is left to dry for a day or two. This is an extra step before lasting to ensure that all the stretch or memory has been removed from the leather. If this process is not performed, wrinkles will appear in the curves of the boot over the top of the foot.

Crow Wheel: a wooden-handled tool with a wheel mounted in a forked carriage, which uses sharp prongs to print narrow, decorative designs on the waist and heel of a boot. The crow wheel is sometimes confused with the peg wheel. The tool is heated and then applied to either damp or dry leather. In a catalog from 1900, there were over a dozen different wheels with various dots and fancy designs. One of these was a V shape, similar to a crow print, hence the popular name.

Custom-Made: a boot specially made for a specific customer. The bootmaker forms a last or has one made which conforms to the measurements of the customer's foot. Then a boot is designed in every detail by the bootmaker in collaboration with the person buying the boots.

Custom Makeup: a term used by boot factories to describe their version of custom-made boots. The major difference is that there is no custom last, nor are there any measurements, involved. A stock factory last in a standard size that comes as close as possible to accurately fitting the customer's foot is used instead.

Die: a metal pattern with razor-sharp edges which works like a cookie cutter. It is used to cut out sections of the boot in various shapes; these will then be glued and sewn together to form the vamp, counter and top of the boot.

Ears: another name for inside or outside pull straps.

Forty-Penny Nail: a nail which old-time bootmakers would beat flat and then shape to the dimensions of the wearer's foot. The nail was then covered with a layer of leather, stitched, glued, and sometimes pegged between the insole and outsole to work as a shank which would support the wearer's arch. Jumping on and off a horse all day can be rough on a boot, so many West Texas cowboys still request forty- and sixty-penny nails put into their boot soles today.

Foxing: a term describing a piece of leather that is sewn (overlaid) over another part of the boot simply for decoration. Bootmakers will say that the toe or heel is "foxed."

Fudge Wheel: a wooden-handled tool with a cylindrical serrated wheel, also known as a boot rand wheel, wheel jigger, bunking wheel, stitch prick, or seat wheel. The fudge wheel is heated, then rolled around the finished welt of the boot in order to mash, tighten and firm the leather and the stitching. It creates ridges and gives a uniform appearance to the stitching. Many old-time bootmakers think it gives the boot a nice finished look.

Handmade: boots that are built entirely from scratch by hand in the old way. There is little or no machinery involved, other than a foot-peddled sewing machine for some of the fine stitching.

Heel: the part of the boot attached to the rear or seat of the sole. The heel comes in any shape and height imaginable and should be constructed to add support, comfort and form to the overall boot design.

Inlay: strictly decorative fancywork which involves multiple layers and colors of leather. These may be overlaid or underlaid. Overlaid patterns are sewn over the principal boot leather, while underlaid ones are invisibly sewn in from underneath to produce a cutout window-type design.

Insole: the layer of leather between the foot and the outsole or bottom of the boot. The insole forms the inner foundation of the boot to which the outsole is attached.

Last: an Old English word for footstep. The last is the model used to make all custom and factory boots. Until recently it was always carved from wood, but now fiberglass poured into foot molds has almost entirely replaced wood. The toe, however, can be fastened to the end of the last in any style the customer desires. And small pieces of leather are shaped and glued and then sanded down smooth to compensate for any irregularities in a foot or changes which normally occur as a customer ages.

Mule Ears: elongated pull straps sewn to the outside of the boot which resemble long ears, hence the name. Some of these extend to the top of the boot and literally touch the ground at the bottom. Many times you will see initials, names, etc., inlaid down the ears. Buck stitching, lacework, and sometimes fringe are added for effect.

Needle Nose: the absolutely sharpest point possible on a cowboy boot. A needle-nose toe has to actually be hand filed to create less than an eighth-of-an-inch point. This style is still popular with many Nashville performers. The only custom bootmaker who manufactures these toes today is James Leddy in Abilene, Texas.

Peewee: a nickname given to the short boots popular in the 1940s and fifties. A standard cowboy boot is twelve inches high. Basically any boot less than ten inches tall is considered a peewee.

Pegs: wooden pegs, little stakes of wood made from maple or lemonwood, usually from Germany. These pegs, in rows of one to three, run from the breast of the heel down the waist of the sole of the boot. Along with stitching and glue, they hold the insole and outsole together. Pegs are usually a sign of a better-quality boot. They are visible on the bottom of the boot, and you should also be able to see the tops of the pegs when you look inside your boots. Bootmaker Ray Jones is the legendary "king of the pegs," known to use as many as 300 pegs per pair.

Peg Wheel: a wooden-handled tool composed of a metal wheel with tiny metal spikes. It is used when the leather is damp and is rolled along the sole of the boot to create a path as a guide for the bootmkaer to space his pegs evenly.

Piping: rounded strips of leather that run up the side seams of the boots. Sewn dead center between the back and front of the boot, piping can be in the same color or a contrasting color of leather to make the boot or its stitching patterns stand out more. Early bootmakers had to hand make all their piping. Now it comes in rolls in dozens of colors, already rounded and ready to sew.

Pull Holes: finger holes at the tops of boots which replace pull straps and are very often used by working cowboys, who also call them "windows." Outside pull straps can catch on things and have been known to pull a rider off a horse. Inside pull straps sometimes rub against a leg and create a lot of discomfort.

Pull Straps: straps which are literally used to assist in pulling the boot on. They can be on the outside or the inside of the boot in any size or shape. In the 1940s and 50s, when men and women frequently tucked their jeans and trousers into their boots, bootmakers and factories began to stitch their names into the cotton cloth pulls, which then hung out over the top of the boot for free advertising.

Roper: a style of boot with a wide, round toe, no decorative stitching, usually a nine-to-ten-inch top, and a low walking heel. In the 1920s through the 1960s, this work-style boot, rugged, but plain, was called the Wellington. It came with low or high tops. In the late 1970s the boot was renamed "roper" by the factories. The style caught on and became very popular with both men and women. The roper bears little resemblance to what we think of as a real cowboy boot from any era.

Saint Crispin: the patron saint of shoe-and bootmakers whose festival is celebrated on the twenty-fifth of October. Legends and stories about Saint Crispin, who supported himself as a cobbler while preaching the gospel, are popular with bootmakers.

Scallop: the V shape in the front and back of the cowboy boot. This scallop or V can be shallow or cut very deep.

Shank: the portion of the boot which is used as reinforcement for the wearer's arch. Most bootmakers today use a thin, precut strip of eighteen-gauge steel, which is glued, whip-stitched, or tacked in place. On urban sidewalks this works fine, but most folks in the country, including cowboys, still prefer that forty- or sixty-penny nail for support.

Skive: from the Norse work "skifa": to make leather thinner. Skiving is also known as feathering the leather. This is usually done when overlapping is required, as in overlay and inlay. The back side of the leather is scraped thin along the edges, or wherever the leather is too thick, with a sharp knife, lightly sanded for continuity, then quickly burned with a match or flame to remove any small, loose beads of skin that remain. The leather is now ready for glue and thread.

Sole: the only part of the cowboy boot, besides the bottom of the heel, which actually has contact with the ground, unless you happen to get thrown off a horse or a bull.

Spur Rest: a ridge or shelf on the back of the boot which helps hold up a spur. Below the counter, extending from the heel base, the top of the actual heel is pronounced by a quarter-inch or more. Looked down upon by some older cowboys as a wimpy crutch for those who don't know how their spurs should fit, this spur ledge has become very popular with young cowboys today.

Stay: the strip of leather that runs up and down the back of the inside of the boot lining to stiffen and support the boot and hold up the top, which gets the most movement. The width of the stay and how high it extends reflect an individual bootmaker's idea of how a boot should be made. Most working cowboys prefer a stay which extends all the way from the bottom of the boot to the top and is about four inches wide.

Stovepipe: refers to the top of the boot when there is no scallop. The boot resembles a pipe sawed off. Most early cowboys, before 1900, wore boots with stovepipe tops because they were still clinging somewhat to military fashion.

Straights: a term describing boots that have no designated right or left foot. Because high-heel lasts were more difficult to make in mirror images, straights remained popular from the 1600s until 1819, when the irregular-shape copying lathe was invented. Straights continued to be worn extensively until 1900.

Toe Box: a stiff piece of material which is placed in the top of the toe of the boot between the outer vamp leather and the lining to reinforce the shape. All toe boxes used to be made of leather until the advent of super man-made materials. However, many custom bootmakers still use leather, while the factories use plastic or man-made toe boxes.

Toe Bug: also referred to as the "toe flower," "medallion," "fleur-de-lis," or just plain "toe stitch." Every bootmaker has his favorite design. Many will only use one stitch pattern on the toe of their boots. It becomes their signature, which can identify the boot to others. Usually only one or two rows of stitching are used to create a delicate and artful design. You seldom see cowboy boots without decorative toe stitching unless they are made from exotic skins, in which case the stitching would not be visible.

Tongue: the top part of the vamp, usually cut into a decorative shape. The tongue is sewn to the upper front portion of the boot. Because a cowboy's stirrup hits this area of the boot all day, it was originally reinforced by a third layer of leather inside or was cut extra wide to prevent wearing out.

Tools: the dozens of implements used in boot making. Most of these have their roots in Europe. Some have names and manufacturers; others do not. Most bootmakers hand-fashion many of their battery of tools—even today this is very common. To a bootmaker tools are known by their function and not their name.

Triad: a type of boot with no counter. A regular cowboy boot as we know it has four outer sections: the shaft, or top of the boot, which normally has two parts, the front and the back; the counter, or heel piece; and the vamp, which is the foot of the boot. A boot with a one-piece top has no side seams and is sewn or laced up the back. In a triad the front of the boot extends all the way to the sole, and the vamp stops before the side seams and is stitched down.

Underslung: a descriptive word for the angle of the back of the heel. Underslung heels are also sometimes called "undershot." From 1880 to 1960 most cowboy boots had higher heels. To keep them from having a heavy, blocky shape, bootmakers hand-fashioned the backs of the heels to angle toward the foot. This style was taken to its extreme in the 1940s at the Leddy Boot Company in San Angelo, Texas, when bronc buster Alton Barnett had all of his boots so undershot that you could not squeeze a penny between where the heel and the sole met. Other than those with a low, flat walking heel, most boots today have some undershot to them.

Vamp: the lower front portion of the cowboy boot that covers the foot. The vamp attaches to the counter in the back, and to the front parts of the boot shaft in the front.

Welt: a strip of heavy leather which is sewn around the lasting space of the upper and joins it to the insole. The sole is then stitched to the welt with a second seam. The welt is also known as the rand.

Wing Tip: a fancy leather piece, which can be any shape and even have inlaid designs, which is stitched over the toe and a portion of the lower vamp area. In the 1940s, fifties and sixties, wing tips were usually associated with dress boots. Now wing tips are experiencing a revival and can be seen on everyday cowboy boots. A wing tip can be as simple as a small tip of exotic lizard or other skin sewn over the principal leather.

Wrinkles: the straight lines of stitching on a toe, usually located behind the toe flower.

ARIZONA

Stewart's Boots
30 W. 28th St.
S. Tucson, AZ 85713
(602) 622-2706
Custom bootmaker.

Paul Bond Boots
Box 1949
Nogales, AZ 85621
(602) 287-3322
Custom bootmaker.

CALIFORNIA

American Classics
7368 Melrose Ave.
Los Angeles, CA 90046
(1-800) 783-BOOTS
(213) 655-9375
New and vintage boots, denim and leather.

Falconhead
11911 San Vincente Blvd.
Los Angeles, CA 90049
(310) 471-7075
New boots and takes custom orders, sells belts, buckles, hats and western clothing.

Jonathan's
1705 S. Catalina Ave.
Redondo Beach, CA 90277
(310) 373-8708
New boots and western clothing.

Mark Fox
7326 Melrose Ave.
Los Angeles, CA 90046
(213) 936-1619
New and vintage boots.

Thieves Market (14 locations in CA)
(714) 380-7700
New boots and western clothing.

CANADA

Texas/Eddy Liptrott
332 Richmond St. West
Toronto, Ontario, Canada M5V2A4
(416) 348-9664
New and vintage boots, denim, leather, and vintage western wear.

COLORADO

Great Western Bootmakers
26 Broadway
Denver, CO 80203
(303) 777-4165
Custom bootmaker.

FLORIDA

J. W. Cooper
3015 Grant Ave.
Miami, FL 33133
(305) 441-1380
New boots and takes custom boot orders, sells belts, buckles and western clothing.

KANSAS

Olathe Boot Company
705 S. Kansas
Olathe, Kansas 66061
(1-800) 255-6126
Boot factory.

Sheplers Western Wear (19 stores in KS, OK, MO, TX, AZ, NV, CO)
(1-800) 835-4004 (for free catalog)
Complete line of boots and western wear.

MASSACHUSETTS

T. P. Saddleblanket Company
152 Main St.
Great Barrington, MA 01230
(413) 528-6500
Sells new and vintage boots and western clothing.

MONTANA

Wilson Boots
110 E. Callender St., Dept. E
Livingston, MT 59047
(406) 222-3842
Custom bootmaker.

NEW MEXICO

Back At the Ranch
235 Don Gaspar
Santa Fe, NM 85701
(505) 989-8110
Vintage boots and takes custom boot orders, sells denim and western clothing.

Dean Jackson
108 W. Snyder
Hobbs, NM 88240
(505) 393-6583
Custom bootmaker.

D. L. McKinney
120 N. Main
Roswell, NM 88201
(505) 622-6424
Custom bootmaker.

L. W. and Deana McGuffin
605 Connelly
Clovis, NM 88101
(505) 769-0833
Custom bootmaker.

P. T. Crow

P. T. Crow
114 Amherst SE
Albuquerque, NM 87106
(505) 256-1763
New and vintage boots and takes custom boot orders, sells western clothing.

NEW YORK

Billy Martin's Western Classics
812 Madison Ave.
New York City, NY 10021
(1-800) 888-8915 (for a catalog)
(212) 861-3100
New and vintage boots and takes custom boot orders, sells belts, buckles and western clothing.

Katy K
22 E. 4th St.
New York City, NY 10003
(212) 677-6020
New and vintage boots, own line of western wear.

OKLAHOMA

Dan Wells
Rt. 1, Box 85
Beggs, OK 74421
(918) 267-4773
Custom bootmaker.

Howard's Boot Shop
55 Ranch Drive
Ponca City, OK 74604
(405) 628-2780
Custom bootmaker.

Jay Griffith Bootmakers
120 S. 2nd / Box 726
Guthrie, OK 73044
(405) 282-3824
Custom bootmaker.

OREGON

Bill Crary
2 NE 80th St.
Portland, OR 97215
(503) 253-8984
Custom bootmaker.

TENNESSEE

Acme Boot Company (Dingo, Dan Post, Avirex)
Box 749
Clarksville, TN 37040
(1-800) 937-2263
Boot factory.

Bo Riddle
7016 Church
Brentwood, TN 37027
(615) 661-9230
Custom bootmaker.

Manuel
1992 Broadway
Nashville, TN 37203
(615)-321-5444

TEXAS

Acuff Boots
3035 34th St.
Lubbock, TX 79410
(806) 797-7060
Custom bootmaker.

Amado Boot Company
734 2nd
Mercedes, TX 78570
(512) 565-9641
Custom bootmaker.

Ammons Boots
9401 Carnegie Ave.
El Paso, TX 79925
(915) 595-2100
Custom bootmaker.

Armando Boot Company
169 N 7th St.
Raymondville, TX 78580
(512) 689-3521
Custom bootmaker.

Austin–Hall Boots
491 Resler, Suite A
El Paso, TX 79912
(915) 581-2124

Ayers
Box 926
Anthony, TX 79821
(915) 886-4903
Custom bootmaker.

Bell Custom Boots (Alan)
2118 N. Treadway Blvd.
Abilene, TX 79601
(915) 677-0632
Custom bootmaker.

Boot Town (6 retail stores in TX)
(214) 243-1951 for the store nearest
you
New boots and western clothing.

Burk Boot Shop
206 E. 3rd St.
Burkburnet, TX 76354
(817) 569-4990
Custom bootmaker.

Camargos
717 Hwy. 83
Mercedes, TX 78570
(512) 565-6457
Custom bootmaker.

Capitol Saddlery
1614 Lavaca
Austin, TX 78701
(512) 478-9309
Makes custom boots, saddles and tack.

Cavenders Boot City (6 retail stores in
TX)
(214) 239-1375 for the store nearest
you
*New boots and a complete line of
western wear.*

Jack Reed
Hwy. 29 W. Box 123
Burnet, TX 78611
(512) 756-7047
Custom bootmaker.

James Leddy
926 Ambler
Abilene, TX 79601
(915) 677-7811
Custom bootmaker.

James Owens
Box 776
Clarendon, TX 79226
(806) 874-2191
Custom bootmaker.

Jass Boot Shop (Pablo)
803 E. Ave. G
Lampasas, TX 76550
(512) 556-3857
Custom bootmaker.

Justin Boot Company
(817) 332-4385 (or contact your near-
est western wear store)
Boot factory.

Just Justin (2 retail stores in TX)
1505 Wycliff
Dallas, TX 75207
(214) 630-2858
New boots and western clothing.

Kimmel Boots (Eddie)
Route 2
Comanche, TX 76442
(915) 356-3197
Custom bootmaker.

Little's Boots (Dave)
110 Division
San Antonio, TX 78214
(512) 923-2221
Custom bootmaker.

Lucchese
402 S. Broadway
San Antonio, TX 78209
(512) 828-9419

6601 Montana
El Paso, TX 79915
(1-800) 637-6888
Boot factory.

Lone Star Boot (3 retail stores in TX)
(214) 445-0277 for the store nearest you
New boots.

M. L. Leddy
2455 N. Main St.
Fort Worth, TX 76106
(817) 624-3149

2200 W. Beauregard
San Angelo, TX 76901
(915) 942-7655
Custom bootmaker.

Morado Boots
402 Frisco St.
Houston, TX 77022
(713) 694-7571
Custom bootmaker.

Nocona Boot Company
Box 599
E. Highway 82
Nocona, TX 76255
(1-800) 433-0915
Boot factory.

Palace Boot Shop
1212 Prairie Ave.
Houston, TX 77002
(713) 224-1411
Custom boots and western clothing.

Rancho Loco
830 Exposition
Dallas, TX 75226
(214) 827-1680
*New boots and rockabilly western
wear.*

Ramirez Boots
804 N. Hancock
Box 1889
Odessa, TX 79760
(915) 332-3923
Custom bootmaker.

Rios of Mercedes
Box 895
Mercedes, TX 78570
(512) 565-2634
Custom bootmaker.

Rocketbuster Boots
2905 Pershing
El Paso, TX 79903
(915) 562-1114
Boot factory.

Rocky Carroll
34th and Ella
Houston, TX 77018
(713) 682-1650
Custom bootmaker.

Rusty Franklin Boot Company
3275 Arden Road
San Angelo, TX 76901
(915) 653-BOOT
Custom bootmaker.

Shorty Hall
205 Ave. F NW
Childress, TX 79201
(817) 937-2862
Custom bootmaker.

Stanley's Boot Shop
1112 N. Chadbourne
San Angelo, TX 76901
(915) 655-8226
Custom bootmaker.

Tex Robin Boots
115 W. 8th St.
Coleman, TX 76834
(915) 625-5556
Custom bootmaker.

Texas Traditions / Lee Miller
2222 College Ave.
Austin, TX 78704
(512) 443-4447
Custom bootmaker.

Tomlinson Boot Shop
119 E. Main
Llano, TX 78643
(512) 247-5441
Custom bootmaker.

Tony Lama Boot Company
1137 Tony Lama St.
El Paso, TX 79915
(1-800) 347-5262
Boot factory.

Trujillio Boots
409 E. Morgan St.
Meridian, TX 76665
(817) 435-6133
Custom bootmaker.

Two Moons
3411 Rosedale
Dallas, TX 75205
(214) 373-8822
Takes custom boot orders, sells belts, buckles, tooled leather and cowboy memorabilia.

Western Warehouse
10838 N. Central Expressway
Dallas, TX 75231
(214) 891-0888
New boots and western clothing.

Wheeler Boots (Dave)
4115 Willowbend
Houston, TX 77025
(713) 665-0224
Custom bootmaker.

Wild Bill's
603 Munger
Dallas, TX 75202
(214) 954-1050
New boots and western clothing.

WYOMING

Jim Birdsaw / Frontier Boot Shop
321 W. 18th St.
Cheyenne, WY 82001
(307) 638-7538
Custom bootmaker.

PLACES TO SEE VINTAGE BOOTS

The Canyon Museum, Canyon, TX

Country Music Hall of Fame, Nashville, TN

The Cowboy Hall of Fame, Oklahoma City, OK

The Cowgirl Hall of Fame, Hereford, TX

The Gene Autry Western Heritage Museum, Los Angeles, CA

The Hollywood Stuntman Museum, Moab, UT

The Roy Rogers Museum, Victorville, CA

The Texas Ranger Museum, Waco, TX

The Tom Mix Museum, Dewey, OK